Public Speaking

PETER LANG
New York • Washington, D.C./Baltimore • Bern
Frankfurt am Main • Berlin • Brussels • Vienna • Oxford

W.A. KELLY HUFF

Public Speaking

A CONCISE OVERVIEW
FOR THE TWENTY-FIRST CENTURY

PETER LANG
New York • Washington, D.C./Baltimore • Bern
Frankfurt am Main • Berlin • Brussels • Vienna • Oxford

Library of Congress Cataloging-in-Publication Data

Huff, W. A. Kelly.
Public speaking: a concise overview for the twenty-first century /
W.A. Kelly Huff.
p. cm.
Includes bibliographical references and index.
1. Public speaking. I. Title.
PN4129.15H84 808.5'1—dc22 2008010858
ISBN 978-1-4331-0259-2

Bibliographic information published by **Die Deutsche Bibliothek**.
Die Deutsche Bibliothek lists this publication in the "Deutsche
Nationalbibliografie"; detailed bibliographic data is available
on the Internet at http://dnb.ddb.de/.

Cover design by Clear Point Designs

The paper in this book meets the guidelines for permanence and durability
of the Committee on Production Guidelines for Book Longevity
of the Council of Library Resources.

© 2008 Peter Lang Publishing, Inc., New York
29 Broadway, 18th floor, New York, NY 10006
www.peterlang.com

Printed in the United States of America

I dedicate this book to my wife, Rita; to my children, John and Laura; and to my father and mother, W.R. and Mary Lynn Huff, who made all of the rest of us possible.

Contents

Preface

Having taught numerous sections of public communication or public speaking over the years, I have made a sincere effort to determine what should most effectively comprise a basic public speaking or public communication course and its accompanying textbook. *Public Speaking: A Concise Overview for the 21st Century* is the product of more than 24 years of teaching, research, and service in the fields of speech and mass communication; nine years of professional communication experience in radio, television, public relations, and journalism; and a whole lot of input from students. James Thompson Baker (1928), author of his own speech communication book, believed: "If a book is practical and really worth while, it grows out of experience. Of course this alone does not guarantee every such book, but without this element few texts are of great value" (p. viii).

By design, this is a concise book focusing on information that students should learn in a basic public communication or public speaking class. It is targeted toward college students, and hopefully, it will serve as a means for the student to learn more about life and career through the study of real communication. In order to get a better handle on how to organize and write *Public Speaking: A Concise Overview for the 21st Century*, I asked students in my classes to tell me what they want (and don't want) in a public speaking textbook. My intention is to follow the advice of my students as closely as possible. *Public Speaking: A Concise Overview for the 21st Century* is written for college students who come into the basic public communication course hoping to learn from an instructor who is a real, live person and to use the textbook as a *concise* companion to the material presented by that instructor in the classroom. College students want their instructors and textbooks to be able to relate to them, and they say the best way to do that is through realistic examples and humor. Most students don't mind reading as long as the information gets to the point, has relevance, and doesn't waste time and energy they could put into other endeavors. For instance, one day in class as I was emphasizing the importance of a brief but powerful speech, I mentioned a public speaking book by Ron Hoff (1996) called *Say It in Six: How to Say Exactly What You Mean in 6 Minutes or Less*. Immediately, one student raised her hand and asked, "How long is the book?" Her point was that most people who recommend brevity usually aren't very brief in getting across their own points.

College students want to be given credit for knowing some things before they enrolled in the class. They enjoy expressing themselves to others and they want guidance in how best to do that. Modern college students know how to use computers and other electronic technology and they probably know more about it than most instructors and authors. Therefore, they don't want to waste time going over redundant and frequently outdated information. Contrary to what many people may think, college students don't need or want all the extras. They don't want colorful boxes and illustrations; they don't want CD-ROMS and publisher Web pages; and they don't think bigger and more expensive textbooks are worthwhile. Simply, they want to learn and be treated as adults. By design, students and instructors should find the fundamentals here and will not find elaborate details.

The knowledge gained from a basic public speaking course and this companion textbook should serve college students well as they develop their own talents and skills and practice these things in their subsequent college courses and on into their professional careers. I hope that this book accomplishes as many of these goals as possible and that my students will be proud and honored that I listened to them.

Acknowledgments

I would like to thank Rita C. Huff, M.Ed., for tirelessly reading and re-reading the manuscript, for editing, for making suggestions, and for supporting my goals and objectives in writing this book. I would also like to thank my many students who read the manuscript and who made thoughtful suggestions about what they did and did not want to see in a public speaking textbook. I express my appreciation to Dr. Greg Leichty of the University of Louisville who reviewed the manuscript. Dr. Leichty offered valuable suggestions that made the text much stronger. I am also appreciative of Dr. Jack Bridges. Dr. Bridges, a true friend and colleague since our days in the doctoral program at the University of Southern Mississippi, has given me tremendous support, encouragement, and advice. I also want to acknowledge my late friend and colleague, Dr. Percy Miller, who was always there for me when I needed him. Finally, I offer my appreciation to Peter Lang Publishing's Mary Savigar, acquisitions editor, and Sophie Appel, production supervisor, for their advice, assistance, and efforts in publishing this book.

Chapter 1
Public Speaking and Communication in the Real World

Communication has changed in the 21st century. That is not a profound statement and it probably is not an original one. Although general, it is accurate. People of all ages, in an era of rapid technical and technological wonder, are communicating differently than ever before. Simple *conversation* is not as prevalent as it once was. Seldom does our American society see neighbors and family members chatting—or even *gossiping*—over the boundary fence or on the front porch. Rather than walking outside and interacting personally with their neighborhood friends, many of us think nothing of entering a cyber chat room, sending e–mail, or talking on our cellular phones. Rather than visiting the library, we search for information on the World Wide Web (WWW) and the Internet. Conversation, or talk, has even become a lost art on talk television. Television critic Diane Werts (2007) observed: "Here's a shocking revelation. People on talk shows used to TALK. Not ram through gags, not blow hype smoke, not rant and shout, not reveal baby–daddies or body parts. Talk. In normal tones of voice. About real, authentic sometimes intimate sometimes consequential stuff. Yes! Really!" (p. F4). Werts lamented: "It's a sea change that doesn't seem likely to change back. [Jay] Leno, [David] Letterman, [Jimmy] Kimmel, [Conan] O'Brien—they're all after the laugh" (p. F4). What happened to conversation?

There is no argument offered here that electronic communication is an evil entity, because any technology is only as good, bad, or indifferent as those programming its content. These technological innovations have given rise to new terminology, such as face–to–face communication (FtF) and computer–mediated communication (CMC), which interpersonal communication authors Beebe, Beebe, and Redmond (2002) describe as "communication between and among people through the medium of computers" including "e–mail, chat rooms, bulletin boards, and newsgroups" (p. 384). It might be communication, but as broadcast veteran Hugh Downs (1995) be-

lieves, "so much of the new technology is simply cold, empty, and lifeless" (p. 271). Author Patsy Rodenburg (1993) agreed:

> Somewhere along the line we stopped being an oral society. We threw up civilizing barriers between ourselves and words. The steady transmission of our family tongue and cultural identifications ceased to be by word of mouth. Storytelling, discussion, debate or just the simple enjoyment of words and word games ceased to be part of our daily lives. Oh, yes, all this is still important to us but perhaps not as vital as it was in the past. (p. 5)

Could this be a major reason for why more and more students seem to fear public speaking? Actually appearing in person before a group of other people may be so uncommon that the thought of communicating face–to–face has become disconcerting. E–mail, for instance, has made it so much easier for students to approach professors. I have probably never had a thousand conversations with students in a year, but I now average more than a thousand e–mail exchanges per year with students. In a normal year I have perhaps 200 different students in interpersonal communication and public speaking classes, so the average would be about five e–mail exchanges per student. Rarely have I had an e–mail exchange that achieves the same level of satisfaction of an actual conversation.

The onslaught of electronic communication due to personal computers has had a tremendous impact on the decline of writing and organizational skills. Communication, mass communication, and journalism programs in higher education are reflecting the changes by offering electronic communication courses. The broad spectrum includes new media courses such as computer graphics, information on the Internet, and even modern concepts in print and photojournalism. It ranges to broadcasting via radio, television, videotape, film, and the Internet to public relations, interpersonal communication, organizational communication, public communication, and health communication. Even in speech communication, technology has become a major factor in delivering speeches or presentations. Although there is far more to a career in the field of communication than technical application, the communicator who can effectively use technology will have a tremendous advantage in today's job market. However, a solid curriculum in the various fields of communication requires a sound knowledge of theoretical, historical, as well as technological perspectives.

When it comes to communication, some things are certain—even when they are uncertain. First of all, imperfect human beings communicate, so

one's communication can be both interpreted and misinterpreted. Second, communication is inevitable—it happens intentionally and unintentionally. Once something is communicated, whether intentional or unintentional, it cannot be taken back. One should think more, not only before speaking, but also before clicking to send an electronic message.

Misconceptions about Public Speaking

Among the major problems educators face in teaching public speaking classes is the huge misconception of just what such a course is all about. Although there are some students who love being the center of attention, many students enroll in public speaking courses with great trepidation. For many, the very thought of public speaking frightens them. Much of that fear is based on ignorance. The overwhelming perception of public speaking is that the primary objective is for one to overcome the tremendous obstacle of standing before a group of his/her peers and saying something without feeling awkward or embarrassed. Obviously, there is much more to public speaking than "just getting up there and talking." Academic advisors who apparently know little about what goes on in the course do not help resolve the stigma attached to public speaking. On many occasions, highly educated colleagues have been overheard telling students: "I understand that you have trouble with math, science, and history, but I have heard you talk so I think you'd do well in public speaking. All you have to do is get up and talk." It is unfortunate that some people view public speaking in such a simplistic light. Nonetheless, many students have adopted the belief that they will successfully meet the course objectives simply by getting up front and talking. To put their misconception into perspective, I frequently find myself showing them how silly their view is. I have said: "Every time that I walk from my office to the classroom I pass by and through scores of students on campus who are talking. Many of them are talking to several people at one time. So, if we are to be graded on how we 'talk,' there is no reason to take public speaking. I'll just walk around campus all day and grade students on how they are talking to each other."

Indeed, misperceptions about the discipline of speech communication led to academic revolt in 1914. On November 28 of that year, 17 teachers of "speech" protested the misperception by walking out of the annual National Council of Teachers of English (NCTE) convention in Chicago. Those 17 individuals requested a place on NCTE's program for a group discussion on

their unique concerns in teaching public speaking, but NCTE officials refused their request. One NCTE member declared: "If a man can write, can he not also speak? When does the greater encompass the lesser" (Gray, 1964, p. 11)? James M. O'Neill, one of the dissident 17, argued to NCTE that the disciplines of speech and English "were worlds apart" (p. 11). Partly in protest and mostly to declare the unique attributes of the speech discipline, the 17 moved forward to found the National Association of Academic Teachers of Public Speaking, which later became the Speech Communication Association and then the National Communication Association. From the modest number of 17, the NCA's membership has grown to exceed 7,500.

Most people can talk and give a speech, but fewer become good or great communicators. There are many people who can sing and play musical instruments, but fewer still can really *sing* and *play*. Rodenburg (1993) explained:

> We can all strike the keys of a piano and some of us can even play a tune. But learning to play superbly and movingly takes choice, practice and desire. A great musician makes a connection with his or her score. Likewise the way we use words can and should reflect what and who we are. It should also connect with the clear process of thought. Finally, it should signal variety and a facility with words. All of these connections with words are aspects of voice and speech that each one of us can master. (p. 4)

Certainly, effective public speakers must be able to put thoughts together coherently and in a particular order that is suitable to meet their objectives. Public speaking requires skill, practice, and experience.

Another misconception about public speaking is that it is primarily about talking. However, public speaking is based on a two–way process that includes *listening* and responding. Listening plays a large and important role in public speaking as it does in all other forms of communication. Listening and critical thinking skills are essential to effective communication. Later in this chapter, we will examine the importance of communication to various disciplines and careers. Business communication experts Kitty Locker and Stephen Kaczmarek (2007) explained: "Good listeners pay attention, focus on the other speaker(s) in a generous way rather than on themselves, avoid making assumptions, and listen for feelings as well as for facts" (p. 297). Locker and Kaczmarek (2007) added: "As a newcomer in an organization, you'll need to listen to others both to find out what you're supposed to do and to learn about the organization's values and culture" (p. 6). Colleen

McKenna (1998), author of *Powerful Communication Skills*, quantified the importance of listening:

> Research shows that 40 percent of your professional salary is earned by listening. This percentage increases as you climb the professional ladder. Eighty percent of a CEO's salary is earned through listening. Sperry Rand targeted listening as the communication skill it most wants its employees to improve. Sperry spends millions on effective listening training. Management recognizes that their employee's listening skills are not as effective as they could be, even though listening consumes a major portion of the workday. (p. 30)

It should be noted that a good listener will pay as much attention to the non-verbal communication of the speaker as to the words being used. Although we will touch on this further in Chapters 2 and 10, a very important motivation for taking a public speaking course is that it can make us better listeners—especially more critical listeners.

Public Speaking and Conversation

Authors George Fluharty and Harold Ross (1966) observed: "Conversation is an important element of all social relationships and is the most used and least studied form of speech" (p. 334). We do know that there are both differences and similarities between public speaking and conversation. How many times have we heard someone say they are going to hear a "talk"? However, good conversation, like a good speech, is not just "talking." Public speakers spend a great deal of time preparing to address others, but good conversationalists also think about what they will say. Certainly, *some conversations are planned, but not at the level of a formal or even informal speech.* Conversations, like speeches, can be formal or informal. Some formal or planned conversations might include a job interview, an attempt to resolve conflict, selling something, asking for a date, etc. Gloria Hoffman and Pauline Graivier (1983) believed: "The art of talking to people consists of spontaneity built on preparation. It's no accident that some people are great conversationalists. They're prepared to be" (p. 147). Ronald K.S. Macaulay, Emeritus Professor of Linguistics at Pitzer College in Claremont, California, added:

> We speak differently to different people. We speak differently depending upon whether we're in an informal situation with our friends or in a formal situation with people we know less well. We speak differently when we're speaking to someone who is in a superior position to us or a person who is older than us than to somebody

who is in an inferior position or somebody who is younger or to our peers and so on. There is a great variety in the ways in which we speak. (*The Art of Communicating Language*, 2000)

President Abraham Lincoln is remembered for his remarkable public speaking, but he was perhaps even more accomplished at conversation. Donald T. Phillips (1992), an expert on Lincoln's leadership qualities, believed that Lincoln is "the only president of the United States who was a true humorist in the tradition of Mark Twain or Will Rogers." He used conversation as his "chief form of persuasion and the single most important and effective aspect of his leadership style" (p. 155). Phillips added that Lincoln's love of conversations "was one reason he created such open access to the White House" where "everyone and anyone was invited to come in and talk to him". (p. 155). Lincoln used his skills as a conversationalist to become a brilliant public speaker and he was able to speak to anyone anywhere.

Another difference from conversation is that in formal speaking situations *the public speaker is often physically and distinctly separated from others involved in the public speaking process*. The public speaker is typically at the front of the room, behind a podium, on a stage, or in some other physical position that causes that separation. Listeners in a speech setting are not expected to interact verbally until after the speech is over. Typically, public speakers would do almost all the talking, except for possible brief comments that may be uttered by audience members. In some situations speakers are verbally heckled or even praised (such as a hearty "Amen!") and the audience certainly offers continuous nonverbal feedback. In a conversation, participants take turns talking. However, we all know people who can really dominate a conversation. They may listen to you, but only until it prompts them to jump in and take over a conversation. *Greedy*, or *self–absorbed*, listeners can be a bad thing in interpersonal relationships, but a good thing in a public speaking setting. The speaker wants the listener to take information away from the presentation. Otherwise, what is the point of imparting the information? After your presentation, you hope that you have stimulated audience members to interact with you. That probably means they were interested in what you had to say.

Many students who enter college have little experience in public speaking and not much more experience with meaningful conversation and discussion. Some students have done some sort of public speaking, such as book reports or in clubs, but few have had formal education in public communica-

tion. Higher education puts emphasis on public speaking as an introductory course and rightfully so, but we also need to encourage more advanced public communication courses and to increase our promotion of good, old–fashioned interpersonal discussion and conversation. Author John Dolman, Jr. (1922), observed: "Good speaking, whether public or private, is communication. The word means the act of sharing something with others" (p. 9). Harrison Karr (1953) observed: "Only the most popular speakers make more than three or four speeches a week; even campaigners–for–office seldom make more than three or four speeches a day during the hottest part of their campaigns; probably the average for all college students would be more like three or four speeches a year" (p. 487). Even today when conversation has declined, the average conversations per person would still far outnumber speeches. Karr (1953) added: "To say this is not to discount public speech. Public speech from ancient times to present has wielded an enormous influence. On numerous occasions it has helped to determine the course of history …Yes, public speech is enormously important—but conversation is the very breath of our collective life" (p. 487).

If students were more used to interacting interpersonally with others, then there wouldn't be as much shock to their systems when they are called on to transfer those skills to the podium. Although we'll discuss anxiety in detail in Chapter 3, it would serve you well to meet as many of your classmates as possible before giving your speeches in a class. Get to know your fellow students through conversation and by the time the first speech is given, you will experience far less anxiety than there would be going up before a cold, strange crowd.

The Study of Rhetoric

Public speaking is rooted in the study of rhetorical communication, which has been around almost as long as humans have been able to talk. Rhetoric, which has been pondered from the times of Plato and Aristotle to the present, has many definitions. Simply stated, rhetoric is the study, art, and practice of the efficient and effective use of language or symbolic expression. In classic rhetoric, it is the facility of influencing the thought and behavior of an audience. The definition that best suits the objectives of this book is summed up very well by Professor Andrea A. Lunsford, who stated: "Rhetoric is the art, practice, and study of human communication" (Eidenmuller, 2008). An excellent overview of the rhetorical tradition can be found in both James C.

McCroskey's (2006) *An Introduction to Rhetorical Communication*, which traces rhetoric back to the earliest known essay on effective speaking from about 3000 B.C.; James A. Herrick's (2005) *The History and Theory of Rhetoric: An Introduction*; and Sharon Crowley and Debra Hawhee's (2009) *Ancient Rhetorics for Contemporary Students*.

The earliest book on rhetoric was *The Precepts of Ptah–Hotep* by Ptah–Hotep c. 2200 B.C.E. It is a collection of maxims focusing on human relations and the peaceful virtues of kindness, justice, truthfulness, moderation, and self–control. Ptah–Hotep was a vizier, or counselor, to King Izezi of the Fifth Dynasty in Egypt. McCroskey traces rhetorical history from that point forward. Most of our rhetorical tradition originated in Greece and was later refined by the Romans. Corax and Tisias are considered the founders of Greek rhetoric and the first sophists, or teachers, of rhetoric. Some scholars contend that Corax and Tisias are one person or even the result of legend, as our knowledge of them, particularly Corax, comes from later authors Plato, Aristotle, and Cicero. Corax is said to have invented an art of rhetoric to allow ordinary men the ability to state their own cases in the courts. Tisias, a student of Corax, is said to have developed legal rhetoric further and he is believed to have been the teacher of Isocrates. Corax and Tisias were the first to organize messages into what we know as the introduction, body, and conclusion.

Protagoras of Abdara was an original Greek sophist, who became known as the Father of Debate. Protagoras believed that every proposition consisted of two sides and that effective speakers should be prepared to argue on either of the two sides. McCroskey proceeds from Isocrates, Plato, Aristotle and his *Rhetoric* (from 330 B.C.) through the Roman period and then all the way to modern times. Aristotle is also considered by many experts to be the Father of Speech Communication. Because this textbook focuses on public speaking in the 21ˢᵗ century, I recommend the books by McCroskey (2006), Herrick (2005), and Crowley and Hawhee (2009) for those who want to know more about the history of rhetoric.

For those who want to learn more about the history of communication, particularly in regard to major researchers and their studies of communication, please consult Everett M. Rogers' (1994) *A History of Communication Study*. Rogers concentrated on North America and the U.S. because, as he wrote, "that is where the communication field grew to strength" (p. xiii). Rogers (1994) added: "Communication study came of age intellectually mainly in the United States during the 1900s, but its roots go back several

decades earlier in Europe. The history of communication study is the story of the social sciences, with important contributions also from biology, mathematics, and electrical engineering" (p. xiii). Rogers, as you will discover in this book, believed that interpersonal communication and mass communication share much common ground and segregating the two "is not a useful way to divide the field of communication today" (p. xiii).

Public Speaking: Communication in the Real World

Other than the primary purpose of exploring public speaking, a major objective of this book is to make the real world connection of public speaking and communication to one's academic, professional, and daily life experiences. Thus, it is about *real communication*. One would be hard pressed to find a professional endeavor in the real world that does not require effective communication to a great extent and public speaking to perhaps a lesser degree. Dolman (1922) believed that public speaking is "not a conventionalized imitation of life, but life itself, a natural function of life, a real human being in real communication with his fellows; and it is best when it is *most* real" (p. 5). Fluharty and Ross (1966) added:

> Without speech there could be no civilization, for civilization depends upon co–operation between people, and co–operation depends upon the ability of people to talk purposefully with each other. The hearing of spoken messages is more essential than the seeing of written messages, for the only real language is the spoken language. The majority of speakers inhabiting the earth have always been unable to read and write. (p. 1)

Although many students understand the academic objectives and ramifications of a public speaking course, many other students never take it seriously. They demonstrate their lack of understanding by choosing inappropriate, or at the very least immature, speech topics. Some of these include showing a class how to make something, such as a pizza or dessert. Others want to tell "how to plan a party" or "how I spent my weekend" or "how to roll a joint." Their sources are personal interviews with friends who partied with them or with whom they spent the weekend. There has been no legitimate research, but if one's speech isn't based on research, then what is the purpose of public speaking as a college course? They need to find supporting materials, organize and re–organize it, and then present it effectively to an audience. It is all about a process, as we will see in Chapter 2. Jack

Welch, CEO of General Electric, stated: "Real communication is an attitude, an environment. It's the most interactive of all processes. It requires count-less hours of eyeball–to–eyeball back and forth. It involves more listening than talking. It is a constant, interactive process aimed at [creating] consen-sus" (Baldoni, 2003, p. 108).

As a student, you may misunderstand the most important fact about pub-lic speaking—that *real communication* involves far more than standing up and talking. It is interpersonal and rhetorical communication. Part of that misunderstanding may be caused or influenced by a lack of few contempo-rary examples of great speaking. Rodenburg (1993) lamented:

> At one time the criteria for great statesmanship included the overwhelming ability to make acts and judgments through speech. There are too few Gettysburg Addresses written for today's political voices. Mostly we hear our politicians aggressively of-fering curt denials about misdeeds rather than constructive programmes [sic] framed in words…. We live in an age of "sound bites" where even our leading politicians can only speak in disconnected fragments and simplistic homilies. The "great speech" is no longer in them. It no longer rings in our ears. How many of us can say that we can name one great public orator? (p. 5)

When practicable, students should consider presenting or delivering speeches in their classes that are reflective of situations that they will en-counter in their careers, because verbal and written presentations are required in virtually every profession. Among factors most important in helping graduating college students obtain employment, communication skills—both verbal and written—consistently rank at the top of the list. Among factors or skills rated most important for successful job performance, interpersonal communication and teamwork skills also rank near the top (Coplin, 2003). Steve Allen (1986), the late entertainer and author, observed:

> The area in which a poor education shows up first is in self–expression, oral or writ-ten. It makes little difference how many university courses or degrees a person may own. If he cannot use words to move an idea from one point to another his education is incomplete. The business of assembling the right words, putting them down in proper sequence, enabling each one to pull its full weight in the conveyance of meaning—these are the essentials. (p. xiii)

Freshmen tend to groan at the realization that college is not vocational and that not every class in their curriculum will directly relate to their chosen fields of study. Certainly, every college major requires a rather lengthy list of

seemingly unrelated classes that are required for graduation. Almost everyone, from business to education, will take similar core courses in math, science, history, communication, etc. No matter the major, the ability to communicate one's ideas publicly can be very useful in a person's career. Most educated people in the real world will speak publicly via talks, lectures, or presentations in a variety of situations such as meetings, conferences, conventions, and public events. To most college students, however, public speaking can be erroneously considered of no more use to them than all those history, math, and science courses. Taking these courses may seem burdensome and useless at first, but the knowledge and experience gained will prove to be useful in the future—no matter the student's professional or personal objectives.

In his 1984 autobiography, former Chrysler CEO Lee Iacocca attributed much of his success to communication in general and public speaking in particular. Iacocca observed: "The only way you can motivate people is to communicate with them" (Iacocca & Novak, 1984, p. 53). Lowrey and Johnson (1953) wrote: "A doctor once said, 'If I were advising a pre–med student I'd tell him to spend more time in the English and speech departments. He will get his scientific training in medical school. He needs an understanding of human beings and how to deal with them such as he should gain from a study of speech and literature. If he does not get this in his college course he is likely never to get it and to be a poor doctor because of it" (pp. 8–9). Futrelle, Mannes, and Weisser (2005) of *Money Magazine* listed confident speaking among the "50 smartest things to do with your money." They wrote: "No one ever got a raise by being a wallflower. Spend a few hundred dollars on a public speaking class at a community college or get training and practice" somewhere. Author Julie Cannon has written a number of books, but she never considered that she would be invited to give speeches about them. Cannon "didn't like the idea of speaking in front of anybody," but she decided to take a public speaking class, overcame her fear, and now enjoys the experience (Ford, 2006, p. C3).

Students taking public communication courses intend to major in a wide variety of disciplines, such as journalism and mass communication, advertising/public relations, business (marketing, management, accounting), agriculture, medicine (physicians, nurses, pharmacists), the sciences (biology, chemistry, physics), engineering, liberal arts, etc. This is where the *real world* purpose or professional objective of one's communication comes into play. Shouldn't students be allowed, even expected, to learn how to commu-

nicate effectively within their chosen fields? Iacocca observed: "I've known a lot of engineers with terrific ideas who had trouble explaining them to other people. It's always a shame when a guy with great talent can't tell the board or committee what's in his head. More often than not, a [public speaking or other communication] course would make all the difference" (Iacocca and Novak, 1984, p. 54).

Public speaking classes teach future professionals poise under pressure. Professionals expect that they will be called upon on a regular basis to do extemporaneous speaking and presentations to both small and large groups. Public speaking must be done with confidence, as professionals have the burden of showing a company's credibility on a subject. In the business world, effective public speaking is needed for presenting recommendations or proposals to your organization concerning what needs to be done in regard to projects or future planning. Public communication is likewise used for recruiting, development, motivation and retention of staff members regarding company procedures. Yaverbaum and Bly (2001) explained: "When you speak, you're perceived as the expert. If your talk is good, you immediately establish your credibility with the audience so that members want you and your company to work with them and solve their problems" (p. 145). In fact, one does not necessarily need to have a specific discipline of study in order to have a successful career. Liberal arts majors are highly desired by many employers. Phil Rockwell, a career services counselor at Georgia State University, explained:

> Liberal arts majors are in high demand by employers who interview on our campus. Companies want employees with good communication skills. They need people who can think critically; who can write and speak well; who can run projects, interact on teams and sell on paper or in person. Liberal arts majors can do all those things. Our challenge is to get them to expand their own thinking—to know their values, skills and interests so that they can put their degrees to work. (Raines, 2007b, p. R1)

The importance of effective public communication is obvious for certain professional pursuits, but some are not as obvious. In the following paragraphs, I will discuss some of the fields in which communication is of utmost importance.

Having good public speaking skills is very important in most business fields because many occasions require speaking before both large and small groups of people, whether it is to persuade a group of coworkers to choose your idea on a project, speaking with a group of executives, or speaking to an

audience of potential business clients. Good public speaking skills could be the difference between getting a client to go with your product or service or them leaving you and going to someone who sold their business better. Those who communicate well with clients and customers will go a long way, because the one who can connect the most effectively with the client will usually win their business. It is also important to be able to communicate well with others in your office so that if there is a group project and you can persuade the group to go with your idea, the executives will see that you are a leader and this will take you far in the business world and will open many doors such as pay raises and promotions. Communication is also of utmost importance to management, who need to share information about the company with employees about their responsibilities, what they need to do better, etc.

Many people don't consider the importance of public speaking and other forms of communication to *accounting*, which of course, is another business discipline. Andrew Denka (2005), a business communication advice columnist, said that accounting firms are searching for individuals who possess good skills in interpersonal communication, written communication, and verbal communication. Accountants, Denka explained, may be required "to prepare a financial report and also present...findings to company management" and "be able to convey complex information to an audience that may or may not have accounting knowledge." Using a survey of accountants, business researchers David Christensen and David Rees (2005a, 2005b) discovered that "promising careers in accounting are impaired by poor communication skills." The researchers concluded that "command of the language and the ability to make informative, interesting and persuasive presentations are key components of an employee's and employer's success" (Christensen & Rees, 2005b). They advised, "it is also very important that" accountants "continue to nurture the development of the communications skills that are being emphasized in the university."

Real estate involves a great deal of negotiating when it comes to contracts. In a process of negotiation, one tries his/her best to convince the other side to come closer to meeting one's own parameters for an agreement. Therefore, persuasion and, for that matter, the ability to communicate information (relevant due to informative speeches) is very important in the profession as well. *Risk management and insurance* is another business discipline for which communication is a necessity. Without good oral communication skills it is impossible to build the relationships that are required

to survive and maintain profitability within the insurance industry. Insurance is such a face–to–face business and the ability to interpret nonverbal communication is just as important as verbal communication.

At many universities, most major disciplines require students to take public speaking and/or interpersonal communication. A basic communication course or two is certainly prerequisite for journalism and mass communication students. As will be pointed out in this book, there are similarities between the organization of speeches and print and broadcast news writing. The connection between verbal communication and broadcasting is obvious. Advertising majors, in particular, are frequently surprised to learn that persuasive speaking and persuasive advertising are very much linked. The late professor Alan Monroe, as you will discover in Chapter 10, certainly saw the similarities as he developed his motivated sequence organizational pattern for persuasive speaking.

There is absolutely no question that public speaking plays a major role in *public relations*. A cousin of advertising, public relations (PR) is a management function that is utilized in a vast variety of fields. As for the choices available to most college students, PR can be considered to be the communication equivalent to a liberal arts degree. PR majors may also study speech communication (interpersonal, small group, rhetorical, etc.) or mass communication (radio and television, print journalism, advertising, etc.). Indeed, successful public relations professionals use a variety of verbal and written communication skills to accomplish goals and objectives. In the field of PR, good communication is a must and public speaking is an important part of the job description. Ethical public relations practice follows the tenet of Aristotle, who observed that rhetoric is discovering every available means of persuasion. Marketing is the process of hustling the goods out of the door and advertising involves enticing the target to come into the door to be sold the goods. Public relations, however, is a process of creating, building, and furthering human understanding—listening as well as speaking—while arriving at a mutual understanding and respect if not completing a conversion.

Although public relations practitioners may be called upon to give speeches, it is just as likely that they will be asked to ghostwrite speeches. Public relations professional Vic Gold (1975), a speechwriter for many politicians from Congress to the president, observed:

> Ask any American for an off–the–cuff impression of how a President ought to go about preparing a public address and what you'll get is the Lincoln story: the lonely

figure in a stovepipe hat and shawl scribbling out his classic address en route to the speech site. It makes a good tale, but from my own experience with Republican politicians, I doubt its authenticity. The Gettysburg Address had to go through at least five drafts—with three inserts put in at the suggestion of Cabinet member, friendly Congressmen, and the chairman of the Pennsylvania State Republican Committee—before Lincoln even got out of the Washington train station. (p. 177)

Public speaking is primarily about communication and there is more to it than writing a speech. One needs to be able to shape and deliver messages and to relate to a variety of audiences from a group of common citizens to highly educated industry leaders. Frequently, both can comprise the same group and there are pitfalls to avoid. The effective communicator is able to speak to both groups simultaneously without insulting either one. The best strategy is to be genuine, sincere, and cordial while acknowledging the strengths and weaknesses of both groups.

Good public speaking skills are essential to *political science*, a field similar to PR, in which one needs to present information clearly, accurately, and convincingly—all of which are skills taught in a public speaking class. Audiences may range from superiors to policy makers to registered voters and even to students. A speaker needs to adapt the speech and style of presentation to appeal to varying audiences.

Legal professionals, such as lawyers, certainly depend on good rhetorical and interpersonal communication skills. Lawyers spend considerable time interviewing clients and speaking in court. Whether a lawyer litigates, judges, or writes briefs for appeals court, communication plays an essential role in an attorney's work because cases lie in the hands of the jury and the judges, whose opinion must be won by means of persuasion. Persuasive skills learned in public speaking are vital to an attorney's success. John Roberts, recently appointed as a Supreme Court Justice, was noted for his ability to speak his thoughts clearly and concisely in his confirmation hearing before the Senate. Although questioners posed seemingly difficult questions, Roberts appeared to answer in a dignified and knowledgeable manner that revealed a deep and intricate knowledge of the law. One magistrate judge has said that her profession requires judges to speak as clearly as the written word. A court reporter takes down the spoken words but is unable to decipher pronouns, inflections, and other subtleties as could be done were the proceeding recorded on audio and/or video.

One should realize that communication in legal settings can be very different from communication in other settings. Gerry Spence (1995), a nation-

ally known attorney, celebrity, and author, compared courtroom trials to war: "When decision–making bodies with power are gathered to hear our arguments, we must understand that the dynamic is one of war. And to the victor go the spoils. In such a contest, there is usually an opponent who speaks for power, most frequently the government, industry, money. Usually the odds are against us" (p. 196). Spence added: "But to win, one must always be in control—in control of one's own forces, one's own self, and, hence, of one's own war. We control the war when we are exquisitely in control of ourselves" (p. 197). Whether it is in the courtroom speaking to a jury or writing briefs in some cubicle, all of the interpretation, enforcement, and decisions of the law are based around the ability to communicate clearly and effectively.

Scientists are in the business of discovery, which leads to many important opportunities to speak in front of groups to convey—in an understandable manner—one's discoveries to colleagues and to other publics. What good are your discoveries if you are unable to explain effectively to others what you've found? Public speaking is very beneficial in convincing the government or corporations to fund research. Speaking persuasively to gain funding requires well–organized ideas and a clear and concise method of presentation. One must be able to communicate the importance of the research in a fashion that will convince audience members to donate their money. Understandably, speech communication is useful to those who pursue their scientific endeavors both in and out of academe.

Communication is vital to both *medicine* and the *medical sales* industry. Doctors, nurses, and other medical personnel meet with patients and confer with other professionals on a daily basis. Many times we may hear the words "bedside manner" applied to medicos. What we really mean by that description is the degree of one's communication effectiveness. Medical and pharmaceutical sales representatives meet with those same medical personnel. One medical sales rep says she spends a great deal of time talking and trying to get appointments with these very busy people. Good communication skills are extremely important to the success of her business, as she uses persuasion to land appointments and to sell her products. She observed: "A speech class like your Public Speaking class is a very good way to learn how to communicate with others and giving speeches in front of your peers is a practice that will teach your students many of the skills I use on a day to day basis with my business." She noted that she should have taken a public speaking class in college because it took her a long time to learn how to be comfortable speaking in front of others.

Even those who primarily deal with *wildlife and nature* need to know how to communicate effectively. All of us may not be in a position to research the life expectancy of the horny toad and its impact on ecology. One student told me he didn't see the point in taking public speaking because it would be of no use to him as a forestry major. He asked, "What good would it do to speak to birds, animals, and trees?" My answer was that it probably wouldn't, but I certainly expect a person in that field to communicate that information to others in an understandable manner. Professionals who deal with nature on a regular basis are frequently required to give informative speeches to peers and employees. Oftentimes meetings are required with landowners and the general public to discuss management options. Your ability to convey a clear message will make all the difference as to whether or not the public accepts your hard–researched management plans.

The U.S. military is acutely aware of the importance of communication. Consider this excerpt from *Communication Techniques Volume I* (1980), a publication of the U.S. Air Force's Air University:

> By teaching speech, writing, and problem solving through logical thinking, the Air University helps the students to become more effective Air Force members, whatever the specialty or assignment in which they may serve. The broad goal of teaching communication techniques is to increase the student's ability to think, listen, learn, speak, and write. These abilities are required of all commanders, staff officers, and supervisors. No Air Force activity can be operated efficiently by leaders who do not understand and apply communication skills to their daily tasks. Command is impossible without leadership, and leadership depends upon skill in communication. (p. iii)

Even for those who go into physical therapy, food sciences, exercise and sport science, recreation and leisure, communication is a good way to educate an audience on a familiar or unfamiliar topic. Teachers speak to students and parent organizations; ministers preach to congregations, municipal employees and concerned citizens address city councils, virtually every profession requires budget proposals and if you pursue a graduate degree, you'll have oral comprehensive examinations. Please keep in mind that the list above is by no means exhaustive.

Chapter 2
What Is Communication?

Speech, to some, has become such an ugly and misunderstood word to use in the 21st century. The word "speech" can conjure up uneasiness and fear in many people, but "communication" does not seem to have the same adverse effect. As John Dolman (1922) stated in *A Handbook of Public Speaking*, communication "means the act of sharing something with others; it comes from the Latin *con* (with) and *munus* (a business), through *communis* (common) and *communico* (to confer or consult with one another)" (p. 9). Communication, then, is a reciprocal act that we do *with* someone else. Speech courses can be offered in departments with various names, such as Communication Studies, Communication Arts, Speech Communication, Communication, Speech & Theatre. The departments can be in Schools or Colleges of Arts & Sciences, of Arts & Letters, of Music, Theatre & Art, of Communication, of Journalism and Communication, of Journalism and Mass Communication, etc.

Communication or Communications?

One of the problems with communication is that many people, including scholars in the field, tend to add an "s" to the end of the word. Sometimes those within the discipline debate the proper spelling, use, and connotation. However, Dr. Gary Cronkhite (1984) offered us perhaps the best explanation for leaving off the "s". Cronkhite, an esteemed communication scholar, who was asked to review a book for the *Quarterly Journal of Speech*, became incensed by the editors' use—or misuse in this case—of the word "communications." Cronkhite (1984) wrote:

> Unfortunately, referring to the study of communications is a widespread illiteracy in our field. Abstract conceptual nouns that refer to ideas, processes, or conditions cannot be pluralized by adding an "s" or "es." To attempt to do so, when it does not produce total nonsense, engages the related concrete morpheme and, while it may appear to make sense, changes the basic meaning. Consider that those who study radio, television, and press do not necessarily study radios, televisions, and presses; students of journalism are not students of journalisms, scholars engage in scholarship, not scholarships; biologists study life, not lives; medical students study medicine in general, and medicines only occasionally; nutritionists study nutrition, not nutritions; attorneys study justice, not justices; and Tolstoy's book was titled *War*

and Peace, fortunately, not *Wars and Peaces*. Theorists of communication may occasionally analyze specific messages, or communications, but that is not the name of their field of study. (p. 473)

Cronkhite (1984) closed his review both apologetically and sarcastically: "I apologize for this outburst, but reading this volume has exceeded my tolerance for this particular illiteracy. Future installments in this series will review the 'media–medium' and 'verbal–oral' distinctions" (p. 473). For those who study communication, understanding the difference between "communication" and "communications" is imperative.

The Communication Process

This section of the chapter includes discussion of a basic model of communication. It isn't unusual to see a chapter like this in public speaking books, but most of them fail to make the connection to real communication, that is, to help students understand why the communication models and theories are included. The purpose here is not holistic, global, or exhaustive in scope. In other words, this book is for public speaking courses—not for communication theory courses. This chapter is ultimately about what real communication is and how public speaking is, after all, not just rhetorical but also interpersonal communication and even mass communication. No matter what you may call it, it all comes down to human communication and communication can be many things to all people. Communication is a process that runs the gamut from informal to formal settings, from personal to impersonal, and all points in between. Some examples of interpersonal communication are interactions between a mother and a child, a supervisor and an employee, two siblings, a professor and student(s), a married couple, two or more friends, and so on. Interpersonal communication, although typically rather intimate, can be impersonal as exemplified when strangers communicate with each other. Until we meet, aren't we all strangers? When we meet, it is through implementation of interpersonal communication. Sometimes relationships develop, but at other times encounters are insignificant and short–lived, such as when someone asks a stranger for the time or for directions.

Because interpersonal communication is typically seen as *dyadic*, or as an interaction between two persons, many students don't seem to understand that public speaking is also a form of interpersonal communication. They see it as getting up in front of an audience and talking. Success to them is overcoming the fear of standing there and talking, memorizing, or reading their

way through a speech. Although we may be speaking to a group of people, large or small, we are still interacting and communicating with one person at a time. Communicators who realize that fact are, as a result, successful in achieving their purpose and objectives.

Mass communication is also human communication with a focus on mass media, such as radio, TV, film, books, magazines, newspapers, and perhaps even the Internet. During my broadcasting career, I once worked with a radio personality who continually reminded himself of the reciprocal nature of communication (and in this case mass communication), or one–on–one interaction, by using his own little innovation. He placed a picture of singer Diana Ross on the other side of the microphone and every time he addressed the listening audience, he talked as though he was communicating to her. His conversation was then between two people, making the listener feel like he/she was the only person listening. It was put on an intimate interpersonal level. Note the reference above to "radio personality." Many people refer to such persons as a "disk jockey" or even an "announcer." Those are erroneous terms because they don't indicate communication or a reciprocal interaction. Terms such as radio personality, air personality, or air talent are much more suited to describe effective radio communicators. Anyone can play a musical recording, which would make him or her a disk jockey. Anyone can make an announcement, but not everyone can communicate or share information effectively. Hausman, Benoit, Messere, and O'Donnell (2004), authors of *Announcing: Broadcast Communicating Today*, stated:

> Today's on–air broadcaster is a *communicator*, a catalyst for a message. Whether the message is news commercial copy, an interview segment, or a game show, the communicator's task is to serve as a conduit for communication between the originator of the message and the audience. The traditional announcer with the stylized delivery is no longer the backbone of the industry. He has been replaced by professionals who can convey greater intimacy, the image of a real person rather than a disembodied voice or a talking head. (p. 14)

Jay Leno has become an effective communicator on television, but he didn't start out that way and almost failed in his endeavor to replace the legendary Johnny Carson. When Leno took over NBC's *The Tonight Show* in 1992, he tried to fill the void left by Carson rather than filling his own niche. Carson was by nature a shy person who could perform before a camera, but he didn't want the audience to be too close to him. That was acceptable, because it was his style. However, Leno developed his personal style by work-

ing intimate clubs and other venues where he worked closely to his audience and pulled them into his space. Soon, Leno realized he needed more intimacy with his audience. So, he moved into his own space (a different studio than that used by Carson) and he brought the audience very close to him. Whereas he had previously come out to a predetermined spot to deliver his monologue as Carson had done, Leno began physically to encounter and interact with the audience interpersonally. He now meets them literally halfway and shakes hands, gives high fives, and/or hugs audience members. His ratings shot up and he has never looked back. Again, let's go back to the first sentence and the term "late night television entertainer." Many observers would call Leno a talk show host, but that would not do justice to his craft as a professional communicator. He might head up his own TV show, but he has achieved his success through effective communication.

Successful media personalities use other tricks of the trade to put their communication on a dyadic level. Consider the weather forecaster, or meteorologist, who says: "Your Tuesday is going to be a wet one. You'll see plenty of showers and you'll be a little chilly with a high only in the low 50s. So, on to what you'll see in the next seven days." Doesn't that person live in the same area for which the forecast was made? Why did the person say "your" instead of "our" or "we"? Let's reconsider the same forecast this way: "We're going to have a wet Tuesday. We'll have plenty of showers and we'll be a little chilly with a high only in the low 50s. So, let's move on to our seven–day outlook." Typically, a media personality becomes popular, as evidenced by ratings, because he/she has developed a relationship with the audience member over a period of time. The first example was impersonal communication and the meteorologist did not include himself/herself in the group to which he/she was speaking. The behavior can be explained using a concept of interpersonal communication known as *psychological data.* Communication can be intimate or impersonal. We are more intimate with people who we know and we are impersonal with those who we don't know. Sometimes, relationships move on a continuum from impersonal to intimate. For example, when you walk into a classroom and meet a professor for the first time, you react to that person as a professor rather than as a person. You respond to his/her position in life as opposed to the person himself/herself. Likewise, the professor treats you as just one in a group of students. But, over time, the relationship can become more personal as you respond to each other not as members of groups but as unique individuals. With the aforementioned weather forecast, the communication situation was meteorologist–

to–audience member and was therefore impersonal in nature. The meteor-
ologist treated the audience as members of a generic group. It is not unlike
other situations that we experience. When we hear our new preacher for the
first time, we place him/her into the general category of preachers. When we
walk into a classroom of a different professor for the first time, we treat them
as we do all professors. However, as we get to know each other, we make the
relationship more personal. We don't act as preacher and congregation mem-
ber; we may become friends. We don't act as professor and student; we in-
teract as human beings. So, how does someone speaking through a
microphone and/or camera and through a transmitter to a radio or TV set
build a relationship? He/she does it by understanding that he/she is invited
regularly into the listener/viewer's home and uses *inclusive* language.

The principles in the above paragraph apply to public speakers. As we
will see in Chapter 5, the speaker uses the introduction of a speech as Jay
Leno would the monologue. It is there to build a rapport with the audience,
to get them to like you, and to get them interested in hearing what you have
to say. Music icon Willie Nelson said: "My show is about connecting to the
audience" (Nelson & Pipkin, 2006, p. 52). So, after seeing these examples of
effective communication and communicators, let's look at what has been
occurring. It is easier to understand the process of communication by analyz-
ing a basic communication model as diagrammed in Figure 2.1.

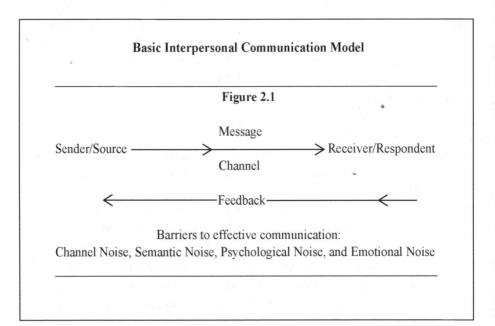

Basic Interpersonal Communication Model

Figure 2.1

Sender/Source ⟶ Message ⟶ Receiver/Respondent
Channel

⟵ Feedback ⟵

Barriers to effective communication:
Channel Noise, Semantic Noise, Psychological Noise, and Emotional Noise

Basic Interpersonal Communication Model

In the basic interpersonal communication model, the *sender*, also known as the *source*, is the person who initiates the communication process. The *sender* may be a public speaker or just an acquaintance, friend, family member, coworker, or stranger. In mass communication, the sender may be an announcer, an author, an actor, etc. The *receiver*, or *respondent*, is the person or persons with whom the sender/source has initiated the communication. In a *dyadic*, or two–person, communication situation, the receiver is the other person involved. In a public speaking or public communication situation, the audience is made up of receivers. The numbers can vary from a few to a few hundred. The speaker may use only his/her voice or may need a public address system. In mass communication, there could be literally hundreds, thousands, millions, or even billions of receivers. Patsy Rodenburg (1993), an expert on voice and text, acknowledged that media can reach a far larger audience than public speaking (and even theater), but believed that humans need "to hear and judge a message directly" (p. 49). Rodenburg added: "When the word is made flesh it really does dwell among us and move us in ways that electronics will never duplicate" (p. 49).

In dyadic communication or public speaking, the *channel*, or a means of sending or receiving information, is both verbal communication (the spoken word) and nonverbal communication (gestures and one's appearance). Sometimes nonverbal communication is referred to as *body communication*, but it is *not* body language. *Language* is communicated verbally via humans employing discretionary sounds transmitted via vocal articulation in standard ways with standard meanings. The standard meanings come from systems of words that have shared meaning for people who may live in close association or proximity. Interpersonal communication authors Sarah Trenholm and Arthur Jensen (2008) observed: "Most everyone will agree that only people use language naturally and spontaneously, giving us a flexibility and creativity denied to all other creatures" (p. 5). Although one communicates nonverbally through the use of the body, it is not vocal and it is not representative of a system of words.

The participants in the communication setting are in the physical presence of each other. Again, public communication may require a public address system, but mass communication would need a mass medium to channel the information—such as radio, TV, film, books, magazines, newspapers, etc. In a dyadic or public communication setting, the source can get

direct verbal and nonverbal *feedback* (responses) from the receiver(s). The source and receiver can see each other's reactions, such as smiling, frowning, laughing, applauding, etc. Roger Ailes, chairman, CEO, and president of Fox News, added: "You (the speaker) are selecting and sending symbols (words, facial expressions, and so forth) to the audience. The audience may not be speaking back, but they're sending you symbols as well—for example, facial expressions and body [communication]. Learn to read those symbols coming back to you" (Ailes & Kraushar, 1988, p. 33). Mass communication also promotes feedback, but it is delayed feedback. *Delayed feedback* may take the form of ratings, phone calls, e–mail, subscriptions (or cancellations thereof), letters to editors, movie revenue and reviews, book sales and re-views, etc.

There are those who believe a phenomenon called *communication breakdowns* exists, but it is a concept that is greatly misunderstood. As inter-personal communication expert Julia Wood (2007) observed: "We cannot not communicate" (p. 29). Wood added: "Even when we don't intend to com-municate, we do so" (p. 29). There is probably no such thing as a communi-cation breakdown, but there are *barriers to effective communication*. Whether the communication act is interpersonal or mass, there is frequently interference in the channel. *Noise*, also known as *interference*, is a barrier that can be caused by misunderstandings when communication participants don't share meaning (*semantic noise*), when there are physical interference or problems (*channel noise*), or when *psychological and/or emotional inter-ference* is present. With both channel noise and semantic noise, communica-tion is impeded.

Channel noise is a kind of interference that occurs due to some physical barrier and is mostly due to our senses of smelling, touching, tasting, hear-ing, and seeing. There are many examples of channel noise, including laugh-ing, talking, coughing, sneezing, snoring. Someone can walk between the speaker and audience, leave to go to the restroom, stand between audience members and a screen, overhead projector, etc. The cable TV going out, the electricity going off, or a tape or disc fouling up can cause channel noise. It can occur in print media with smeared print, writing on a page, or part of a page missing. The channel noise can be inside the setting or outside (external noise), such as aircraft flying over the building, a lawnmower outside the window, people yelling or talking loudly in the hallways or outside windows, a booming car stereo system. It can be someone walking between another person and a television set or someone standing up or exiting an aisle at a

movie theater or a ballgame. In a class, their own note taking may distract students. Sometimes it is better to listen more and write less. The speaker can create barriers, too, through appearance, voice, and annoying mannerisms. Note these things as you watch your fellow students speak. Perhaps the speaker is wearing a ball cap, t–shirt, and flip–flops. Will a rational audience really take the person seriously as he/she tries to convince them that the minimum drinking age should be lowered to either 18 or 19 years of age? Will an audience tend to think that a person with a speech impediment may be less intelligent than other speakers? Some bias cannot be overcome, but we may be just as distracted by someone who has a good voice but who mispronounces words and uses poor grammar—things which can easily be corrected. Likewise, the speaker may be one who drums on the lectern with her fingers or it might be someone who jingles the keys in his pocket. Perhaps the speaker does not make effective eye contact. There can be any number of reasons that the person distracts the audience.

Semantic noise occurs when the sender and receiver don't share meaning. They might have a different *frame of reference*. According to the Apostle Paul as quoted from 1 Corinthians 14:9 in *The Living Bible*, "if you talk to a person in some language he doesn't understand, how will he know what you mean? You might as well be talking to an empty room." Sometimes even those who share a language will not understand one another, especially if there is a knowledge gap or if colloquialisms are employed. There may even be a contradiction between verbal and nonverbal communication. Two people can use the same language or words, but have different meanings for what they say. Rodenburg (1993) stated: "When we speak words, in whatever context we use them, we instantly come up against all kinds of barriers, cultural, mental and physical. There are even technical barriers learned from school that are attached to certain words. Words like 'poetry', for example, immediately throw up barriers" (p. 36). Semantic noise can occur if one person tries to communicate to another person in a language he or she does not know. Educational level and dialects can both cause barriers in the communication process. Perhaps you have had a professor that uses words that you don't understand because students use many words differently than do professors. Even though you may both speak English, there are some words that one may use and that another doesn't. Some of the problem could be due to differences in education and age. Most people in the U.S. speak English, but we have so many cultural influences and dialects that there are semantic problems. This is nothing new, as each generation has come up with its own

jargon. However, until one learns how these words and terms are used, semantic problems will exist.

English is the primary language of the U.S., England, Australia, and other countries, but many words are assigned different meanings. These are indeed countries divided by a common language. For example, an American woman and an Australian woman became very good friends while teaching at the same U.S. elementary school. The American was often amused by some of the communication between her and her friend. One day, the Australian asked where she might find the guillotine. Of course, the American and her fellow teachers wondered what kind of drastic disciplinary measures the Australians impose upon their own children. As it turned out, she was merely seeking a paper cutter, which in Australia is called a guillotine. Likewise, there are some words that may be vulgar in one country and perfectly acceptable in another.

Many of these same–language barriers have been erased over the years. There was a time when someone from the Southeast and someone from the Northeast would have more trouble understanding each other than they would today. That is primarily due to the influence and saturation of media. Because people around the country, and even around the world, have been exposed via media to people like Jeff "you might be a redneck if . . ." Foxworthy and his *Blue Collar TV* colleagues, there is much more understanding between regions. Twenty or so years ago, that simply was not the case at all.

Frequently, when parties who speak different languages encounter each other, more emphasis is placed on nonverbal communication with bigger and more enhanced gesturing occurring. Sometimes the communicators begin to speak more loudly, as though that might somehow help in overcoming the problem. Who knows what the receiver is thinking, but it is probably along the lines of: "I'm not deaf, you stupid person; I just speak a different language." There are also incidences when one might even try—subconsciously or consciously—to imitate the accent of the other person.

Typically, students do not consider that *listening* will be a major component of a public speaking class. Nonetheless, students will have far more opportunities to listen than they will to speak in a public speaking course. Good listeners can have a truly positive impact on other students. Likewise, bad listeners can have an adverse effect on speakers. Novice speakers need positive encouragement and constructive criticism so that they may learn and improve. Looking out on an audience of fellow students who are attentive and nonverbally responsive in a positive manner cannot help but boost the

morale of the speaker. Good audience members will pay attention and make every attempt to encourage the speaker. They will be careful to avoid making noise, gestures, or walking in and out of the room. How demoralizing it is to a speaker when some audience members are reading or studying for other classes, or when one or two might rest their heads on their desks. As a faculty member, I have seen both kinds of listeners—or non–listeners, as the case may be. Even though I have given hundreds of lectures, it is still disconcerting for me when students are not paying attention, when they talk to each other, or when they enter and leave the room.

Psychological noise and emotional noise also present barriers to communication. Nervousness and anxiety can be barriers in a communication situation, as can tension that may be caused by controversy or conflict. A speaker might use words or phrases that may be perceived negatively by the audience. The topic itself can be controversial or antagonistic to an audience whose individuals will automatically be biased from the outset of the speech. At the other extreme is the boring speaker, boring topic, or both. It isn't long before audience members are *daydreaming*. A certain amount of daydreaming is always going to occur, but the effective communicator can eliminate a great deal of it by being prepared and by mentally and emotionally involving the audience in the speech.

When coming up with a topic, always consider the audience's interest level. If they don't like the topic, they won't listen. Therefore, effective speakers will be *audience–centered*, meaning that they will seek to maintain the audience's interest. Frequently, students run their topics past me for my input. A good example was the person who wanted to give her speech on how to plan a wedding. I suggested that she consider the demographic makeup of the audience, as we will see in Chapter 4, and how she would orient them to the topic and how she would recommend that the audience apply the information. After some discussion, she realized that most of the audience would not find her topic interesting. I suggested that she could focus on weddings, but why not explain to the audience why certain things are included in weddings? Why a cake, a white dress? Why something old, something new, something borrowed, and something blue? Tell us about how these things originated and how they evolved. As it turned out, the audience eagerly listened to the material.

In a public speaking class, audience members can be distracted because they are thinking about their own speeches or about a test next period or what they are going to do tonight. It can also be caused by fatigue. Some-

times the time of day has a lot to do with the kinds of barriers. It might be too early in the morning, too close to lunchtime, too soon after lunchtime, or too late in the day. Any or all those times can cause problems. Some people try to disguise their inattentiveness by *faking attention.* That probably isn't a bad thing for the sake of student speakers, but it can be a problem in other situations. As a student, I was caught faking attention on some occasions. What can you do when caught? In an attempt to try and escape, you can ask the source to rephrase their question because you didn't quite understand. Perhaps you have your own solution to the problem.

It is possible that some people just don't like some speakers. In such case, some audience members will not pay attention to the speaker no matter what the message is. As noted earlier, it could be due to the speaker's appearance, speaking voice, or some other unexplainable reason. In other words, some people just do not like other people. They might not even be able to understand or explain why they don't like someone else.

In today's world, there is all kind of competition for our attention. As human beings we are subject to many problems shared by all manner of imperfect people. As a sender or source, we must always be aware that our audience consists of people who have real problems that compete with us for our attention. As speakers, we must understand that our audiences of individuals have the choice of listening to us or to thinking about other things, such as careers, families, friends, health, and all manner of other problems or situations. Effective communicators can affectively capture their attention and motivate them to listen to their message, as we will see in the section under introductions in Chapter 5.

There was a time when there was less competition for the audience's attention. Many people wanted to hear speeches because that was the best way they knew to be informed about issues. Author Paul Boller (1991) explained:

> Until the age of ghostwriters, media consultants, opinion pollsters, and TelePrompTers, the American people took speech–making seriously. They flocked to campaign rallies where celebrated speakers like Henry Clay, Daniel Webster, and William Jennings Bryan were scheduled to appear; they crowded the galleries of the House and the Senate when lawmakers noted for their eloquence announced they were going to hold forth at some appointed hour on a public issue of consequence; and they devoured books of oratory. (p. 70)

Likewise, Boller (1991) observed: "Congressional orators responded to the vogue for elocution with verve and imagination. They worked hard to live up to public expectations" (p. 70). Of course, we all realize that speech–making still exists, but there is little question—and unfortunately so—that it is not depended upon or received nearly as well as it once was.

Lasswell's "Act of Communication"

American political scientist Harold Dwight Lasswell was a pioneer in communication research who used content analysis, which he developed, to investigate World War I propaganda messages. Everett Rogers (1994), a communication scholar and historian, defined content analysis as "the investigation of communication messages by categorizing message content into classifications in order to measure certain variables" (p. 214). Lasswell, through his vast research analyzing content of propaganda messages, offered another way to look at the communication model. Lasswell (1948), who focused on the effect of the communication message, stated:

> A convenient way to describe an act of communication is to answer
> the following questions:
> Who
> Says What
> In Which Channel
> To Whom
> With What Effect? (p. 37)

If one compares Lasswell's model with the aforementioned interpersonal communication model, it is obvious that his question provides a succinct summation of the communication process. "Who" would be the *sender* or *source*, the person who begins the communication act. "Says what" is the *message* being sent. "In which channel" refers to the method of delivery, such as the spoken word, a microphone, a television set, etc. "To whom" is the *receiver*, who then becomes a *respondent*. That leads to *feedback* that would tell the source "with what effect" the message had on the receiver. Indeed, the last part of Lasswell's question may well be the most important part of the equation. A lot of a message's effectiveness will be due to how well the speaker can overcome the barriers, noise, and interference we discussed in the previous section.

Lasswell (1948) also suggested communication serves three vital functions in society. The first is *to survey the environment* to discover the dangers and opportunities in one's surroundings. In public speaking, this would encompass audience analysis, as effective public speakers are audience–centered. The second is *to correlate responses* to those challenges and dangers, meaning the speaker needs to formulate a message for that audience. The third is to transmit "social inheritance," or culture (p. 51). Rogers (1994) noted: "Later communication scholars added a fourth function of communication: entertainment. These four functions are still taught to students enrolled in most introductory courses in communication" (p. 223).

The Speaking Situation and Context

Communication always takes place in a *context* that affects the nature and intent of one's messages. That is why it is so difficult later to tell about something that happened. We sometimes end up saying, "Well, I guess you had to be there." Jay Leno discovered that the *physical dimension*, the space where communication takes place, has much to do with effective communication. He realized that he was out of his own comfortable environment. Fortunately for him, he discovered it soon enough to save his job. We all feel more comfortable on our own turf, be it in our own chair or our favorite place.

Rhetorical scholar Lloyd Bitzer (1968) noted that rhetoric occurs in a particular situation. According to Bitzer, the *rhetorical situation* consists of "a complex of persons, events, objects, and relations presenting an actual or potential exigence which can be completely or partially removed if discourse, introduced into the situation can so constrain human decision or action as to bring about a significant modification of the exigence" (pp. 1–14). Bitzer believed the rhetorical situation normally has five constituents: the exigence (or pressing or urgent need/requirement), the audience, the constraints, the speaker, and the speech. Bitzer (1968) explained how communication should be purposeful:

> Imagine a person spending his time writing eulogies of men and women who never existed: his speeches meet no rhetorical situations; they are summoned into existence not by real events, but by his own imagination. They may exhibit formal features which we consider rhetorical—such as ethical and emotional appeals, and stylistic patterns; conceivably one of these fictive eulogies is even persuasive to someone; yet all remain unrhetorical unless, through the oddest of circumstances,

one of them by chance should fit a situation. Neither the presence of formal features
in the discourse nor persuasive effect in a reader or hearer can be regarded as reli-
able marks of rhetorical discourse: A speech will be rhetorical when it is a response
to the kind of situation which is rhetorical. (p. 8)

Anthony Hillbruner (1966), a contemporary of Bitzer, considered those
conditions outside the speech and those concerned with the actual speech.
For Hillbruner, the audience and occasion were two important components of
the "total speaking situation" (p. 31). "The times," and "the composition of
the audience and the reason for the occasion," are important in effectively
evaluating the speaker's persuasiveness (p. 31). Bitzer (1968) agreed that the
rhetorical audience should be investigated, because members of the audience
"function as mediators of change" (p. 7).

Ethical Considerations in Public Speaking

Of course, a major part of the communication process is based on the ethics
of those involved. What are ethics? Ethics involve moral principles or rules
of conduct. Basically put, ethics are concerned with philosophical issues of
what is right and what is wrong. S.E. Frost (1942, 1962), author of *Basic
Teachings of the Great Philosophers*, observed: "…throughout the history of
man's thought we discover the problem of good and evil (which we speak of
as 'ethics' or 'the ethical problem') persistently challenging each philoso-
pher" (p. 81). Rhetorical specialists A.M. Tibbetts and Charlene Tibbetts
(1987) added: "From the time of the ancient Greeks, authorities in rhetoric
have pointed out that the arguer's character is very important. The Greek
word for 'character' was *ethos*, and a writer (or speaker, in ancient times)
whose work showed him to be honest, fair, and reasonable was said to be
employing *ethical proof*. As Cato, a Roman, put it, an orator should be 'a
good man skilled in speaking.'" (p. 318).

There are those communicators who pay little attention to ethical impli-
cations. Giambattista Vico, professor of rhetoric at the University of Naples
from 1699 to 1741, was one of the earlier educators to lament a lack of focus
on ethics. Vico observed:

…the greatest drawback of our educational methods is that we pay an excessive
amount of attention to the natural sciences and not enough to ethics. Our chief fault
is that we disregard that part of ethics which treats of human character, of its dispo-
sitions, its passions, and of the manner of adjusting these factors to public life and
eloquence. We neglect that discipline which deals with the differential features of

the virtues and vices, with good and bad behavior–patterns, with the typical charac-
teristics of the various ages of man, of the two sexes, of social and economic class,
race, and nation, and with the art of seemly conduct in life, the most difficult of all
arts. (Bizzell and Herzberg, 1990, p. 720)

Vico's words may never have rung truer than they do today, some three cen-
turies after he wrote them.

Ethics come into play from the time one plans a speech to the time it is
presented to an audience. As a speaker, you should always be prepared.
There is nothing more uncomfortable in a classroom setting than watching a
person try to fake his/her way through a speech. Unlike a paper, which a pro-
fessor would read privately, the entire class can tell when a speaker is ill pre-
pared to do the job. Be prepared or you will embarrass both yourself and
your classmates. In the real world, such lack of preparedness could be pro-
fessional suicide. You can fail to land an account, lose an account, or other-
wise not live up to your end of the bargain when you are unprepared.

It is also important to tell the truth. The first assignment in my class is a
speech of introduction, in which two classmates interview each other and
then give a speech about the partner. One time, as a student spoke about his
counterpart, I noticed a look of horror come over her face. Afterwards, she
said the fellow had made up most of the information about her. He replied:
"Well, she wouldn't tell me anything, so I had to make it up so I could do my
speech." Obviously, both students were unethical. He didn't tell the truth and
she would not share information so that the assignment could be completed.
In this case, he should have sought help from the professor, who could have
intervened on his behalf.

Because speech topics are almost limitless, discretion is frequently re-
quired. For example, a speaker might give a speech that advocates the legali-
zation of marijuana. There is nothing wrong with that topic, but when a
speaker steps before an audience there is an ethical obligation not to deceive
the audience or to try to get them to do something that is illegal. Therefore,
the ethical speaker would not try to convince the audience to buy, sell, pro-
duce, or consume marijuana. As all of those things are illegal, it would be
wrong to try to get anyone to do them. Likewise, a how–to speech on "how
to roll a joint" would be just as wrong. It would be okay to give a speech that
proposed to lower the legal alcohol consumption and possession age from 21
to 18. It would be unethical to give a speech that urges those audience mem-
bers who are under the age of 21 to drink alcohol. Greek philosopher Plato

noted that in an ideal world all public speakers would be truthful and devoted to the good of society, but alas we recognize that is not the case. Hitler was a great persuasive speaker, but he used his skills to achieve despicable objectives.

Although, as a listener, it might be difficult at times, try not to be prejudiced against a speaker. If for no other reason, give them an opportunity so that you are not unethical yourself. The U.S. is a great country in part because we try to allow everyone a free and open exchange of ideas. We want to express ourselves, so we need to allow others the same chance. Freedom of speech and expression, however, do not include name–calling and verbal abuse. We have all heard: "Sticks and stones may break my bones, but names will never hurt me." How untrue that statement is, because too often names and other verbal uttering are far worse than physical abuse.

Chapter 3
The Fear Factor: Dealing with Communication Anxiety

Many times the real difference between success and failure in public speaking is confidence, or the lack thereof, that results in nervousness or anxiety. There are many, many reasons for one being or not being confident and for being or not being nervous. The purpose of this chapter is to look at reasons some people fear public speaking, as well as other forms of interpersonal and mass communication, and to offer suggestions for dealing with anxiety, nervousness, fear, and tension.

There are those people who feel at ease and comfortable when communicating most of the time, but there are occasions when each of us can find ourselves feeling apprehensive in a particular communication situation. Even a self–confident person may suddenly feel shy or awkward when giving a speech to a huge crowd, when going on television for the first time, when asking for a date, or when proposing marriage. Such experiences are normal. Neal Anderson, Dave Park, and Rich Miller (2003), authors of *Stomping Out Fear*, explained: "It is perfectly normal to be concerned about the things we value. That's why we need to distinguish between temporary anxiety and an anxious trait that goes on and on. A state of anxiety exists when we're concerned *before* a specific event" (p. 16). We may experience heightened communication apprehension while being evaluated, such as for our job performance or for a college entrance exam. Anxiety can occur when audience members have high expectations for the speaker, when significant members of one's reference or peer group are present, etc. Why? Because an important outcome may hang in the balance as a result of the communication situation.

However, some people have such severe communication apprehension that they need systematic procedures such as desensitization or similar procedures used by psychologists and others to help people overcome particular phobias. Some people experience generalized anxiety disorders and may "alter their minds with drugs, alcohol, food, or music" (Anderson, Park & Miller, 2003, pp. 16–17). Dr. Susan Jeffers (1987) believes that anxiety is never as bad as one may think it is: "You may be surprised and encouraged

to learn that while inability to deal with fear may look and feel like a psycho-logical problem, in most cases it isn't. I believe it is primarily an educational problem, and that by reeducating the mind, you can accept fear as a simple fact of life rather than a barrier to success" (p. 4). Anderson, Park, and Miller (2003) observed that there are significant differences between fear, anxiety, and panic attacks. They stated that a panic attack is very severe, appears sud-denly and unexpectedly for no obvious reason, and are not the result of "any abnormal thinking or the approach of danger" (p. 17).

Many people are apprehensive about communicating with others and not just to groups and audiences but also in one-on-one conversation. *Communi-cation apprehension*, or reluctance to communicate with others, is common. Some individuals may be timid or bashful in general or they may suffer from shyness or anxiety that may be connected to speaking or performing in front of others. Such a condition may also be known as *stage fright*. Others may run from or avoid public communication altogether resulting in *stage flight*. Joseph A. Devito (2004), interpersonal communication expert and author, observed that communication apprehension "is the most common handicap suffered by contemporary Americans" (p. 82). He identified *trait apprehen-sion* as a "fear of communication generally, regardless of the specific situa-tion (p. 82) and *state apprehension* as "specific to a given communication situation" (p. 83).

There may be many reasons for communication apprehension, but Theo-dore Zeldin (2000), an authority on conversation, believed that those with communication apprehension could find the courage to communicate with others:

> Surely not everybody has the gift of being able to converse: what about all those who are naturally quiet, or introverted, and what about the enormous numbers who are shy? What part can they expect to play, if conversation were to become the most important kind of interaction, and the main agent of change? I don't think you have to be talkative to converse, or even to have a quick mind. Pauses in conversation do no harm. One of the most memorable conversationalists in history, the French dip-lomat Talleyrand, who suffered from a lonely upbringing and a physical handicap, would often sit through a party without saying a word, but then suddenly come out with a sentence which people said was the sort they never forgot. What matters is whether you are willing to think for yourself, and to say what you think. Many peo-ple are not, either because they've been told too often that they are just ordinary people and they assume that they have nothing of importance to say, or because they have received too many knocks from life. My answer is that throughout history, or-dinary people have suddenly come out with the most amazing statements, when they

find the courage. What matters most is courage. The most rewarding discovery I have made in my study of history has been about the way people who do not think of themselves as brave forget their reticence, their hesitations, and do brave things. (pp. 15–16)

Personal Experience with Communication Apprehension

I will make a confession about my own past communication apprehension. My students find it hard to comprehend that, like many of them, I feared public speaking when I was an undergraduate. I sat in the back of the room in all of my classes and kept my mouth shut. Basically, I lacked confidence in my abilities and myself. However, after listening to my fellow students over time I finally began to realize that they had no more to offer than did I. Slowly, I began to come out of my shell and to contribute not only in my public speaking class, but also in my other classes. I also began to work as a professional announcer in radio and television. When I entered graduate school and subsequently started my career as an educator, I began to present my research at professional conferences. However, I found that anxiety had crept back into my psyche. I had to reassure myself that I would not have been invited to speak unless someone figured that I had something to contribute. From that point forward, I have had little problem with communication anxiety.

For students and other novice speakers, a speech of just a few minutes can seem like an eternity. That is because many people dread speaking in front of others, even when the group is relatively small like most public speaking classes. A consistent finding of researchers is that many people fear public speaking more than death. That means that at a funeral, those people would rather be lying in the casket than delivering the eulogy. Marveling at our society's penchant for facilitating fear, Reverend Norman Vincent Peale (1959), a noted expert on positive thinking, observed: "We are a curious generation when you come to think about it. We have developed the resources of the earth and advanced our scientific knowledge to a remarkable degree; we are masters in so many areas. Yet we are not really masters of our own anxieties. We still live in fear" (pp. 102–103). However, as Peale (1982) added, it is not so much fear as it is tension: "What is this thing called tension, this painful feeling called tension? It is not easy to define. Fear can cause it, but it's not exactly fear. Worry can cause it; so can guilt, hate, or frustration. One thing is sure: We all know the dismal feeling that comes

when tension digs its claws into us. The sense of strain. The feelings of in-adequacy. The pessimism. The low boiling point. 'My nerves are shot,' we say, 'I'm uptight. I'm ready to climb the walls'" (p. 127).

In the latter part of the 20th century, executive Lee Iacocca raised Chrys-ler Corporation, a major automobile manufacturer, from near extinction. Iacocca recalled: "Although I was a member of the debating team in high school, I used to be afraid of public speaking. For the first few years of my working life, I was an introvert, a shrinking violet" (Iacocca & Novak, 1984, p. 53). That all changed when Iacocca, then a Ford Motor Company man-agement trainee, was sent to take a Dale Carnegie public speaking course. Iacocca said the most important aspect of the undertaking was when "the course started off by trying to get us out of our shells" (p. 53). Over time and with practice, Iacocca learned to love public speaking. He explained: "As the weeks went by, I started to feel more relaxed. Pretty soon I was willing to get up and speak without being asked. I liked the challenge….Once I started speaking, I couldn't get enough of it. (I'm sure there are those who wish I hadn't leaned to like it so much!)" (p. 54). Public speaking gave Mr. Iacocca the confidence to become a leader. He explained: "I've known a lot of engi-neers with terrific ideas who had trouble explaining them to other people. It's always a shame when a guy with great talent can't tell the board or a com-mittee what's in his head" (p. 54). He added: "Not every manager has to be an orator or a writer. But more and more kids are coming out of school with-out the basic ability to express themselves clearly" (p. 54).

Anxiety Is Normal

Anxiety and nervousness are normal and need not always be considered negatively, as they can be good. A certain amount of anxiety can keep one alert, sharp, and fresh. Many famous actors and other public performers ad-mit that when they start to lose their anxiety, acting loses some of its appeal. It is natural and healthy to experience anxiety. Shelley Lane (2008), an inter-personal communication scholar, believes that *motivation* can help us over-come anxiety. Motivation, Lane explained, is one's "desire to communicate" and the need to overcome anxiety so that we will be seen as competent communicators (p. 9). A good example of motivation is found in Will Smith, a musical artist and actor, who uses his personal fears as motivation. Smith, also known as "The Fresh Prince," stated: "I can't run away when I'm scared. I always have to attack. That's how I deal with seemingly difficult

things" (Rader, 2004, p. 4). He added: "I still doubt myself every single day. I've had painful situations, times when it was really tough. What people believe is my self–confidence is actually my reaction to fear" (p. 4). All in all, Smith said his greatest motivation has been "a horrible fear of not achieving," which evolved from his desire not to disappoint his mother and grandmother. Both believed Smith "could do anything" (p. 4). Today, Smith is one of the bigger stars in motion pictures, in large part because of his fear. Smith explained: "I've learned to use it…to flip that negative energy around and make it a challenge. I keep going because I doubt myself. It drives me to be better. I've learned that the mastery of self–doubt is the key to success" (p. 4).

These days Regis Philbin is one of the more recognized individuals in American television. Finally, after more than 45 years, he won two Emmys in 2001 as Best Game Show Host for ABC's blockbuster *Who Wants to Be a Millionaire* and Best Talk Show Host for syndicated, top–rated daytime talker *Live with Regis & Kelly*. However, as a young college student at the University of Notre Dame, Philbin secretly wanted to major in broadcasting but couldn't find the courage to do it. He was just too nervous to communicate to audiences. After two years in the Navy, Philbin decided that he wanted a broadcast career after all. Over time, he had realized that his fear was unreasonable and that he had to overcome it if he wanted to do what he really wanted to do in life. Philbin returned to his hometown of New York City, where he began a long career. He has worked on *The Tonight Show*, at various TV stations around the U.S., on ABC's *The Joey Bishop Show*, on NBC's *Get Smart*, in Woody Allen's 1972 film *Everything You Always Wanted to Know About Sex,* on *Live with Regis & Kathie Lee*, and he makes regular appearances on *The Late Show with David Letterman*. All in all, that isn't bad for a fellow who was too afraid even to enter the broadcasting department at Notre Dame.

Reverend Peale (1982) agreed that Smith's and Philbin's situations are all too common and admitted to experiencing tension himself: "I know this from my own experience. Every time I deliver a sermon or make a speech, I feel some tension. Maybe it is a throwback to my old inferiority complex days; maybe it is some dim recollection of that small boy being dragged into the parlor to reluctantly recite poetry to visiting relatives. Whatever the cause, it's painful and I don't like it. And yet I know it is a kind of spur, goading me to give my best effort. Without tension, most of us would never rise to the potential that the Lord put into us" (p. 128). Peale (1959) stated:

"A positive thinker does not refuse to *recognize* the negative, he refuses to *dwell* on it" (p. 13). He added: "You have the power to overpower fear. It need not be allowed to harm you at all. The great fact is that you can, if you will, do something constructive about what you're afraid of. The ability to do this is one of the greatest results of positive thinking. Positive thinking presupposes a firm mind control. When you control your thoughts you will be able to control your emotions, including fear and worry" (p. 104).

It is important to realize that one's nervousness might not be that noticeable to others. I have had students tell us how nervous they were beforehand, so we—as an audience—tended to look for that anxiety. On the other hand, I have had many students who did not appear nervous at all. After their speeches, they would gasp and say something like, "Oh, my goodness, I felt like I was going to die." The point is that we did not know it and we never would have known about the nervousness had the speaker not told us. We can indeed be our own worst enemies.

Fear of Failure and Unrealistic Expectations

As an old saying goes: "Everybody wants to see heaven, but nobody wants to die." A primary reason that many people fear public speaking is that they are afraid to fail. Few are afraid of success. If one knew that he or she was going to make a perfect speech with no mistakes, he/she wouldn't be afraid. Unfortunately, no one is perfect and everyone makes mistakes, but it is not the end of the world. Once a speaker accepts that the presentation will not be perfect, the anxiety will ordinarily begin to diminish. Merely hoping to be better is not enough, as you must commit to being better and establish a reasonable plan for improvement. Don't set yourself up to fail. You aren't perfect and you will fail if you think you are. Nothing less than perfect will ever measure up, as your expectations are unrealistic. Make sure that you set achievable goals and objectives. Set your sights on incremental change that will take place over time and with increasing experience. You won't lose your anxiety and become a great speaker or communicator overnight. Be patient and positive results will happen soon enough.

Public speaking ability does not come naturally to most people. It is a learned talent and we can find a parallel in athletics. Some athletes are natural, but those who are not can still play at a high level. Although one may not be able to dunk a basketball, one can still play basketball effectively by developing other skills, such as passing, shooting, dribbling, etc. Although one

may not be born with great talent, it can be overcome through hard work and dedication. In his *Guide to Confident Public Speaking,* James E. Sayer (1983) explained: "Effective public speakers were not and are not anointed at birth. Effective public speakers are made, not born—everyone, barring severe mental or physical disorders, may become an effective public speaker. Maybe you think that this statement does not apply to you; that you could never become an effective speaker or enjoy speaking to an audience. It is important for you realize that saying or believing such things does not make them true" (p. 2).

Indeed, the mental preparation for public speaking can be very similar to the mental preparation for athletic endeavors. Let's take golf, for example. Golfers, like speakers, can become very nervous when other people are observing them. As a result, the golfer can be so uptight that he/she will shank, pull, slice, top, or even miss the ball entirely. My father was the same way until one day he stopped to watch other golfers on the first tee. He noticed that most of them messed up, so from that point forward he has not worried about making a mistake in front of others. Why be embarrassed over something that most people do? As a result, the pressure was off and he began to hit the ball cleanly almost every time. Even Tiger Woods hits clunkers. In the Masters tourney one year, Woods—who can hit drives of 300+ yards—hit one drive just 70 yards after he hit several inches behind the ball. However, he did not quit and he went on to win the tournament. How many people can play golf as well as Woods? Not many, but it is important to understand that even the best in the world foul up from time to time. Public speaking is no different once you realize and accept that no one is perfect—including you.

Imperfection Equals Audience Identification

There is another way to look at imperfection that many people may not have considered. Monica Wofford (2004), president of a speaking and training company, observed: "Even if you seem to do everything perfectly, trying to lead the audience to believe you're the picture of perfection may backfire; people know perfection is unobtainable. And most people would rather spend their time making connections with people who are not slick, smooth and perfect, but who are real, just like them" (p. 90). Wofford (2004) added: "I'm not saying you shouldn't try to do your best at the podium. But remember the saying 'nobody's perfect.' Your audience expects humanity and imperfections, not a flawless super–speaker" (p. 90). Harriet Lerner, a professional

speaker and psychotherapist, found herself bumbling through a speech one evening. Embarrassed, she was ready to make a quick exit, but she discovered that the audience had found her speech to be refreshing. Lerner (2004) recounted:

> When I lifted my head, I saw to my surprise that a small crowd of women had gathered around the lectern. There were smiling at me. "*Thank* you," said one, reaching out her hand to shake mine. "It was wonderful to see you being so real." A younger woman, a psychology graduate student, chimed in. "I've always been afraid to speak in public," she confessed. "Now, I feel, if you can do it, I can do it!" Others spoke of the palpable connection they felt with me during my talk, a sense of being in the presence of someone whom they already knew and understood. Being approached by members of an audience following a speech wasn't a new experience for me. What was new, however, was the level of vitality and connectedness I felt flowing toward me that evening. I looked around at the open, loving faces surrounding me and felt my embarrassment melting away. (p. 34)

In other words, many audience members can identify more readily with, and put their trust in, a speaker who isn't perfect.

Check Your Ego—The Message Is the Important Thing

It is important to realize that the listener, or audience member, is typically not present for your speech because *you* are speaking. Rather, they are there to hear what you have to say. Your message is what matters to them. Even Moses, the great religious leader, was afraid of public speaking. When God told him to take a message to Pharaoh, Moses argued in Exodus 6:28–30: "I can't do it; I'm no speaker—why would Pharaoh listen to *me*?" Rather than forcing Moses to speak, God told Moses' brother Aaron what to tell Pharaoh (Exodus 7:2). Eventually, Moses overcame his fear of speaking because he understood that he was not as important as the message. Deuteronomy records Moses' February 15 speech to the people of Israel after their exodus from Egypt 40 years earlier. Indeed, most students don't go to lectures to hear the speaker, but to hear what the instructor has to say and to learn that information. A congregation doesn't necessarily attend church to hear the minister, but are there to hear the sermon. So, when you get up to speak in class, at the fraternity house, at someone's wedding, at work, etc., they aren't paying so much attention to you as to what you have to say. Jamie Stokes (2001), an authority on occasional speeches, explained:

> Consider how you yourself feel when listening to somebody give a speech at an oc-
> casion like a wedding. Do you sit there intent on finding fault with the speaker? Is
> your heart full of malice? No, you are there to have a good time and to be enter-
> tained. Nine hundred and ninety–nine times out of a thousand every member of your
> audience will be the same. People don't listen to speeches to find fault with the
> speaker, people listen to speeches to be entertained and maybe have a few laughs.
> Most people are as supportive towards a speaker as they can be; half of them are sit-
> ting there thinking "thank God it's not me up there." (pp. 10–11)

Focus on your words and not on your fear. Try not to think about any-
thing other than your message and the impact it will have on the audience.
With the spotlight off of you and on the material, why be nervous? There are
many good examples of that involve sermons, which are speeches. One of
my former associate ministers, who occasionally filled in for the minister,
once told me that he became very nervous when he saw me in the congrega-
tion on the days that he was to deliver the sermon. He said he was certain
that, as a speech communication professor, I was critiquing his performance.
I told him that he had no need to worry, because I was sleeping just like ev-
eryone else. He was taken aback, but I quickly explained that although I was
kidding him about the sleeping I wasn't there to think about my own job or
to focus on him. I was there merely because I wanted to hear the message.

Rebecca McDaniel (1994), a public speaking educator and author,
added: "When you place thinking about yourself as secondary and communi-
cating the message as primary, you will have learned to control nervousness.
This is the magic key that opens the door to enjoyable and exciting public
speaking" (p. 13). Don't be self–centered; be message–centered. The audi-
ence does have certain expectations of you, but they don't necessarily expect
you to be dynamic, humorous, or entertaining. What they do want is to hear
what you have to say.

Certainly, public speaking class should be the last place for one to be
nervous, as all students are in the basic public speaking course together.
Your classmates do not see you up there speaking. Rather, they see them-
selves. If you stumble, they are pulling for you to get past it. They are for
you—not against you. One should also realize that other students are proba-
bly focusing on giving their own speech, are recovering from the speech they
just gave, or may simply be thinking about other things. Sometimes they just
sit there in silence, trying to gather their own composure, calm, or cool. It is
doubtful that you will remember all the speeches given just before or after
yours, and the same applies to your fellow students.

Many of us fail to realize that others experience similar anxieties as our own, so we tend to excuse our inadequacies because others have more advantages than we. Sara Lowrey and Gertrude Johnson (1953), experts on interpretive reading, observed: "Some students defeat themselves by acquiring the mental attitude that others with more speech training, more ability, or better clothes have an advantage over them" (p. 7). In reality, nothing could be further from the truth. Lowrey and Johnson explained: "You have just as many hours in the day as any other student; it is the use you make of your time which counts in accomplishment. You have equal access to the library; it is the use you make of the library which is important to your development. You have equal opportunity to learn from the teacher, from the other students, and from the assignments; it is the use you make of these advantages which determines your progress" (p. 7).

We cannot lay all the blame about nervousness on speakers, as there is anxiety found among audience members, too. Many persons in the audience are afraid to interact after speeches—while still in the public setting—because their questions or comments would also take place in front of other people. However, those same people will come up to the speaker afterwards to converse privately, even though they may have to wait in line for some time to do so. The same situation occurs all too frequently in classroom situations. Some students will not ask the professor a question or otherwise interact during the class, but they will wait until after the class ends. Most of the time, the answer to the question would have been beneficial to all students, as some professors will inform them. Some students take the situation even further, as e–mail has given them yet another way to shy away from any kind of face–to–face communication.

Suggestions for Overcoming Anxiety

It seems that at some point during any television situation comedy's run, there will be at least one episode in which one of the characters will be asked to give a speech. As a result, other characters on the show take it upon themselves to give advice. These amateur recommendations are typically without basis. The most common of these suggestions has the speaker imagining that audience members are in their underwear or are naked. Some "experts" suggest that a speaker focus on a favorite quiet place, such as the sky, beach, water, forest, sounds of nature, etc. It might make someone less nervous, but it probably makes them wish they were at one of those places rather than giv-

ing a speech. How either of those scenarios helps in lessening one's anxiety is anyone's guess, but it is believed by some people to be true. Remember that there is no tried and true remedy for lessening your anxiety and that one size never fits all if there was such a solution. However, we can explore a few practical suggestions that may help in controlling your anxiety.

Focus your attention on a person in the audience who seems the most interested. Some speakers find that looking primarily at one person makes them feel more comfortable. This is similar to the situation I mentioned in Chapter 2 regarding my radio colleague who placed a picture of singer Diana Ross on the other side of the microphone so that he could communicate with her. Making the speech more dyadic, or between two people, can help a speaker focus less on the "public" part of public speaking.

Be yourself. Roger Ailes, chairman, CEO, and president of Fox News, agreed: "The trick in good communications is to be consistently *you*, at your best, in all situations. All communication is a dialogue" (Ailes & Kraushar, 1988, p. 33). Harriet Lerner, professional speaker and psychotherapist, (2004) explained:

> One reason that public speaking is so terrifying is that it's hard to feel we have the right to be ourselves—flubs and all—at the lectern. After all, the podium has historically served as a place for an elite group of men to reflect themselves at twice their natural size. It has never been a place to admit ignorance, confusion, or even complexity. To stand at a podium is to elevate oneself—literally—above other humans. To pretend to have all the answers and to never drop one's papers, break a pointer, or, god forbid, lose track of a shoulder pad. (p. 34)

Develop a pre–speech routine. Some would call this systematic relaxation, but the system should be one you develop yourself. One thing you can do is get to the venue early and stand at the front of the room for a few minutes before the speech to get used to the surroundings. You might want to loosen up a little by practicing your speech a bit. In baseball, pitchers, fielders, and batters warm up or loosen up before, during, and after the game. The same goes for golfers, football players, and any other athlete one could name. Golf instructors are noted for getting their students to establish a routine before addressing the ball. It leads the golfer to concentrate on the task at hand and helps them take their focus off the nervousness. Legendary golfer Arnold Palmer (1997) has said "playing good golf is mostly mental" and those who are most successful learn to visualize what they want to achieve (p. 45). The same philosophy can be applied to public speaking. Visualization is key to

doing well in a speech, in golf, and in almost every other endeavor. To paraphrase Palmer, when planning a speech, visualize every aspect of it—from beginning to end. Palmer (1997) explained: "Visualizing the result you want also blocks out negative thoughts" (p. 45). He added: "The more you practice visualization, the better you'll get at it" (p. 46). The legendary Yogi Berra, a member of baseball's hall of fame, agreed with Palmer:

> Every ballplayer, every successful person, has great imagination. They imagine themselves succeeding. Jack Nicklaus, well, he had a great mental game. He saw his golf shots before he hit them. Like I say, that's great imagination. Dreaming is one thing, giving it focus is another. You have to realize how to realize your dream, as dumb as that sounds. Figure out how to improve, how to get help. (Berra & Kaplan, 2002, p. 54)

Upon following this advice, one can expect to reach what Palmer has identified as an "Ideal Performance State or IPS," which is a state of being "confident, relaxed, calm, energized positive emotion, challenged, focused, alert, automatic, instinctive, fun, and enjoyment" (p. 45). Some athletes refer to IPS as being "in the zone." Many amateur golfers, as well as many beginning speakers, do not follow Palmer's advice, as they tend to migrate toward negative visualization. How many times do golfers, who are faced with having to make a shot over water, go to their bag and find their worst ball? That indicates that they have no intention of seeing the ball again. Then, most of the time they indeed proceed to plunk the ball into a watery grave. Why not take out a good ball with the intention of making a good shot? Some would call such a concept a *self-fulfilling prophecy*, which is something that actually happens because an individual does what is needed to make it happen. In other words, a person can predict that they will succeed and they will succeed. Another person might be so convinced that he/she will fail that failure becomes a reality.

Employ positive visualization. Public speaking is indeed affected either positively or negatively by the powerful tool of visualization. According to experts, you have a much better chance of doing well if you visualize the speech positively than you would if you visualize negatively. Dr. Vikki T. Gaskin–Butler, a clinical psychologist, said: "If you can imagine something, you can make it happen" (White, 2003, p. R1). She added: "When we tap into our brainpower, we can live in that world of 'make–believe' and make it true" (p. R1). Dr. Bob McDonald, a psychologist, explained: "The right hemisphere of the brain is where a lot of the creative work of the mind goes

on. A lot of people feel they are not really creative. That's not true; it's just about how to access it. The right hemisphere works holistically. It pulls a lot of things together and, a lot of times [they are] things that don't logically come together. Creativity is pulling things together that logically don't belong together" (p. R1). Dr. Gaskin–Butler added: "Visualization helps people remove that layer of 'I don't believe this can happen; it won't happen; it can't happen.' It's about imagining what you want to do and imagining doing it successfully. And, you imagine the obstacles as well, but you imagine that you overcome them" (p. R4).

As a speaker, you can also get the audience to think of you positively or negatively, which is something we will discuss in Chapters 4 and 8. In Chapter 4, we will consider the different kinds of audiences and audience members a speaker can face. If an audience thinks you will do well, they will help you do well. If they think you will do badly, then you will do badly. It is very similar to the self–fulfilling prophecy, but when others have expectations of you a *Pygmalion effect* can occur. People will pre–judge you and you can rarely overcome that preconception. We are all that way to a certain extent. In fact, people we like are always smarter, better looking, harder working, etc., than people we don't like. The converse is also true. We call such a phenomenon *perceptual accentuation*. In Chapter 8, we will consider a person's delivery and appearance as we examine how a speaker can have a more positive impact on an audience.

Be prepared, practice, and rehearse your behavior. Perhaps the best way to deal with anxiety is preparedness, practice, and rehearsal. Unfortunately, there seems to be less emphasis on public speaking in many of our schools today. Even though most of us could speak before we could write, our educational systems seem to be geared more toward the written word than the spoken one. No wonder college students are afraid to speak publicly; most have had little experience in it. To be prepared one must pick an appropriate topic for the purpose (Chapter 4), research the topic thoroughly to find the proper supporting materials (Chapter 7), organize the introduction, body, and conclusion (Chapter 5), and then practice the speech enough times to know the material.

Good public speakers know that practice will not help—and can even be detrimental—if one practices the wrong way. Again, a parallel can be drawn between public speaking and athletics. The legendary golfer Ben Hogan was probably the best at employing a pre–event routine and visualization combined with preparation, practice, and rehearsal of his behavior. Hogan once

said that his purpose "was to incorporate a belief system into his psyche" (Vasquez, 2004, p. 96).

After preparing and practicing your speech, have someone listen to you, have them time you, and don't forget to incorporate visual aids—if you plan to use them—during your practice speeches. Visual aids, as covered in Chapter 7, can affect your interpersonal interaction with the audience and they can have an impact on the time it takes to give a speech. Quantity without quality won't help you a bit when practicing your speech, so practice the correct way. A good communicator will become familiar with the material and use note cards to keep on track. Many students believe that they can overcome their anxiety by reading or memorizing a speech. They may not be as nervous, but they are not very good communicators. Furthermore, when one loses his/her place while reading or reciting, the anxiety increases instantly and causes more problems than the original anxiety that the speaker was seeking to avoid. So, it comes down to preparation and familiarity with the topic.

When your time comes, get up there and speak. Remember that if you don't get into the water you'll never learn to swim, that you can't get to second base if you don't take your foot off first, and that you'll never win if you don't even play the game. Don't think about being anxious or nervous; get positive and focus on doing a great job. Also, don't get into the mindset of "getting the speech over with." A fan once told a college football coach that he sure would be glad when the next game was over and that he was certain that the football coach shared his sentiment. However, the coach replied: "The games are the fun part and I'm in no hurry to get it over. It is something that we prepare for year round and we get so little time actually to play the game." My advice echoes what the coach said. Enjoy the speech and don't just try to get it behind you.

These are just a few suggestions, but the list is by no means all encompassing. In fact, you may find other suggestions or you may develop your own methods of overcoming anxiety. Indeed, there are legitimate reasons for nervousness and ways to cope with it. As Reverend Peale (1959) declared: "A difficulty can break you, or it can make you. It all depends on how you take hold of it, and what you do with it" (p. 130). In other words, you can crash and burn or you can seize the moment. The choice is up to you and the person who is best equipped to help you is the public speaking instructor. You are taking the course to learn about public speaking, so learning to cope with your fears and apprehensions is a part of that process.

Chapter 4

The Interrelated Elements of Purpose, Topic, and Audience

Purpose, topic, and audience are three interrelated components. In order to develop an effective speech, the speaker must have a clear purpose or strategy in mind for what he/she wants to accomplish with the audience. A classic example of the importance of purpose, topic, and audience is found in an episode of the television classic *The Andy Griffith Show*. In "The Sermon for Today," a minister from New York comes to the sleepy town of Mayberry to deliver a sermon with the purpose of convincing the audience that the world is in too big a hurry and needs to slow down. During the sermon, various audience members are shown nodding off into sleep. People in the South would say, "He was preaching to the choir," as he was merely being redundant to the laid back citizens of Mayberry when he shouted the rhetorical question, "What's your hurry?" Detz (1984) explained: "Your audience can understand your subject only by relating it to their own ideas and problems and experiences. So, approach the subject from *their* perspective, not *your* perspective" (p. 19).

Some experts believe that *what* a speaker says is of more importance than *how* a speaker says it. Such a premise is debatable, as others contend that *how* something is said is equally as important as *what* is said. The rationale is that someone might be an expert in his/her field, but if he/she cannot communicate "*what*" effectively then there is little reason to speak. During my own college years, I encountered a number of professors who obviously knew a great deal about their disciplines but who were not effective in communicating that information to students. A lot of the problem stemmed from their lack of skill in delivery, which we will examine in Chapter 8.

Purpose is your aim, intention, or goal for your speech. In a college class, the instructor assigns the purpose to students but not necessarily the topic or subject. The same can be said for speeches given in the real world. In a classroom, your audience is a captive audience consisting of your classmates who are present because they have to be. However, inside or outside

the classroom, a speaker's success in informing, entertaining, or persuading should always be measured in terms of the response your receiver(s)—or audience—gives to your message. No matter where the speech is delivered, what the purpose is, or whatever the occasion might be, the speaker must understand that the audience holds the key to success or failure.

In Chapter 2 we examined the communication process and barriers that can interfere and cause communication to be ineffective. Although we discussed channel noise, semantic noise, and psychological and emotional noise, we didn't delve much into the barrier created by just a plain old lack of interest in the speaker's topic. Beginning speakers often fail because they pay too little attention to purpose and audience response when planning their speeches. I recall one student who did a better job than most speakers in successfully integrating purpose, topic, and audience. The assignment was for an informative speech. The topic chosen by the student was to demonstrate how to repair drywall, a.k.a. sheetrock. The audience quickly learned why the topic was appropriate for most college students. As the speaker learned from his research, the most common reason for students losing their apartment security deposits was holes in the wall. Within four to six minutes, the speaker showed the audience how to repair the drywall for less than five dollars. Certainly, it was worth the investment to have a deposit of several hundred dollars returned at the end of the lease.

The Purpose: General and Specific

Why are you speaking? What is it that you want to achieve? How does it affect others? How is the audience going to be affected and how will it react? Klepper and Gunther (1994) explained: "Speeches, after all, are only air. But what you do with this air is up to you" (p. 8). In that respect, public speaking is like broadcasting in that it is a space in time. As Klepper and Gunther (1994) added: "If you are giving a speech to fill time, that is all you will do" (p. 8). Frequently, students don't understand that public speaking is about purpose and strategy. It requires effective, two–way communication, so they need to know what their purpose and objectives are. What Dolman (1922) observed in the early 20th century still rings true today:

> When I ask a student speaker what his purpose is, in nine cases out of ten he answers: "To tell about Lincoln" (or "the war," or the tariff," or whatever his subject happens to be). He does not say, "To tell *you* about Lincoln," or "To tell *them* about Lincoln." He uses the transitive verb "tell" without a direct object. He does this be-

cause he is not thinking about his audience at all; he is thinking about himself and his subject matter, and how to get it off his chest. He can do this while staring at the ceiling, or the wall, or out of the window, and he can do it just as well—perhaps better—when no audience is present. This is not public speaking. Nobody can possibly speak well when he thinks of himself and his subject and ignores his audience. (p. 8)

Depending on whom one asks, there are usually two or three major purposes in public speaking: *to inform, to persuade*, and *to entertain*, which could fall under the category of *occasional speeches*, meaning for a special occasion. Some would argue that another purpose is *to motivate*, but that would probably fall under the heading of persuasive or even occasional speaking. Although entertainment is frequently integral to the occasional speech, entertainment should be an overall objective for most speaking purposes, but it is not necessarily a major purpose. To entertain means to gain a pleasant response from the audience, which can be done by piquing their curiosity, by amusing them, by keeping them in suspense, etc. So whether the purpose is to inform or to persuade, entertainment value (or audience interest) must be considered. As mentioned above, motivation seems to be a form of persuasive speaking, so for the purposes (no pun intended) of this book I will focus on informative, persuasive, and occasional speeches.

Informative speeches are essentially designed to share knowledge with the audience by demonstrating, explaining, defining, describing, reporting, or analyzing. Persuasive speeches are formulated to accomplish one of several objectives: to convince, to reinforce, to elicit action, or to inspire. A speech to convince would seek to alter the audience's opinion about something. A speech to reinforce is one that motivates those already in agreement with our perspective. A speech of action tries to get the audience to do something, such as to vote or to lose weight or to quit smoking. A speech to inspire seeks to stir the emotions of the audience.

After the speaker knows the general purpose of the speech, the *specific purpose* can be developed. Later, the speaker will formulate a central idea or thesis statement. The specific purpose focuses on one aspect of a topic and takes the form of a single infinitive phrase, such as "To inform my audience about . . ." or "To persuade my audience to . . ." The objective of the specific purpose is to state what the speaker expects the listener to take from the speech. The speaker emphasizes what the audience is expected to understand, to learn, to do, or how the audience is expected to act after hearing the speech. Here are some examples of general and specific purposes:

Example One:
General Purpose: To inform
Specific Purpose: To demonstrate to my audience how grapes are turned into wine.

Example Two:
General Purpose: To inform
Specific Purpose: To teach the audience how to make a balloon monkey.

Example Three:
General Purpose: To inform
Specific Purpose: To explain to the listener the origins and makeup of the Advent Wreath.

Example Four:
General Purpose: To persuade
Specific Purpose: To convince my classmates that the college meal plan is not worth the money that it costs.

Example Five:
General Purpose: To persuade
Specific Purpose: To convince my fellow citizens of the need for mandatory testing of senior citizen drivers.

Example Six:
General Purpose: To entertain
Specific Purpose: To entertain attendees of the football banquet as I relate experiences from my career in professional football.

When developing the specific purpose statement, there are some important suggestions to follow. As already mentioned, *the specific purpose takes the form of an infinitive phrase and full sentence.* "Baking a cake" might make a decent title, but it is not a specific purpose. The speaker should make certain that *the specific purpose is a statement and not a question* such as "What is truth?" The speaker's job is to tell what "truth" is, not to ask what it is. Likewise, the speaker should confine *the specific purpose to a single idea.* In other words, the sentence should be simple and not complex. The following is an example of a purpose that is not specific at all: To teach my audience how to catch fish, how to identify different species of fish, and how to cook fish. Any one of the three "how–to" suggestions would be more than

sufficient for one speech. Finally, the speaker's *specific purpose should not be vague* such as "To persuade my audience to go to movies."

The Topic

Selecting a topic, or subject, for a speech is frequently difficult for students. On the surface, that may be surprising, but it is true. Many students either lack a natural curiosity or they don't know how to awaken that spirit. They don't look at the small and large wonders of the world and wonder why. The most creative comedians understand that curiosity is a basis for their humor. They ask why something is or why it happened. Curiosity can be very basic. Take, for example, the egg—as it was once called in a television commercial, "the incredible, edible egg." It begs the question: Who was the first person to eat an egg? What inspired them to do it? Some time in the past, someone may have gestured and said, "I just saw something fall out of that chicken; I bet that would be tasty." It's possible, because someone certainly had to be the first. More likely, the person observed an animal—perhaps a dog—eating an egg. It may have then been decided that it was edible. Moving forward a bit, was that the person who cooked or prepared the egg? Did the person fry (scrambled, over easy), boil (hard or soft), poach, or make an omelet or eggs benedict? There are literally thousands of other questions that can arise from one's curiosity, yet many students have trouble coming up with a topic. The good teacher can inspire students to look at the world around them, to draw on their own experiences, and to seek answers.

Finding and Selecting Speech Topics

Frequently, students get very frustrated while trying to come up with a speech topic. The following is a real question that a student sent to me via e–mail: "I have been trying all weekend to think of something to do my persuasive speech on and I am stumped. I can't think of anything. Do you have any suggestions?" This is the response that I sent to her, which is fairly typical:

> Well, there are a million things—literally. You just have to find something that interests you and the audience. Research it, organize it, and present it. Ask yourself some questions like these: Do you think wildlife should be protected from extinction or not; do you think global warming is happening and should be stopped or not; do you believe gun control is right or wrong; do you have a product or service that you can provide or that you can sell; are you against the Atkins diet; are you concerned that enough people don't vote; do you think immigration should be stopped or con-

tinued? The list is infinite. Write down some things and consider them. Also, we'll talk more in class on Tuesday. Topics are hard to come up with aren't they? I hope I have helped some.

To come up with a topic, simply try to come up with one that is of interest both to the speaker and to the audience. One can start by brainstorming. In other words, make a list of broad ideas that may be of common interest and then pare it down to something that is manageable. Let's try one. Let's say music is of interest. We can narrow from there: music, rock music, Southern rock music, and then to the Allman Brothers Band. As DeVito (2004) stated, those messages that are most effective are typically those that are more specific. In other words, the topic can vary in its abstraction. Although general topics might at times be appropriate, it is usually better to have more specificity. Let's try another series of topics to narrow down to something specific: entertainment, television, American television, recent American television shows, situation comedies, and then to *King of Queens*.

You should bounce your ideas for speech topics off other people who are similar to those who will hear the speech. I encourage students to come to me to discuss speech topics. A good example is the "wedding" speech mentioned in Chapter 2. Although the student wanted to give a speech on "How to Plan a Wedding," I encouraged her to refocus on why certain parts of the wedding have become traditional. Indeed, she changed her topic and the audience enjoyed the speech tremendously. Conversely, another student insisted on doing a demonstration speech about floral arrangements. She was not audience–centered and the speech was not well received by the students. The bottom line is that a speaker should always pick a topic that will interest the audience the most.

Although it is fine to come up with a topic from your own background and interests, caution is advised. In Chapter 7 we will discuss supporting materials for a speech. Never assume that your own personal interests are of any significance to others. Another problem with giving a speech on something you think you already know a lot about is that you may not know as much as you think. You may also leave out important information that you knew but that would have helped the audience better understand your point(s). You may consider yourself knowledgeable about your topic, but go ahead and find support for what you have to say. It isn't unlike a trial lawyer who is absolutely convinced his/her client is innocent. Proof must be provided to the judge and jury.

When it comes to topics, don't try to do too much in your speech. You need to make sure that your topic isn't too narrow, but you also need to limit what you are attempting to do. I have frequently seen students try to cover too much ground. One speech that stands out was about "crabbing." The student's purpose was to inform the audience about how to trap crabs, how to identify crabs, and how to prepare crabs for eating. Any one of those areas would have been sufficient for a four to six minute speech. Had she discussed it with me first, I would have recommended that she narrow her topic. Unfortunately, she erroneously thought that more would be better.

The Central Idea or Proposition

After selecting a purpose, specific purpose, and topic, you can then move on to the *central idea* or *proposition*, which is a way of previewing the main points of the speech. The central idea or proposition may also be known as the thesis, the key statement, or the idea that controls the speech. The central idea keeps the effective speaker from wandering or trying to cover too much ground. A good speaker will focus on the overall objective of the presentation and sum it up in one central idea to be communicated to the audience. The central idea is introduced in the introduction to the speech. The speaker can state the central idea directly or can introduce it in a manner discussed under the section on introductions found in Chapter 5. The three types of central ideas and propositions are *fact, value,* and *policy.*

Fact is something that exists or has occurred; it is something that is true or real. For example, it is an indisputable fact that George Washington was the first U.S. president. Because there is no question about that fact, we don't need a persuasive speech to convince us that George Washington was indeed the first president. A factual proposition, or central idea statement, would be suitable for informative speeches of introduction, demonstration, explanation, or exposition, which we will examine in Chapter 9. A speaker would offer an objective or nonpartisan view of the topic or subject. For example, a speaker might demonstrate to the audience how to bake a cake. Should any audience member decide to go home and bake a cake, it would be purely incidental because persuasion was not the speaker's objective. Telling someone how to do something and trying to convince someone to do something are two different things.

Value focuses on a judgment or subjective evaluation about an object or action. Value is *not* your personal opinion. If you say you enjoy something,

then that is your personal taste and not a value. Example: "I enjoy golf." By making such a statement, you are under no obligation whatsoever to explain why you like golf. If you say, "Golf is both a cerebral and a physical sport," then you have made a value statement and might find it necessary to defend or justify your claim.

Policy involves the need for a plan or specific course of action that should be taken by business leaders, legislators, politicians, etc., with the intent of influencing the decisions or actions of others. Normally, the proposition for a policy speech would include the word "should." For example, "We Americans should open up our minds and think in a different way about alternative fuel sources." And another: "Hunting is cruel and unnatural and it should be stopped."

Whether grounded in fact, value, or policy, a good central idea or proposition will be easily explained and supported by the speaker as he/she proceeds through the main points. The central idea or proposition should take the form of a complete sentence, but should *not* be compound, complex, or phrased as a question. Therefore, it should specifically cover a solitary topic that is audience–focused.

Example One:
General Purpose: To inform
Specific Purpose: To inform my audience about the influential Southern rock group called The Allman Brothers Band.
Central Idea: the Allman Brothers Band created Southern rock music by brilliantly mixing blues, jazz, country, and rock.

Example Two:
General Purpose: To inform
Specific Purpose: To inform my audience about the artificial insemination of cattle.
Central Idea: Artificial insemination of cattle is important economically because the production of offspring can be more manageable and more predictable.

Example Three:
General Purpose: To inform
Specific Purpose: To inform my audience about the benefits of prescribed burning.

Central Idea: Prescribed burning is the wise use of fire in fields and woodlands to bring about specific benefits such as better wildlife habitats and the prevention of accidental fires.

Example Four:
General Purpose: To persuade
Specific Purpose: To persuade the audience to avoid the unhealthy practice of indoor tanning.
Proposition: Indoor tanning is dangerous to one's health and should be avoided.

We will further investigate propositions of fact, value, and policy as we consider persuasive speaking in Chapter 10.

Title

A speech should have a title that is true to the speaker's objectives. Indeed, a good title can get the attention of the audience before they even arrive to hear the speech. Likewise, a bad title can convince audience members not to attend. Titles should neither be too short or too lengthy. A speech called "Alzheimer's" would sound far too general and would be far too short. An example of a title that is much too long, but that probably would be a good central idea, is "Alzheimer's is a disease that will potentially affect you or someone you love and it is important to understand the severity of this disease." Perhaps "The Agony of Alzheimer's" would be compelling enough to interest an audience. Rather than a speech called "Alcohol Consumption," how about "Has alcohol ever worsened a situation for you?" Here are some more actual student informative speeches:

Aphrodisiacs: Love or legend?
Audio recording fundamentals
The curse of the bambino
The sport of cockfighting
Card tricks
Wine: A cultural experience
Bigfoot: Fact or fiction?
Knitting and crocheting
Flat tire repair
Emu processing and product development
Investing in the stock market
Some reasons people become vegetarians

Vulnerable people of the world: Refugees, stateless, and displaced persons
The tree that owns itself
Superstitions of athletes
Biological warfare: America's hidden battle
Breeding Pomeranians for fun and profit
The dos and don'ts of dating
A history of the fast food industry
When and why do dreams occur?
Fire Safety 101
Dos and don'ts of formal dining
The behavior of a honeybee colony
The history of sneakers
Jack–o'–lanterns
Kabbalah
How to make a balloon animal
A cure for hangovers
Polygamy and its relationship to modern America
Toilet Paper: The invention we take for granted
From grapes to wine
The history of the doughnut
The Masters: A prestigious tournament
Atlantis: The Lost Continent
Diamonds: A girl's best friend
Getting acquainted with sleep
The Advent Wreath and how to make one
Skiing: Not just for the Olympic athlete
Perfume's many unknowns
The history of pizza

The Audience

When designing a speech, it is imperative that the speaker understands to whom he/she will be directing their remarks because any good topic will be audience–centered. Good radio programmers know that stations must be formatted to play music to attract specific or general audiences. Air personalities are not hired to play what they like, but are employed to play what the audience will like. Some formats are more specific and some are more general. It all depends on the audience you are seeking to address. In speechmaking, like in radio programming, you—as sender—*must* know the makeup of the audience. In other words, who is it that you are targeting? Who will be listening to you? Detz (1984) explained: "It's a fact: audiences tend to trust—and to like—speakers who show a real understanding of them" (p.

19). Effective public speakers, or communicators, try to create a bond with their listeners (audience) by focusing on common values, goals, and experiences. The process is that of *identification*. In other words, the speaker needs to understand what we discussed back in the communication model in Chapter 2—*frame of reference*. Every speech contains two messages. There is the one sent by the speaker and the one received by the listener. As we say in interpersonal communication, meaning is not in the message but in the receiver. That is because people listen and interpret selectively—they hear what they want to hear and believe what they want to believe. Elizabeth Natalle (2008), an interpersonal communication scholar, observed: "Interpretation bases its approach on the general notion that human beings communicate within realities they create for themselves" (p. 115). So we also need to understand that people are *egocentric*, meaning they pay more attention to messages that affect their own values, their own beliefs, and their own well–being. Most people ask, "Why should I care?" The kind of audience to whom you will be speaking can be determined through the use of *demographics* and *psychographics*. *Demographics* are the statistical characteristics of human populations, such as age, sex, race, marital status, educational level, socioeconomic status, occupation, religion, political orientation, etc. Each of these characteristics can have an impact on the effectiveness of the speech either considered alone or in combination with any or all of the other characteristics. *Psychographics* show us what the audience members may have in common. It is the determination or measurement of their opinions, beliefs, and interests. Unlike demographics, psychographics describe information about the audience's opinions. Those opinions might have to do with views on gun control, the death penalty, bottled water, laundry detergent, etc. It is important to remember that not everyone listening to our speeches can be persuaded to act as we want or will even be interested in what we have to say. Depending on the circumstances, there are some *general kinds of audiences* that one might encounter. The most desirable audience, of course, is the *favorable audience*, which is made up of people who are already convinced that they agree with the speaker. A good is example is the minister who every week speaks about a faith or other views that he/she shares with the congregation. They all believe basically the same things or they probably would not be in the same church. Another example is that of the Democratic or Republican National Conventions. It is pretty safe to assume that attendees of either would be there in support of their respective party. The *neutral*, or *indifferent*, *audience* is one that may be uninformed, undecided, or

simply indifferent to what the speaker has to say. Perhaps you have been in such a situation when a friend or family member has asked you to attend a talk, lecture, or speech about which you have no real opinion or knowledge. Classroom settings can be that way when there are students who are there merely to satisfy core requirements to graduate. Another analogy can be made with politics. In any election, the winner normally is the person who can sway the most undecided voters to his/her side. *Hostile audience* members are those who already know that they are not in agreement with the speaker or his/her position. Sometimes hostile audience members try to disrupt the speech, but sometimes they merely share their feelings after the speech. They should be attentive to a speaker's remarks, be polite and show respect, and be ready to ask follow-up questions or make meaningful comments. The hostile audience member need not agree with the speaker, but should respect the situation. We could also add the *uninitiated audience* to this discussion. Uninitiated audiences contain those people who may have no idea about anything you may say. In such case, the speaker should understand that ahead of time and plan accordingly by employing foundational or basic information.

As with demographics, not all audiences are homogeneous, as there can be a mixture of favorable, neutral, hostile, uninitiated people in an audience. Such a situation can frequently occur in a classroom setting. A good example may also be the Democratic or Republican National Conventions. Although most attendees are probably there to be favorable, there can be division when it comes to individual candidates or issues. Furthermore, there may be those in attendance who are there just to see what it is all about. Therefore, it is important for the speaker to know exactly what it is that he/she hopes to accomplish. From the time the speaker begins preparing the speech, he/she needs to keep in mind what kind of reaction or response they will seek from the audience. If the goal were merely to entertain, as in occasional speaking covered in Chapter 11, then the speaker would want a response of excitement from the audience. If the speech is to inform by instructing, explaining, describing, discussing, or reporting, then the speaker wants the audience to understand what he/she is saying. If the speech were designed to persuade, then the speaker would want to convince, to reinforce, or to elicit action from the audience.

In public speaking and in communication in general, one's words—or language—can include or exclude others. Some experts refer to it as inclusion talk and exclusion talk. As we will explore in Chapter 8, people indeed

judge us on the words we choose to use. Thomas Roeper, a professor of linguistics at the University of Massachusetts, stated:

> Language prejudice is as much a problem, or can be as much a problem as race prejudice. It becomes a way of judging somebody in just a few seconds. If all dialects are the same then we should respect them all equally. But what we know is that people make very quick, rapid, and emotional determinations of what they think of another person by how they speak. (*The Art of Communicating Language*, 2000)

To avoid excluding others, analyze the audience and adjust your words, or language, to accommodate as many audience members as possible. For example, a doctor should speak entirely differently to a group of his/her colleagues than to a group of uninitiated listeners. In other words, they need to use less technical jargon and focus on lay terms. The same principle applies to other demographic characteristics as indicated by Professor Roeper. Try to include as many people as possible by being sensitive to the perspectives of various audience members. Use words and examples to which everyone can relate.

Speeches, then, should be suitable for both an audience and for the speaker. If the speaker expresses little interest in a topic, then why should the audience be interested? The occasion for a speech is important. Although we will go into detail about occasional speaking in Chapter 11, the occasion is just as important in informative and persuasive speaking. Students sometimes complain about time limits in classroom speeches. Some students don't want to speak enough and some want to speak too much. Time limits are certainly important and any speaker should find out ahead of time how much time he/she will have to deliver the message. There are also times in the real world when you might be faced with having to get your point across in 30 to 60 seconds. Laura Raines (2007a), a career and jobs reporter for *The Atlanta Journal–Constitution*, calls it the "elevator speech" (p. R1). It is not a presentation that would have to occur in an elevator, but there are times when all you have are 30 to 60 seconds to introduce yourself, to tell someone about what you do, and to tell them what you want to do. Jay Block, a certified executive career coach, explained: "Your elevator speech has to hit those emotional triggers that will get someone to take the action that you desire. It should address the major results that you can produce" (Raines, 2007a, p. R4). Organization, as we will see in Chapters 5 and 6, is of utmost importance for effective public speaking. A hungry audience will not pay much attention to a lengthy missive when the speaker is asked to speak prior to a

meal. Likewise, a full audience will not want to listen very long either if they feel drowsy. Speakers must always be aware of the audience and should always monitor feedback from them.

Chapter 5
Beginning and Ending Speeches

In his autobiography, former Chrysler Corporation CEO Lee Iacocca extolled the benefits of public speaking courses. Iacocca said the main thing a speaker needs to understand is that although "you may know your subject," the "audience is coming in cold" (Iacocca & Novak, 1984, p. 54). Therefore, "start by telling them what you're going to tell them. Then tell them. Finally, tell them what you've already told them. I've never deviated from that axiom" (p. 54). It sounds simple, but Iacocca summed up the basics of speechmaking. All effective speeches are organized into three parts: a beginning, middle, and end or the introduction, the body, and the conclusion. The method of organization might seem redundant, but it is important to repeat the points because "unlike readers of an article, listeners of a spoken presentation can't flip back to a previous page or paragraph to refresh their memory or study your material in more detail" (Yaverbaum & Bly, 2001, p. 151). The same principle is applied in radio and television. Many listeners don't understand why they hear the same commercials over and over, but broadcasters understand that people listening to radio in the morning are getting showered and dressed. Channel noise, as discussed in Chapter 2, can cause the listener to miss all or part of the message, so repetitiveness better ensures that the listener will eventually hear the entire commercial.

Vic Gold, a public relations professional and political speechwriter, sees the speech as a process. In his autobiography, Gold (1975) believes speechmaking is like an encounter between "seducer and seducee" (p. 187).

> A speech, after all, is a symbolic political sex act, you see. You don't? Well, let me explain...First, there's the foreplay: a preliminary warm–up in which the speaker softens his audience with ingratiating remarks or light humor. Then comes first contact with the subject matter: move slowly at this point to bring the audience to the sofa without jolting its sensibilities. Then comes the body of the speech itself, with the speaker building audience response to a peak until, finally—what else? Orgasm, if the speech is good and the speaker does his job. Meaning, an audience left standing and cheering, fulfilled in every expectation. And the speaker left limp and ready for a nightcap. This technique varies, of course, depending on the size and intimacy of an audience. (p. 187).

Without question, both Iacocca and Gold have summed up the basic organization of a speech. Any way you look at it, the speech begins with an introduction that provides an overview of the speaker's topic. Then, the body details each of the main points and their supporting materials. And, the speech is wrapped up with a summary of the material previewed in the introduction and discussed in the body.

The purpose of this chapter, then, is to help you learn how to organize two major parts of your speech: the introduction and the conclusion. It really is not difficult if you think about what it is you want to do. For some reason, most students seem to have less trouble establishing the body of a speech than in introducing and concluding a speech. Generally speaking, introductions and conclusions are difficult for many people and the problem is not limited to speechmaking. Many authors know that the introduction and conclusion are the hardest parts to write when it comes to books, articles, or essays. Despite the difficulty, the beginning might be the most important part. Despite the order in which they are covered in this book, the recommendation here is to work on the body first and then deal with the introduction and conclusion. We will learn about the organization of the body of the speech in Chapter 6, but keep the introduction and conclusion in mind as you develop the body. That should make it easier to lay out the introduction and conclusion when the time comes.

The effective speaker should be aware that the body contains the bulk of the speech and consists of about 75 to 85 percent of the speech. That leaves about 10 to 15 percent of the total speech time for the introduction and 5 to 10 percent of the total time for the conclusion. These percentages are not set in stone and can vary according to the speaker, the situation, and to the content of the speech. Still, these are good guidelines and the speaker should keep in mind that the shortest part of the speech is the conclusion. Once you get there, the audience expects rather quick closure.

Introductions

To use a food analogy, the introduction is the appetizer before the meal and can even be a menu (preview) of what is to come in the speech. A speaker needs to accomplish several objectives in the introduction. It should be understood that the speaker's first priority is to establish a rapport with the audience and to gain their attention. Without doing so, it is unlikely that the

purpose of the speech will be achieved, be it to inform, to persuade, or to entertain. Authors Gloria Hoffman and Pauline Graivier (1983) observed:

> The first impression in many instances is the last word. In every face–to–face en-
> counter between two or more people, we have about three minutes to move a moun-
> tain of rapidly forming impressions and opinions into an affirmative position on the
> other person's mental map of who we really are. Lawyers say that cases are won or
> lost in the first three minutes of their first words spoken to a jury. Granted, that's a
> very short audition. But, realistically, that's about the size of it. We've got three
> minutes to sell ourselves in any given situation in life: business, professional, social
> or personal. (p. 143)

In other words, it is extremely important to build a rapport or common ground with the audience from the get–go. As seen in Chapter 4, some speech communication experts call it *identification*. As discussed earlier in this book, there are both differences and similarities between public speaking and conversation. Identification is one of those similarities, and as we will discover in Chapter 10, it is very important in persuasive speaking. It is eas-ier to get someone (listener, audience member) to believe, or for us to believe someone else, when we share common ground. Rodney Dangerfield (2004), the late comedian, concluded that speechmaking and stand-up comedy share much in common. He said: "From the moment you walk onstage, try to make the people like you. That's the most important thing" (p. 30).

Michael Klepper and Robert Gunther (1994), authors of *I'd Rather Die Than Give a Speech*, recommended that "whether you use any one of the techniques discussed" in their book or "opt for a song or pantomime, or shoot off fireworks, make sure your first point of contact with your listeners is designed to get their attention" (p. 21). Be creative in putting together the introduction, especially in gaining attention. A good speaker, like a good songwriter, tries to find a "hook" to grab and keep the attention of the lis-tener. Advertisers and marketers do the same thing because they know that "simplicity is at the heart of creating ideas, and messaging, that sticks in our minds" (Keeping It Simple, 2007, p. 5). A good example is the Golden Rule: "Do unto others as you would have them do unto you." The statement "is a quick summary of a philosophy that can guide every one of your actions— it's just the statements that are simple" (p. 5). Most people know a couple of the greatest speech hooks, or attention–getters, such as "Four score and seven years ago" and "I have a dream." Those words are unforgettable. Later in this chapter, you will see an organizational pattern for the body of the speech

called "journalistic questions." Comparisons are made between speechmaking and news stories—both print and broadcast. A comparison can also be made between news leads, or the opening of a news story, and the introduction of a speech. The lead in a news story is generally considered to be the most important sentence. Like the introduction of a speech, it is designed to capture the attention of the audience and set the stage for the rest of the story. Typically, it also includes or introduces much of the basic information for the story (Keller & Hawkins, 2002; Stephens, 1993).

There are things that a speaker should not do and that will deter the establishment of a positive rapport with the audience. A weak introduction will lead to an ineffective speech. Sometimes it is better not to get into the subject of what one knows or has done, as some audience members may find the speaker arrogant. Other things just don't come across well, such as beginning a speech by saying "My speech is about" whatever or "Hey, I'm" whoever. It can also be troublesome to try and make the audience verbally respond to you. Some speakers are known to begin with an energetic "Good morning!" By so doing, the speaker expects a similar response from the audience. It is particularly annoying when the speaker has a problem with a perceived lack of enthusiasm displayed by the audience when he/she first stated "Good morning!" to begin the speech. So, the speaker then chides the audience into repeating the "Good morning!" Here are some other examples of things a speaker should not say when beginning a speech:

"My topic is…"
"I'm here today to talk about…"
"Uh, hi, I'm really nervous…"
"I'm here to introduce [whomever] and he's right over there."
"I really don't know why they asked me to come here because I
don't have much to say."

The point is that a speaker should develop a creative way to get into the speech. Another pitfall is what some might call a false beginning. In such case, the speaker begins speaking about something that is totally irrelative to the speech topic and content. Then, the speaker might say: "Well, I'm not really here to talk about that. Instead, let's talk about suicide." Not good at all!

After gaining their attention appropriately, it is necessary to continue to motivate the audience to listen. Part of establishing motivation surrounds the

reasons *you* are the best person to speak on a particular topic. Why should the audience listen to you? What do you bring to the table that others may not? To paraphrase Lee Iacocca, in the introduction you will basically be previewing to the audience what they can expect to hear from you in the body of the speech. Therefore, the last part of the introduction would be stating the purpose and the central idea, and previewing the main points or ideas that will be developed in the body. Then, there can be a fluid transition into the body. In outlining a speech, the introduction may look something like this:

 I. Introduction
 A. Opening (Build rapport)
 1. Gain attention of audience
 a. Direct attention to subject
 b. Significance of subject
 c. Relevance of subject
 d. Credibility of speaker
 B. Specific purpose statement
 C. Central Idea
 1. Putting the topic into context
 2. Key prerequisite principles, facts, conditions
 3. Preview of main points, procedure, or process

Openings

Gain the attention of the audience. There are many ways for the effective speaker to capture the audience's attention and to build rapport with them, such as humor, storytelling, quotations, rhetorical questions, statistics, shocking or dramatic statements, physical activities and/or appearance, etc. Before we discuss these devices, it is important to understand that some of these techniques can be used together in combination. In other words, some attention-getters may be rolled together for maximum impact. A "story" may use "humor"; "statistics" might be "shocking or dramatic"; "quotations" might include "statistics"; and so on. However, there are so many that you should never try to use all of them at once. Likewise, use what works best for your speech.

 Humor is frequently used as an effective way to gain an audience's attention, but it can also be a means of helping relax the speaker *and* the audience

at the start of the speech. Monica Wofford (2004), president of a speaking and training company, stated: "People in the audience usually learn better when they are relaxed and laughing. They are also much more likely to listen to you when they believe you are one of them" (p. 90). Rodney Dangerfield (2004), who worked as a salesperson for many years while developing his show business act, said that "it's a big plus if you can make people laugh. In any group, professional or social, people usually gravitate toward the guy with a sense of humor. I learned pretty quickly that I had a much better chance selling a job if I could make the people like me" (pp. 73–74).

It is imperative that humor be delivered effectively. Be careful, because humor only works when the speaker has the delivery skill to pull it off and when the speaker has analyzed the audience correctly. If the speaker's attempt at humor fails, then the rest of the speech may be ineffective. Novice speakers, in particular, may experience great difficulty in recovering from it. Most of the time, though, humor is a good way to ease into the speech. Jamie Stokes (2001), an authority on occasional speeches, observed: "Nothing will get an audience on your side faster than a bit of wit" (p. 13). However, the speaker should not launch into a joke that has nothing to do with the content to follow. A speaker could use the following example of humor in a speech with the purpose of informing the audience about the origins and current issues of Halloween: "Please understand that before I get too far into this speech, there may be some of you queasy types who may hear some things that will make you uneasy. [The speaker shouts] BOO! Well, that was one of those things." James Humes (1975), who has studied the use of humor in speeches, explained the difference between jokes and humor:

> A joke is verbal slapstick—it lacks both build–up and believability. It doesn't come out of your own experience. It has been mass–manufactured, not tailor–fit to your occasion. It is, at best, a fifth–hand commodity worn down by use into a bare two–line exchange.
>
> Humor flows out of the person or the moment. Humor builds suspense and tension, then releases it, sometimes by presenting the unexpected of the familiar in an unfamiliar context. Humor demands something from the audience as well as from the speaker. It is the flash anticipation or sudden insight by the audience that triggers laughter. Humor is build–up, bomb, and burst. (pp. xi–xii)

The bottom line is that there are lots of funny things in the world, but they are not all organizationally or tastefully appropriate for a speech. Always be aware of differences in taste and sensitivity about humor.

Storytelling is good for stoking the imaginations of audience members. Sometimes, speakers use folktales in their introductions because they typically conclude with a moral. The moral then sets the stage for the thesis statement, which is in a nutshell what the speaker is attempting to do. Therefore, be sure that the story gets the intended meaning across to your audience. David Buttrick (1994), an authority on sermon delivery, warned: "Now, we must be cautious; story per se is no guarantee of meaning" (p. 17). However, Madison Avenue advertising agent Alan Koehler (1964) said: "With a little ingenuity you can usually file an adequate point onto most funny stories. But a hilarious story that doesn't make a point is often better than an indifferently funny one that does" (p. 32). As with other devices discussed here, be aware that your vocal delivery of the story is very important. Stories can be humorous or not, but either way effective storytellers use drama and build up to a climactic ending. It is no different from a movie, a TV show, or a good book.

Quotations, like humor and storytelling, are useful in getting a speech off to a good start. As with other attention–getters, it is imperative that the quote share common ground with the speaker's topic. If one's topic were suicide, then a quote from Shakespeare's *Hamlet* would work and could be incorporated as I have frequently demonstrated to my students: "'To be or not to be; that is the question.' Most everyone has heard that quote from Shakespeare's *Hamlet*, whose lead character was contemplating whether he should live or die; whether he should commit suicide or not. Unfortunately, many people in today's society consider those very same options every day." Note that a primary reason the preceding quote can be effective is based on the speaker's delivery. To achieve maximum effect in gaining attention, quotes should take on a style that differs from the speaker's. As with the quote from *Hamlet*, it is almost impossible to quote Shakespeare without taking on a certain air. Depending on the topic, of course, the speaker has a wide variety of sources for quotations, from literature to poetry to song lyrics and beyond. In regard to Shakespeare, perhaps Marc Antony in *Julius Caesar* delivered Shakespeare's most quoted line: "Friends, Romans, countrymen, lend me your ears; I come to bury Caesar, not to praise him." Truly, it was an effective attention–getter.

Frequently, if not always, ministers begin with a reading (quotation) of the scripture that is appropriate to that sermon. However, is it necessary to do the same thing, that is, follow the same procedure, time after time? Buttrick (1994) asked: "Must we *begin* every sermon with some Bible passage? After

all, we are exploring the meaning of life in view of God revealed in Christ Jesus, a task that is essentially theological. So what is the rationale for strict biblical–passage preaching in church" (p. 15)? The purpose here is not to get into a religious debate. Rather, sermons (like lectures) are speeches and Buttrick is being critical of taking the same old approach. The point is, no matter the speech or setting, it is okay to try something fresh every once in a while.

Rhetorical questions can be effective for opening a speech, but they should truly be rhetorical. A rhetorical question is one in which "the audience is not expected to give an answer out loud" (Koch, 2008, p. 59). You do not want the audience to control the speech, so you do not want to get into a verbal exchange with any audience member during the speech. It is typically not a good idea to ask for a show of hands. What if you do not get the response you hoped? Can you cope with that during your speech? A rhetorical question does not ask for an outward response, but it is asked in an attempt to provoke thought on the part of the listener. You want each person to ponder what you are saying and to focus on the topic at hand.

Statistics are useful for attention–getting introductions, but they may need to be explained or interpreted for the listener. Statistics should not be overused or they can become confusing and even tedious and boring. Most of the time, statistical evidence is used in the body of your speech as supporting materials, evidence, or proof to develop an argument. Statistics will be explained in more detail in Chapter 7.

Shocking or dramatic statements are of great use when the speaker has a very serious topic. It can be combined with other devices, such as the rhetorical question and/or statistics. Perhaps the speech is persuasive, with the speaker taking a position against reinstatement of the military draft in the United States. The following example might be used: "What if I told you that ten years from now half this audience could be dead?" Without question, the line is shocking and dramatic, it employs statistics, and it is a rhetorical question.

Physical activities and/or appearance can also help to get a speech off to a good start. In a speech about card tricks, one speaker deftly shuffled the cards as he stated his opening. Other visual aids or props can be used if they are topic–driven. Perhaps the speaker is holding a guitar or some instrument for a speech on music. The speech might be on golf, so the speaker may hold a golf club. However, not all physical activities require objects. One could even drop down and do some pushups for a speech on exercise or conditioning.

One's physical appearance or style of dress can also have an impact. Hoffman and Graivier (1983) explained:

> Our first impressions of others, and theirs of us, are based almost entirely on two things: what we say and how we appear. Our appearance—how we look and sound to other people—is a composite of the clothes we wear, any noticeable accent in our voice and our general attitude—whether we seem to be shy, outgoing, overbearing, egotistical, withdrawn or whatever. We depend a great deal on appearances in drawing first impressions because at first encounter we don't have anything else to go on. (p. 145)

In a business setting, then, appropriate business attire is essential. In other situations, other types of clothing can be employed. Various students, for instance, have delivered speeches about Christmas traditions while wearing an elf costume; about sleep disorders while wearing pajamas; about deer hunting while wearing camouflage clothing. The possibilities are limitless, but we will explore a few more of them in Chapter 7.

Other ways to gain attention and to establish rapport with the audience include making references to *familiar concepts*. Try to find something to which the audience can relate. For example: "I would imagine that everyone in this room hurts for the people whose lives were changed forever by the recent tsunami." A speaker may also *make reference to another speaker*. For example, if it happens that one speaker has a similar topic to another speaker, this could be said: "We all heard Mary's fine speech about skin cancer, so you will obviously find some commonality between her topic and mine."

Sometimes the *location* of the speech can help in gaining an audience's attention. One politician visited his old middle school and began his address by saying: "I remember when I was a student sitting in this very classroom." Likewise, the *occasion* can provide an obvious link between the speaker and audience as Abraham Lincoln's Gettysburg Address exemplifies. Many people seem unaware of the fact that Lincoln's speech was very short and that it was delivered at the dedication of the national cemetery in Gettysburg. Lincoln's first reference to the occasion was: "We have come to dedicate a portion of that field [Gettysburg battle site] as a final resting place for those who here gave their lives that that nation might live." Throughout the speech, Lincoln referred to "we" numerous times.

A speaker should always be prepared in order to avoid the dreaded false start and having to start over. Furthermore, don't try to be someone else by doing something out of character, especially if you are not used to commit-

ting behavior that is very different from your normal style. Be creative and innovative, but be your natural self.

Make the connection, that is, direct attention to the subject. After gaining attention, answer the audience's questions before they can ask. Why is this topic significant or important? Why is it relevant to this audience? Then, the *speaker's credibility* comes into play. The audience may wonder, "Why are you speaking on this topic?" The audience may know the speaker or they may not, so it can be useful to talk about one's self at the beginning. If the audience does not know you, the personal references become even more meaningful. They may assume that you have a background on the topic, but they won't know for certain unless you tell them. Depending on the formality of the occasion, the speaker may be introduced by another person who will establish the credibility for the ensuing speaker.

Specific purpose statement. As we already discussed in Chapter 4, the *specific purpose* focuses on the major aspect or thrust of your topic. It should be stated succinctly in a solitary infinitive phrase, such as "To inform my audience about..." or "To persuade my audience to..." Some examples of specific purpose statements for informative speeches can be seen in Chapter 4.

Central idea. The central idea is closely related to the specific purpose statement as we also saw in Chapter 4. The central idea helps us put the topic into context for the audience; establishes some prerequisite information such as principles, facts, and conditions; and leads us into a preview of our main points and/or the procedure/process we will employ. Then, we transition into the body of the speech. In a way, the central idea is a preview of what is to come and is not unlike the use of *foreshadowing* in plays. Foreshadowing is a playwright's method of preparing for the action that is to follow. It makes the subsequent action credible, builds suspense and tension, and carries the momentum forward.

Conclusions

Some people believe that the conclusion is the most important part of the speech. Others acknowledge that the last sentence, if not the most important, is certainly the second most important sentence in the speech. No matter if the speech is informative, persuasive, or for a special occasion, it is critical to give the speech closure with both the words and delivery to dramatize the

speech's finality. One thing is certain about the conclusion of the speech; *the speaker needs to make it clear that the speech has ended.* Stokes (2001) advised:

> There is nothing worse than coming to the end of your speech only to find that your audience doesn't realize. The best you can hope for in that situation is a few moments' awkward silence followed by ragged applause, instead of the riotous standing ovation that you deserve. Just imagine how you would feel if you had read a really absorbing novel only to discover that the last page was missing. Usually nothing important in terms of the actual story happens on the last page of a novel, but those few closing lines are vital to your enjoyment of the experience over all. (pp. 25–26)

In other words, it is important to let the audience know that you are about to finish. You can use words such as "In conclusion," "Before I finish, I'd like to say," "I'd like to leave you with a final thought," and so forth. When you give that signal, however, make sure you wrap up quickly. The audience is expecting it.

Conclusions share much in common with introductions. As you plan the ending, consider using any of the strategies that we looked at to gain attention at the start, as many of the same techniques can be employed in both, such as *humor, storytelling, quotations, rhetorical questions, statistics, shocking or dramatic statements*, or a combination of any of the above. Consider this example of humor used to end an occasional speech: "As I leave, I would like to express my appreciation to Bill Dufner for laying out the money for this tremendous reception. If money could talk, Bill would hear it saying 'goodbye'!"

A speaker might also use a *personal reference* or *share his/her emotions* with the audience. Orson Welles, noted actor and director, delivered the eulogy for legendary Hollywood producer Darryl F. Zanuck on December 27, 1979. Welles did not dwell on Zanuck's illustrious movie career. Rather, he focused on Zanuck his friend. Welles ended his eulogy with the following paragraph:

> I always knew that if I did something really outrageous, that if I committed some abominable crime, and if all the police in the world were after me, there was one man and only one man I could come to, and that was Darryl. He would not have made a speech about the good of the industry or the good of his studio. He would not have been mealy–mouthed or put me aside. He would have hid me under the bed. Very simply, he was a friend. I don't mean just my friend. I mean that friend-

ship was something he was very good at. And that is why it is so very hard to say good–bye to him. (Safire, 2004, p. 243)

Closely tied to shocking or dramatic statements is the use of a *positive or negative view of the future*, which may be used in persuasive speeches. An example of each could be used in a speech to convince audience members to quit smoking:

> Positive view: "Consider that if you quit smoking now, five years from now your body will have recovered to the point that it will be almost like you never smoked."
>
> Negative view: "If you continue to smoke at the same rate, you may not be alive in five years."

Certainly, both of those are dramatic statements and the second may even be shocking. A speaker might also incorporate statistics to add impact. Perhaps you can also see where a rhetorical question or story might be useful. A persuasive speech might include a *call to action*, which could come in the form of a challenge. When it comes to the conclusion, remember that the audience is ready for you to wrap up, so be short and to the point. Oftentimes, people seem unprepared and dwindle in their conclusion, losing the audience and the power of the speech. As stated earlier, the conclusion should take up just 5 to 10 percent of the total speech. *Never* introduce new material in the conclusion, because you are basically summarizing what you have just told the audience. It is necessary to include a restatement of your central idea in the conclusion and then, to reinforce the points you used in the speech, summarize them to help add reinforcement to them. You have already introduced your points and, if something were terribly important, you would have mentioned it in the body. Therefore, don't confuse the audience by throwing in another point.

Examine the comparisons between speeches and news stories in Chapter 6. As with a broadcast news story, the last sentence (or conclusion) of a speech should present a closing that is clear and strong (Papper, 1995). Likewise, in speeches and news stories the last part of the story corresponds to the *denouement* of a play where both effects and consequences are stated (Green, 1969). Denouement is the final resolution of the plot that ties the entire speech (or story) together in a clear and ordered manner. A good historic example that accomplishes the goals of ending a speech with drama and

great impact is the conclusion of General Douglas MacArthur's address to a joint session of Congress on April 19, 1951. General MacArthur was at the podium after President Harry Truman fired him as commander of the UN forces in Korea. Although his speech wound toward conclusion with a summary of suggestions on how to address the problems facing the U.S. in Korea, MacArthur ended his speech by summarizing some of the options available to the country in pursuing the conflict in Korea. His dramatic ending focused on the lyrics of an old military song. MacArthur, with his vocal delivery working in concert with the content, stated:

> The world has turned over many times since I took the oath on the plain at West Point, and the hopes and dreams have long since vanished, but I still remember the refrain of one of the most popular barrack ballads of that day which proclaimed most proudly that old soldiers never die; they just fade away. And, like the old soldier of that ballad, I now close my military career and just fade away, an old soldier who tried to do his duty as God gave him the light to see that duty. Good–bye.

A good speaker leaves an audience wanting more, but also tells them what they can do with the information. As Iacocca advised: "…you should always get your audience to *do* something before you finish. It doesn't matter what it is—write your congressman, call your neighbor, consider a certain proposition. In other words, don't leave without asking for the order" (Iacocca & Novak, 1984, p. 54). Iacocca personally appeared in his automotive company's commercials and his famous catchphrase was: "If you can find a better car, buy it." Chrysler resurrected the concept in 2005, complete with both Iacocca and his famous challenge. Of course, Iacocca's advice would apply more to a persuasive speech than to an informative one. Still, in an informative speech, the listener needs to know how to apply the information. The conclusion, then, would include a summary of the main points, a restatement of the purpose and the central idea, and a statement as to what the speaker expects the audience member to do with the information. As already mentioned, make the conclusion short and never, ever introduce new material. Just wrap it up and move on.

Which Is More Important: The Introduction or the Conclusion?

There is some debate as to which is more important in a speech—the introduction or the conclusion. The *primacy–recency theory* holds: "If what comes first exerts the most influence, you have a *primacy effect*. If what

comes last (or most recently) exerts the most influence, you have a *recency effect* (DeVito, 2004, p. 99). Interestingly, studies lead us to conclude that the introduction would have more impact, because "initial information helps you form a schema for the person. Once that schema is formed, you're likely to resist information that contradicts it" (p. 99). Schemata, plural for schema, are "mental templates or structures" that help us organize "millions of items of information you come into contact with every day as well as those you already have in memory" (p. 92). To be on the safe side, it would be prudent for the speaker to develop a good introduction and conclusion along with a solid body.

Transitions

In order to move your listeners smoothly from the introduction to the body to the conclusion and from one point to the next in the body of the speech, *transitions or links* between each must be employed. Transitions act like guideposts for the audience. Imagine driving a car with a stick or straight shift as opposed to an automatic transmission. As the car picks up speed, the driver instinctively knows when to push in the clutch and shift to the next gear. That clutch-pushing and gear–shifting is like the transitions in a speech. The speaker wants to move smoothly from introduction to body, from point to point within the body, and then from the body to the conclusion. There are some useful ways to make such transitions and to make the speech flow. *Transitional words* are something that we use all the time, such as *also, in addition, on the other hand, conversely, however. Numbers and letters* can also help the speaker move from point to point in the speech. For example: "There are three main reasons: first…second…third…" or "There are three simple steps: A…B…C…." The speaker can end one point by introducing the next point, which is sometimes known as an *internal preview*: "As we move on from our first step of acquiring the materials, we can proceed to step two, which requires stripping and removal of the existing roof from the house and then step three and the re–roofing process." Likewise, the speaker can do an *internal review*: "So, stripping the roof requires at least two people, a ladder, and a renting a dumpster to take away the old materials." The speaker's physical gesturing and movements can emphasize transitions. You would not transition in mid–sentence or mid–point, so don't make an unwarranted move. Be natural in gesturing. When saying, "on the other hand," most people actually make a motion with at least one hand. When numbering

steps in a process, most of us find it very easy to use our fingers as we say 1, 2, and 3. Just be sure to use the correct gesture with your transition. Transitions are indeed important to the flow of a speech and they make it easier for the audience to follow what the speaker is saying. However, it is also important not to overuse transitions. In other words, make sure that they fit the structure and that they add interest and vitality to the presentation.

Chapter 6
Organizing the Body of Speeches

The body is the bulk of the speech where the main points will be addressed, developed, and supported. The body is to the speech as the meat is to a sandwich. Supporting materials are the garnish on the sandwich, such as the pickles, lettuce, tomatoes, onions, and condiments. Supporting materials are integral to development of the body and will be examined in detail in Chapter 7. Because the body is the major part of the speech, it only makes sense that most of the preparation would go into it. There can be as few as two main points, but it is advisable not to have more than five. The number of points will depend on how much time has been allotted for the speech and how much time will be devoted to the development of each point. Each main point will have materials to support it.

Why worry about organization? Why not just get some information together and then share it with others. Experienced speakers and writers know that without organization it is easy to get off track and one idea or thought can easily lead to other ideas or thoughts. Herbert Spencer (1820–1903), a British philosopher and sociologist, once observed: "When a man's knowledge is not in order, the more of it he has, the greater will be his confusion of thought." Spencer's quote relates to my own profession in higher education. I find my profession very interesting and I tend to get excited about sharing information with students. Because I want to include so much, it can be difficult to stay on one track. We can be interested in, or involved in, many things at one time. Therefore, what one omits from a speech can be every bit as important or effective as what one includes in a speech. Organization is of utmost importance.

Organization of a speech has much in common with many other activities in which we participate in the real world. Despite what you might think as a student, the primary problem is in limiting what one says. Time limits are very important in public speaking, as they are in radio and TV and in so many other settings. Although many students find this difficult to believe, most public speakers are more concerned about not getting enough time to speak.

There is a humorous story about time limits and the late Minnesota Demmocratic senator Hubert Humphrey. Humphrey, who also served as mayor of Minneapolis, as vice president under Lyndon Johnson, and later ran unsuccessfully for president, was notorious for his long–windedness and was frequently teased about it. It is said that when he was once limited to three minutes of speech time at a banquet, he reportedly protested that he couldn't clear his throat in that period of time (Boller, 1991, p. 102).

Depending on the occasion, speeches can range from a few minutes to several days. College instructors can lecture for 50 to 75 or more minutes at a time. Some professionals speak at seminars that last for days. It all depends on the situation. It is estimated that after–dinner speeches or talks, which will be examined in Chapter 11, frequently go from 20 to 30 minutes, which is about the same as executive speeches that are typically about 20 minutes in duration. If you are a parent at a school meeting or a citizen speaking before the city council, you will probably be given a finite amount of time to speak.

Indeed, it is far easier to drone on and on than it is to compact the information in a brief and meaningful presentation. Such a phenomenon has much in common with C. Northcote Parkinson's (1957) eponymous "Parkinson's Law," which states: "Work expands so as to fill the time available for its completion" (p. 2). He expounded: "The thing to be done swells in importance and complexity in a direct ratio with the time to be spent" (p. 2). No matter the situation, you as speaker must be prepared and organized to get your point(s) across effectively. Also keep in mind that very few people ever complain about a speaker ending early. More people dislike speeches that run over the limit. At that point, the speaker might as well stop because he/she has already lost the audience's focus.

Organization of a speech's structure is much easier to understand when it is compared to something with which the student is already familiar. A good example is writing an essay. Outlines for both speeches and essays are very similar. If you can succeed at one, you can succeed at both. However, it should be noted that despite the similarities, speeches and essays are two different things. As we will see in Chapter 8, saying words out loud to an audience is far different from having someone read an essay. Unfortunately, there are some people who agree with that inaccurate assumption that a speech is just an essay that one reads aloud or presents from memory to an audience. Such a comment severely cheapens both the communication and English disciplines. Nonetheless, the commonalities lie in the fact that a speech (like a research paper or a well–written letter or responses to an essay exam) is a

voyage with a purpose. If the voyage is to be successful, then it must be charted. As with voyages, the person who starts out nowhere with his/her speech usually gets there. A public speaker must prepare ahead of time. Their thoughts are not only organized, but are typically reorganized many times before presentation. Successful speakers research their topics. As they do, they take notes and then formulate an outline. As the speech nears completion, the speaker practices the speech aloud—either alone, or to friends or family. During that phase of preparation, the speaker will discover how well the speech flows and whether adjustments need to be made. With rare exception, you should not write a speech. Baker (1928) observed: "One of America's most popular lecturers was once asked how long it took him to write his lecture. He replied, 'A lecture worth giving was never written; it just grew'" (p. viii). Indeed, speechmaking is a process that begins with a single thought or idea and then grows and develops.

Basic Organizational Patterns of Speeches

Organization of a speech, or most anything else for that matter, is not as mysterious as it seems. Basically, the organization of a speech is very simple and there are some established patterns that can be employed. In outline form, the body might look something like this:

II. Body
 A. Point One
 1. Supporting Material 1
 2. Supporting Material 2
 B. Point Two
 1. Supporting Material 1
 2. Supporting Material 2
 3. Supporting Material 3
 C. Etc.

The effective speaker will use appropriate transitions to get from one point to the other, from the introduction to the body, and from the body to the conclusion.

There are several patterns that one can use to organize and outline ideas into a coherent and interesting speech. The speaker's topic or subject matter will typically dictate which organizational pattern will be the most appropriate. Be sure that the pattern of choice is a simple and logical one that can best

relate the central idea to the audience. In other words, the best option is the one that is most audience–centered, as we discussed in Chapter 4. Depending on the pattern chosen, the body can contain two, three, four, or five major points, or parts. Some of these patterns can be used simultaneously, as will be pointed out during the discussion of each. Furthermore, different patterns may be used in different parts of the same speech. The introduction may follow a spatial pattern, but the main points might be arranged chronologically. There are several established organizational patterns and some are used more frequently than others. Among the more widely used patterns are *chronological* (time), *spatial* (space), *process* (example), *topical* (categorical), *causal* (cause–effect or effect–cause), and *problem–solution* (need–remedy or disease–remedy). Other useful patterns are *ascending or descending order* (most to least important or least to most important), *elimination* (method of residues), *journalistic* (five Ws and the H), *deductive order*, *inductive order*, and *motivational* (action response).

The Chronological Pattern

Speeches arranged chronologically follow a timeline. Chronology can be first, second, and third; yesterday, today, and tomorrow; past, present, and future; the 1970s, 1980s, and 1990s; the 18ᵗʰ, 19ᵗʰ, and 20ᵗʰ centuries; and so forth. It can proceed either forward or backward in time. The speaker can refer to what we did, what we are doing, and what we will do. If we were baking a cake, we would first need a recipe. Then, we would acquire the ingredients, mix them together, and then bake the cake. In other words, the chronological order may be a series of events or circumstances or it could be a series of steps in a process.

At first glance, the chronological or time pattern would seem better suited for informative speeches rather than for persuasive ones. However, history has given us an excellent example of the chronological pattern used as persuasion. After the Japanese attack on Pearl Harbor, Hawaii, on December 7, 1941, President Franklin D. Roosevelt responded on December 8 with his "Declaration of War Speech," in which he asked Congress to declare war on Japan. Roosevelt opened his speech by telling what happened: "Yesterday, December 7, 1941—a date which will live in infamy—the United States of America was suddenly and deliberately attacked by naval and air forces of the Empire of Japan" (Rauch, 1957, p. 300). Roosevelt then mentioned that the attacks occurred despite ongoing efforts by the U.S. to negotiate with

Japan. During the negotiations, the Japanese were actively planning the attacks on Hawaii: "Indeed, one hour after Japanese air squadrons had commenced bombing in the American Island of Oahu, the Japanese Ambassador to the United States and his colleague delivered to our Secretary of State a formal reply to a recent American message" (p. 300). And, he added, there was "no threat or hint of war or of armed attack" (p. 300). Roosevelt then proceeded to tell of other attacks on the night of December 7 on other targets such as Malaya, Hong Kong, Guam, the Philippine Islands, Wake Island, and Midway Island. He added: "Japan has, therefore, undertaken a surprise offensive extending throughout the Pacific area" (p. 301). Then, Roosevelt shared his vision of the future: "With confidence in our armed forces—with the unbounding determination of our people—we will gain the inevitable triumph—so help us God" (p. 301). He concluded his speech by referring back to the previous day: "I ask that the Congress declare that since the unprovoked and dastardly attack by Japan on Sunday, December seventh, 1941, a state of war has existed between the United States and the Japanese Empire" (p. 301). (Roosevelt's speech is also known as a declaration speech, which is a form of occasional speech. We will discuss declaration speeches and other occasional speeches in Chapter 11.)

The Spatial Pattern

The spatial pattern, or space pattern, is one that follows a directional pattern or physical placement. That is, the main points move from top to bottom, from left to right, from front to back, from inside to outside, from east to west, or may take some alternate direction. The spatial pattern would normally be enhanced through the use of visual aids. Sometimes radio broadcasters, particularly during sporting events, will use spatial examples to let the listening audience visualize the game. A play–by–play person might say: "Smith is dribbling the ball up the court from left to right on your radio dial." Another example of the space pattern can be illustrated through the following central idea from a speech on bears: "The three main places that black bears sleep are in caves, ditches, or hollow trees."

Frequently, the spatial pattern can also be chronological. Let's refer back to President Roosevelt's "Declaration of War Speech." The president could have used a map to show the physical locations where the Japanese were attacking the Pacific installations at Hawaii, Malaya, Hong Kong, Guam, the Philippine Islands, and Wake Island. He could even show how the Japanese

were expected to attack California on the mainland U.S. By employing a map, the audience can better visualize the points being discussed. There are some who would call this an example of a geographical order or a geographical space pattern (Brody, 1998, p. 45). Nonetheless, it remains basically a spatial pattern.

The Process Pattern

Also known as the *example pattern*, the process pattern is useful when the speaker does a demonstration or how–to speech. The topic can be almost anything, such as how to change a tire, how to change oil in your car, how to repair drywall, how to bake a cake, how to make a scrapbook, how to write a check, how to carve a jack-o'-lantern, and so on. The speaker would use visual aids to explain to the audience in a step–by–step manner how something is, or should be, done. In a speech called "How to Carve a Jack–O'–Lantern," a student employed the process pattern as follows:

I. History of the Jack–O'–Lantern
 A. Celtic vegetable carving
 B. American pumpkin carving
II. Making the Jack–O'–Lantern
 A. Picking your pumpkin
 B. Painting or stenciling the pattern
 C. Carving
 1. Safety first
 2. Cutting the pumpkin
 a. Cutting the top
 b. Cleaning out the insides
 c. Cutting the face
 D. Lighting the Jack–O'–Lantern
III. What to do after Halloween
 A. For carved pumpkins
 B. For painted pumpkins

As you can probably tell, the pattern followed by the process speech is not unlike a set of instructions that would inform the audience members how to set up their new electronic devices. If one follows the instructions, then the process can go much more smoothly. Otherwise, the speech (or process) has

a tendency to become erratic at best or even to fall apart completely. Be sure to relate each step clearly to the audience.

The Topical Pattern

Speeches that are not in chronological or spatial order usually fall into a topical or categorical order. Topical order results when you divide the speech into *subtopics*, or parts that add up to a whole. Each part becomes a main point in the speech. When you use the parts to the whole method you are simply dividing your main idea into several subtopics. An example that uses a topical method of arrangement is found in the body of an abstract definition speech on the word "beauty." Note the three types, or categories, under which beauty can be discussed:

II. Three Types of Beauty
 A. The first type is natural beauty.
 B. The second type is human beauty.
 C. The last type is unnatural or manmade beauty.

There are several variations of the topical pattern that can be employed. Some of these include the *causal pattern*, the *problem–solution pattern*, the *cause–problem–solution pattern*, and the *ascending or descending pattern*.

The *causal pattern* is one in which you put your speech in cause–effect or effect–cause order. You would then have two main points. Depending on your topic, you can either devote your first main point to the causes and the second to the effects, or you can deal first with the effects and then with the causes. Obviously, this pattern shares a common element with the chronological pattern in that one thing in time would lead to another. In other words, *this* caused *that* to happen. A central idea statement about smoking and its relation to disease might read as: "Smoking for a long period of time has been shown to lead to both cancer and emphysema." This particular example shows why the causal pattern is also known as the *need–remedy* or *disease–remedy* pattern.

The *problem–solution pattern*, like the causal pattern, is another form of the topical pattern. It is divided into two main parts or points. In a sense, the problem–solution pattern takes up at the stage of the second point in the causal pattern: "Cancer and emphysema can only be stopped by getting smokers to kick the habit." The first part acknowledges the problem and the second part offers a solution to that problem. If one so desired, the previous

two patterns could be expanded to a three–stage topical pattern of *cause–problem–solution*. For instance, "Smoking for a long period of time can cause cancer or emphysema and the only way to solve the problem is to get smokers to quit."

As a variation on the topical pattern, you can employ an *ascending or descending pattern* by arranging your main points from most–to–least–important or least–to–most–important. It all depends on whether you want to begin with the strongest point or the weakest point. One point would naturally build upon the other and would culminate with the most important or least important point. A contemporary example of the ascending order is David Letterman's "Top Ten List." Letterman strives to make each point funnier than the one that preceded it. Another example of building (or ascending) to a climax is a weekly musical countdown show on radio. The descending order is exemplified by the evening TV news, where "We begin tonight's news with today's top story." The newscast then moves on to stories of decreasing importance. Many times, the entire newscast ends with a story that is pure fluff. The descending pattern is also used in the newspaper and in each individual news story, as we will discuss under the *journalistic questions pattern*. The ascending and descending pattern may be used for either informative or persuasive speeches. It could even be used for an occasional speech, such as at a celebrity roast. The speaker might try to build up to a big climax by moving through a series of setup jokes.

Other topical arrangements include *equipment–use*, *theory–practice*, *general–specific* or *specific–general*, *question–answer*, and *compare–contrast* (analogy). A good example of the equipment–use pattern is found in my lectures to a television production class. First, I tell them about the equipment and then I go about teaching them how to utilize the equipment. I do the same thing in public speaking class when I discuss equipment used in presentations requiring audio/visuals. A student speech demonstrating how to repair a flat tire used a similar pattern, but also incorporated chronological order. This same example can be used for a *theory–practice* pattern:

II. Tools required and steps in changing a tire
 A. How to pull over properly
 1. Come to a stop slowly
 2. Make sure you are on level land
 3. Put the car in park
 4. Block tire diagonal from flat tire

 B. Locate tools in the vehicle
 1. Lug wrench
 2. Spare tire
 3. Jack
 C. Loosen lugs and jack up car
 1. Remove the lugs and then the tire
 2. Replace with spare tire and lower car
 3. Tighten lug

A *general–specific* or *specific–general* pattern is exemplified in a speech on "The Evolution of Punk Rock and the Only Band that Matters." The first part of the body is devoted to clearing up misconceptions about "punk rock" and the second part uses a group called The Clash as representative of punk rock's history. In the body, the student related the origin and history of punk rock, such as when the descriptor "punk" was first used in reference to music and when the first wave of punk rock bands started to emerge. Then, she examined the "punk rock attitude." Finally, the speaker moved into a specific exploration of The Clash, which was one of the early punk bands. Specifically, the student looked at the members of the band, their recording history, and their eventual demise. Conversely, a *specific–general* pattern may have started out with The Clash and then moved into a history of punk rock.

A *question–answer* pattern is just what it appears to be; the speaker asks a question and then answers it. A student at the University of Georgia located in Athens used an example of such a pattern. Many college towns have stories and legends and Athens is no exception. One of the interesting stories is "The tree that owns itself." Some newcomers to the university have not heard the story, but others who have don't always know that much about it. So, a Georgia student explored the topic: "The tree that owns itself, or does it?" She began with the question: What is the tree that owns itself and is it fact or fiction? Then, in the body she asked and answered several questions used as her main points: Where is the tree located? Where did the tree come from? What is the "real" story? What are some other interesting facts about the tree?

Compare–contrast, or analogy, is something we'll also explore in Chapter 7 under supporting materials. It is also known as *association*. A *literal comparison* draws on commonalities between things that share physical attributes. On the other hand, *contrast* is used to show differences. A sales speech, which would be a form of persuasive speaking, might employ a com-

pare–contrast pattern. A really good example of comparing and contrasting can be seen many times a day on television. There is an ongoing battle between cable TV and satellite dish TV. Most of the time, the competitors focus on differences in cost, number of available local and premium channels, reliability of the transmission to one's home, etc. The objective of each side is to point out all the disadvantages of the other.

The Elimination Pattern

Also known as the *method of residues*, the elimination pattern does just what it says it does. The speaker mentions several solutions for a problem and then proceeds to eliminate the various alternatives until the speaker has just one left. Then, the speaker argues for the option that is left over. For example, a legislator might want his/her country to go to war with another. Rather than jump right into the suggestion of going to war, which is his/her goal, he/she would list other options. The options may include economic sanctions, boycotts, embargos, negotiations, etc., but the speaker would in turn reject each of the possibilities and then argue that war is the only alternative that will work. The method of residues is a variation on the problem–solution speech and the ascending/descending pattern could also be employed as the speaker lists the options. In other words, a list of possible solutions could begin with the worst alternative and then end with the alternative sought by the speaker.

The Journalistic Pattern

Who, what, when, where, why, and how, a.k.a. the 5 Ws and the H, can provide a good foundation—or *journalistic pattern*—around which a speech can be organized. However, the difference between a speech organizational pattern and a print journalism pattern is the way the 5 Ws and the H are arranged. In print journalism the entire story is summarized at the beginning in one sentence, called the summary lead, which sets the stage for the details or main points of the story: "Two people were killed in a two–vehicle accident this afternoon at the corner of Broad Street and Milledge Avenue after one of the cars ran a red light and rammed the other broadside."

Who: Two people
What: were killed in a two–vehicle accident
When: this afternoon
Where: at the corner of Broad Street and Milledge Avenue

Why: after one of the cars ran a red light
How: and rammed the other broadside.

The organizational pattern is known as the *inverted pyramid* style, in which the most important information is placed at the beginning of the story and the least important information is included toward the end. The reporter returns to each of the facts and supporting materials listed in the lead in order of descending importance. If the space in the newspaper is too limited, the editor may then cut the story from the bottom up. There is no conclusion in a print journalism story, which uses a pattern known as the inverted pyramid. Similarly, in a persuasive speech advocating the distribution of condoms in school, the important questions can be answered as follows:

Who: Teenagers in the United States
What: Many do not practice safe sex.
When: Immediately provide students the information on the risks of sex.
Where: Schools should provide condoms and teach the proper use of
 condoms.
Why: Abstinence–only programs do not work and simply handing
 out condoms will not work.
How: Parents can advocate for these programs and others can
 donate money to help fund programs.

However, the inverted pyramid is not a good order for a speech, so we need a better pattern to present that information in a speech. A better organizational pattern for speeches is found in radio and television journalism. The 5 Ws and the H are also used, but in a different manner of arrangement than employed by print journalism. Radio and television news stories, like speeches, have a beginning, middle, and end. A radio story, of course, does not have the advantage (or disadvantage as the case may be) of visual aids. A television news story, known as a package, does have visuals. TV news is about storytelling and good stories capture an audience's attention. Don Hewitt (2001), producer for more than 35 years of the ultra–successful and groundbreaking *60 Minutes*, said the formula for the program's success "is simple, and it's reduced to four words every kid in the world knows: Tell me a story. It's that easy" (p. 1). The same can be said of incorporating storytelling into a speech.

Deductive Order

Very simply put, the deductive order would begin with a series of general statements and then would proceed to more specific statements. Some would even call this pattern a *general to specific order*. The persuasive speaker would try to gain agreement from the listener on the general points, thus setting the stage for the speaker to present the specific proposition. If the persuader was selling tires, he/she would discuss features of tires that are important. Then, the person would eventually focus on the selling point that Brand X offers all those desired characteristics. There is another rather humorous example of deduction that may sound absurd, but it does illustrate the concept fairly well. "God is love. Love is blind. Ray Charles is blind. Therefore, Ray Charles is God."

Inductive Order

Inductive reasoning is almost the opposite of deductive reasoning. With induction, the speaker would begin with specifics and then move toward a general conclusion (*specific to general order*). Consider this sequence that considers solutions for gang–related problems:

1. Oxford has a youth basketball league that operates year round and a low incidence of gang–related activity.
2. Metamora has a youth basketball program that lasts the length of the public school year and gangs have decreased significantly.
3. Middletown averaged two gang fights a month for five years; started a youth basketball league two years ago; and then gang fights dropped to two per year.
4. If Brookville would start a youth basketball league, it makes sense that gang–related activities would slow down considerably.

Persuasive communication experts Erwin Bettinghaus and Michael Cody (1987) said an example such as the one above draws an *explicit* conclusion. In other words, the speaker drew the conclusion for the audience. Sometimes the speaker will allow the audience to draw its own conclusion, which would be described as *implicit*. However, Bettinghaus and Cody (1987) warned that there can be problems associated with the allowance of implicit conclusions:

> For example, a political speaker may refer to the poor record the incumbent has generated, but never say the incumbent should be turned out of office. Obviously, there is a

danger in using an implicit conclusion. The audience will probably draw a conclusion, but may *not* draw the conclusion intended by the speaker. In the case of the political speaker, the audience may decide not to vote for the person making the speech but for a third party. A conclusion was drawn, but not the one intended. (p. 143)

The authors suggest that a speaker use the implicit approach "only in those situations where the conclusion to be drawn is completely obvious to the audience" (p. 143).

The Motivational Pattern

The motivated pattern follows the psychological steps of gaining attention, establishing a need, satisfying the need, visualizing the results, and acting on the proposal. Alan H. Monroe developed the motivated sequence to describe a persuasive appeal that can be used in advertising or public speaking. Monroe (1945) stated: "If this sequence is kept in mind, the method of organizing a speech becomes comparatively simple" (p. 159). The five steps can be seen in the progression of a student's speech to convince audience members to become organ donors.

I. **Attention**: Every day there is a growing need for organ donors.
II. **Need**: People all around the world are in need of organ transplants.
III. **Satisfaction**: Organ Donation benefits the recipient as well as the donor's family.
IV. **Visualization**: What if the tables were turned, and you were the one who needed an organ transplant?
V. **Action**: Fill out a donor card.

The Outline

Throughout this book, several references have been made to outlining. Although there may be several variations to outlining, the best method may be the simplest and most straightforward. After deciding on an organizational pattern, an outline can be done. The outline is the foundation, blueprint, or skeleton of the presentation. Not surprisingly, there is a strong correlation between good outlines and good speeches. When the outline is set before the speaker, it is much easier to see how the speech will flow and to understand the relationship between the main points and the supporting materials. The outline can be easily converted to a series of note cards to aid the speaker in

delivering the speech extemporaneously (which will be explained in Chapter 8).

When outlining, be consistent. If you use phrases, known as *topical outlining*, then it is necessary to use phrases throughout. The primary drawback is that it is less detailed than an outline comprised of complete sentences. The *complete sentence outline* is just what it appears to be. If you use sentences, then use sentences throughout—especially for main headings. When you use either method, be sure to use a particular form for a heading and use that same form for subsequent entries for that heading. The topic and central idea statement you have chosen should determine the main points you select. The information that you are presenting to your audience must be organized in a way that makes sense to them and can be easily followed.

When outlining, there is no need to use the word "introduction" under Roman numeral I. By the use of the Roman numeral I, we know that it is your introduction. Rather, put your own word(s) in place of the word "introduction." To me, it is like the scene in the classic college movie *Animal House*. When the Delta pledges were sworn in, the leader asked the group to repeat after him: "I, *state your name*, pledge allegiance to the frat." Of course the recruits were supposed to say their own names, such as: "I, *Jim Morrison*, pledge allegiance to the frat." Instead, all the guys repeated: "I, *state your name*, pledge allegiance to the frat." "State your name" is like a blank space on a form where you are supposed to put your name. You don't write "name" beside your name. So, do not repeat the words "introduction," "body," "conclusion," "main point one," etc. Use your own words that reflect the nature of your speech. Also remember that in proper outlining, I needs II, A needs B, 1 needs 2, and a needs b. When you break a heading into subordinate headings, you must get at least two lower-level headings. If you have a single heading, it probably belonged with the previous major heading. A sample outline for a basic informative speech can be seen in Figure 6.1. Remember that the words used in the sample outline are to be replaced in your own outline by the words that fit your particular speech.

Many academics recommend that outlines take a somewhat different form as seen in Figure 6.2. You will note that the primary differences in the outlines found in Figure 6.1 and Figure 6.2 are in the lack of enumeration for the introduction, body, and conclusion, and the repetitive use of the Roman numerals and lettered headings. It really is not a major issue, as you will probably choose to employ the one that works best for your own objectives. No matter which format you choose to employ, remember the advice given

earlier: When outlining, be consistent. Outlining is very important in planning and organization. Without such a plan, the speech has little opportunity for success.

Figure 6.1.
FUNCTIONAL INFORMATION SPEECH OUTLINE
OPTION I

Title

I. Introduction
 A. Opening
 B. Orientation
 1. Significance of subject
 2. Relevance of subject
 3. Credibility of speaker
 C. Specific purpose statement
 D. Central Idea
 1. Overview of contextual system
 2. Overview of procedure or process
 3. Key prerequisite principles, facts, conditions
 4. Preview of sequential operations or physical events

II. Body
 A. First Main point
 1. Supporting material
 2. Supporting material
 B. Second Main point
 1. supporting material
 2. supporting material
 C. Third Main point
 1. supporting material
 2. supporting material
 3. supporting material

III. Conclusion
 A. Restatement of central idea
 B. Review of main points
 1. Main Point One
 2. Main Point Two
 3. Main Point Three
 C. Closing

Figure 6.2
FUNCTIONAL INFORMATION SPEECH OUTLINE
OPTION II

Title:
General Purpose:
Purpose Sentence:
Introduction
 I. Opening/Orientation
 A. Significance of subject
 B. Relevance of subject
 C. Credibility of speaker

 II. Central Idea
 A. Overview of contextual system
 B. Overview of procedure or process
 C. Key prerequisite principles, facts, and conditions
 D. Preview of sequential operations or physical events
Body
 I. First Main point
 A. Supporting material
 B. Supporting material
 II. Second Main point
 A. Supporting material
 B. Supporting material
 III. Third Main point
 A. Supporting material
 B. Supporting material
Conclusion
 I. Restatement of central idea
 II. Review of main points
 A. Main Point One
 B. Main Point Two
 C. Main Point Three
 III. Closing

Chapter 7
Gathering and Implementing Supporting Materials

Whether speeches are informative or persuasive, it does not matter much what speakers say if their assertions and opinions cannot be supported. Supporting materials vary and they can be grouped into several major categories. To be an effective communicator in the real world, one needs to develop skills for acquiring and using information. To acquire information, it is important for the effective communicator to conduct thorough and effective research. Many people, especially undergraduate students, do not like to hear the word research. It should not be that way, however, because research is an everyday component of life. Research comes in many shapes and forms, such as gathering information about a movie, a stereo system, a DVD player, a prospective mate, where you are going tonight, or what have you. No matter what is being researched, questions are asked and answers are gathered so that more informed decisions can be made.

Research

While research can be complicated, in many instances it can also be very simple. Sometimes it is more random and haphazard; sometimes it is more organized and systematic. Obviously, the more organized and systematic research is, the more likely it is to produce useful results. As a speaker, you can gather information for your speech in a number of ways, such as your own knowledge and experience, written sources, interviews, or electronic resources. Although speech materials can be acquired from a broad range of obvious places, there is no substitute for hard work when it comes to gathering information.

Speakers Can Look Within Themselves for Information

Without question, one's own knowledge and experience can be useful, but caution is advised. There is an old saying that "a little knowledge is dangerous." What that means is that no one knows everything and that sometimes we know just enough to create problems. For example, I remember one time that a student of mine who was from Nigeria proposed to give an informative

speech on her native country. I asked her what she would use for sources. Her reply was that as a citizen of the country she knew all about Nigeria, so she would not need to consult sources. At that point, I told her that she was treading on treacherous ground. When she did her presentation, she indeed could not answer numerous questions about Nigeria. I asked her fellow students how much they could tell us about their native cities, counties, states, or countries. Indeed, everyone discovered that one can be from somewhere without knowing much about the place. It certainly would have been beneficial for the student to gather some sources about her country and she might even have learned some interesting things that she did not know.

Many times I have had students get into similar situations because they were positive that they knew enough about a topic to give a speech. Even though I require a minimum number of sources for a speech, some students refuse to conduct sufficient research. On one occasion, a student gave a speech about how to bake a cake. I asked for her source list of supporting materials, that is, list of references, and she said she had none and that it would be silly to have sources for such a speech. My reply was not a simple one, as I used the situation to teach the entire class the importance of conducting research. First of all, in a college class a topic is not worthy of presentation for academic credit if there is nothing academic to it. Research is integral to academic pursuits. The student then wanted to know what kind of research could possibly have been done. Well, we can start simply by saying a cookbook. Certainly, there would be recipes for cake. Of course, she replied that she just happened to know about baking a cake and did not need a recipe. Again, why should we have such a speech in college? Let's use TV cooking shows as examples. As the chef prepares the dishes, he/she normally discusses why and how ingredients are chosen, how they blend together, etc. Sometimes the audience is told where the dish originated and how it evolved. Therefore, let's use cake as an example. Who invented cake? How did it come about? Somewhere in history, someone baked the first cake. Cakes are sweet, so why is salt in the recipe? The questions can go on and on. A student needs to have a curiosity and a desire to satisfy that curiosity. Research is the only way to satisfy that desire.

Personal Interviews and/or Correspondence Can Be Sources
As long as the person is a legitimate prospect for an interview about the topic, then go ahead and use that information. A student who gave a speech about an aspect of World War II interviewed her grandfather, who not only

was present for an army initiative but also was the commanding officer. She did her research and found a legitimate person to interview. Conversely, another student who interviewed his friends about partying on a football weekend came across to the audience as both uninformed and lazy. It was obvious that he had done little or no preparation for his speech.

Students who plan far enough in advance can write via e-mail or letter to organizations or individuals who have specialized information about the topic. One student wrote a letter to a company president to gather information about the organization's move from the Northeastern United States to the Southeast. He found that the company president was impressed with his initiative, and as a result, he generously provided plenty of invaluable information to the student. Nowadays, many people use e-mail and they might respond to you. Yet, it seems like an old-fashioned letter may garner more and better results, as it proves that the person is serious about his/her inquiry.

Effective Speakers Should Take Advantage of the Library

Despite the proliferation of electronic resources available, which we will discuss next, the library remains the ultimate place to gather information. Electronic sources may be altering the research landscape, but the best place to find materials and sources is still in our libraries. Although electronic sources may be cheaper and may require less space to house, there remains a wealth of information in libraries that cannot be found anywhere else. Walter Cronkite, legendary news anchor, observed: "Whatever the cost of our libraries, the price is cheap compared to that of an ignorant nation." Schedule a session with a librarian—either on your own or with other students. A very helpful librarian at our institution told my class, "Don't be afraid to ask a librarian for assistance and don't apologize. We get paid to help you and we enjoy our jobs."

Electronic Resources Can Be Good or Bad

Electronic resources were intentionally saved for last. Students have been spoiled by the ease at which they can find information through the *Internet* and the *World Wide Web* (WWW). Much of that information is reliable, but there is also a lot of inaccurate material in cyberspace. Realize that anyone can start a Web site and that the Web site might look really good and professional. However, appearance does not mean the site is intelligent, factual, or accurate. Disinformation is a major problem on the WWW. Just because

something might appear a million times on the Internet does not make it true. It is strongly advised that the accuracy and legitimacy of information gathered on the WWW be verified. One way to confirm information is to consult several reputable sources and to compare the findings. Should several legitimate sites offer similar answers, you can feel better about the results. Use common sense to determine what the more "legitimate" Web sites might be. Such a list might include CNN, Microsoft, CNet, WebMD, American Rhetoric, Dictionary.com, Whitehouse.gov, and so on. Most newspapers have Web sites, and even though they might have errors, they are normally corrected when detected.

Although trusted Web sites are likely to give a good starting point for general information, the library is valuable for more in–depth research. This is not a "how–to" on using the Internet and WWW. Indeed, as part of their library tours, today's librarians have become media specialists who can help researchers access legitimate sources via the computer. Some library collections are not available to the general public and a librarian can tell you how to gain access to a number of commercial and private databases.

Today's students have grown up with computers and probably know far more about them than most speech communication instructors or librarians could tell them. That assertion is supported by findings from a study released by the Kaiser Family Foundation (2005) that illustrate the multiple media savvy of today's 8 to 18 year olds. Those youngsters spend an average of 6 hours and 21 minutes per day using media, which is roughly 44.5 hours per week. Eighty–six percent of children live in homes with computers and 76 percent of all children's homes have Internet access. Twenty–eight percent of those young people spend 62 of those daily minutes on computers, which doesn't take into account computer time spent on schoolwork. In their bedrooms alone, 68 percent have TV, 54 percent have a DVD/VCR player, 49 percent have a video game player, and 31 percent have a computer. Interestingly, boys possess more of these media than do girls. If you are an exception to the findings of the Kaiser Family Foundation, in that you know little or nothing about computers by the time you get to college, then you should not expect to learn about them in the library or in a speech communication class. You should take an introductory computer course.

It is necessary to note that just because someone uses technology does not mean they know the terminology associated with that technology. Over the years I have had several radio–television majors with professional experience in the field who took my production classes. First of all, they may

have had experience with "hands–on" aspects but they don't know what things were called or why there were doing them. Yet, they thought they knew everything there was to know. Second, those students were more difficult to teach than were students who admitted a lack of knowledge about the topic. I have discovered a similar phenomenon in the general student population in regard to computer technology. Almost everyone knows how to use them, but they don't necessarily know what the terminology means. With that in mind, I feel obligated to include a few terms in this section of the chapter.

Let's begin with the Internet, which is indeed a proper noun and is capitalized. It is a large computer network connecting smaller computer networks. Your college has a network, my college has a network, and there are literally thousands of other small and large networks. Altogether they form the Internet. To gain access to the Internet, one needs an *Internet service provider (ISP)*. Most colleges and universities are providers, but many people use providers who are paid for their service. Although it has been around for years, the WWW remains the Internet's newest and easiest tool for accessing information. The WWW, or Web, projects information onto easy–to–read screens, which are called *pages*. One can click a graphic or an underlined name, fact, or concept and then be taken to another Web page with information about that subject. We can navigate, or surf, the WWW by using a program called a *browser*. To find information even more easily, we use *search engines*, which are programs used to access the information one needs. Sometimes it takes longer than one expects to connect to a Web site, and there are several factors that can cause that, such as the server being used, how far away the site is, and how fast one's modem is. Cable offers the fastest access to the Internet.

Regarding the Internet, *e–mail* is a word that can be used as a verb or a noun. As a verb, e–mail means to send an electronic message to an individual or individuals. As a noun, it is a message sent to an individual or individuals. The term is widely misused. We don't tell others to "Letter me" or "Mail me," yet it is common to hear others say "E–mail me." It could happen, but the process would probably be similar to Scotty beaming someone up on the original *Star Trek* TV series.

Categories of Supporting Materials

Once the information is gathered, it should be organized as subpoints under the main points. You do not have to use the same pattern for organizing subpoints that was used for the main points. It is advisable to use an order that makes the most sense for your objectives. Interestingly, the organization patterns in Chapter 6 can also be applied to subpoints. However, if you use the topical pattern for your major points, you are not obligated to use the same pattern for the subpoints under the major headings. An example is found in an informative speech defining the abstract word "truth":

II. Grasping Truth
 A. Theories of Truth
 1. Correspondence Theory
 2. Coherence Theory
 3. Consensus Theory
 B. Types of Truth
 1. Subjective vs. Objective
 2. Relative vs. Absolute
 3. Etymology of Truth and Falsity
 C. Truth Affecting Society
 1. Organizational
 2. Academic
 3. Religious

There are several categories of supporting materials that we will consider, such as *illustration and narration, association, explanation, statistics, expert power, quotation, definition, description, personal experience, reinforcement,* and *visual aids*. It is interesting to note that most, if not all, of these can overlap depending on how they are used by the speaker. For example, a definition could also include association, description could be used in conjunction with a visual aid; statistics can help explain something and to explain something might require statistics. There could be any number of combinations. It is important to understand that supporting materials are used to back up, or to prove, what the speaker is asserting. Most observers agree that proof is important to persuasion, but it is also important to informative speaking. Proof is provided in evidence, which is just another way of describing supporting materials. As I alluded at the beginning of the chapter, it doesn't matter what you say if you can't back it up. What is the point of giv-

ing a speech if the audience doesn't believe the speaker? As we examine these categories of supporting materials, it is also important to be mindful that supporting materials can be boring. The most effective materials are usually the most interesting, the most appropriate, and the most credible.

Illustration and Narration

Illustrations and *narration* are typically the most useful, effective, and versatile of all the supporting devices. An illustration can take the form of an example or a story and may be used to make something clear to the audience. Illustration is also another word for pictures, but in this case using words to help provide the listener with clear mental pictures of particular things or situations. An *example* is a typical sample selected to demonstrate the nature or character of all the others. Examples can be brief or detailed, factual, or hypothetical, and humorous or serious. Illustrations can also take the form of anecdotes, personal experiences, allegories, or parables. An *anecdote* is a short and entertaining, trivial but factual, piece of historical or biographical nature. Many times, an anecdote is a personal account of something that has occurred. *Allegory* has a symbolic meaning that may be hidden. *Parables* are allegorical and comparative. They are also short stories, but have a moral or religious dimension.

Association

Frequently, the best way someone can learn something new is to be able to make a comparison or association with something they already know. A *literal comparison* describes similarities between things that are physically alike, but we can also compare differences by using *contrast*—telling what something is by telling what it isn't. What does alligator taste like? Chicken. What does rattlesnake taste like? Chicken. What does chicken taste like? Well, if one has not tasted alligator or rattlesnake, then there can be no comparison made to chicken. So, the speaker might look to contrast, or to tell what something is by telling what it isn't.

One student gave an informative speech on a phenomenon called "BASE jumping." During her speech, she employed several forms of supporting materials to acquaint the audience with the procedure. BASE jumping is done from a building, antenna, span (bridge), or earth (cliff). Hence, you have the word BASE. She first defined it by comparing and contrasting it to skydiving. Obviously, skydiving is done from an aircraft. The student said that

while the airplane is 7,500 feet in the air and the jumper has 30 seconds to open the parachute, the BASE jump is from 500 feet and there are just 3 seconds to open the chute. In addition, BASE jumpers have no reserve chute and the landing area is much smaller than with skydiving.

Analogies and metaphors may also be helpful in supporting your point. *Analogies* are point–by–point comparisons between things. For example, "Environmentalists are like Scrooges when it comes to protecting national forests." *Metaphors*, also known as figures of speech, use a phrase normally associated with one thing to describe another unrelated subject. For example, when one has explored an issue long enough, he/she might say, "There's no need to beat a dead horse."

Explanation

An explanation is another way of making an idea clear or understandable. The speaker may answer questions by addressing who, what, when, where, why, how, and how much. Why does the sun rise in the morning and set in the evening? How does one repair a hole in the wall? How much effort does it take to reach one's ideal cholesterol level? Explanation can be accomplished by *demonstration, definition, description,* or *exposition*. Demonstration is the process of actually showing how to do something. Definition, of course, is used to understand the meaning of words (and we'll examine that later in this chapter). Description can be accomplished by explaining the appearance or other aspects of something. And, exposition involves relationships between things, facts, or ideas. Demonstration, definition, description, and exposition are also forms of speeches and there is a more detailed discussion about them in Chapter 9.

Statistics

As noted in Chapter 5, statistics can be effective in gaining attention in the introduction of your speech. However, statistics are more frequently employed as supporting materials and there are three main statistical averages that are frequently used: mean, mode, and median. Adding together all the elements and then dividing the total by the number of elements calculate the *mean*. In other words, if I have 20 students who take a test, I would add together the total points of all the grades and divide by 20. The grades would be added together as follows: 86, 90, 85, 83, 87, 84, 86, 86, 88, 83, 85, 87, 87, 83, 86, 91, 88, 81, 82, 85 = 1,713. The total figure of 1,713 is divided by

the total number of students who took the test (20), which results in an average, or *mean*, of 85.65. The *mode* is the score that appears most frequently in the grade distribution. Using that same sample of grades, the *mode* is 86 because it is the grade scored by the largest number of students. If each of the 20 scores was different, a mode would not even exist. The *median* is the score that represents the midpoint of all grades. In other words, half the scores are above the median and half are below the median. If there is an even number of test scores, as in this example of 20, the median is computed as the arithmetic mean of the middle two. In this example, the median score for the test is 86. If there is an odd number of data elements, such as 19 or 21, the median is a member of the data set. Using the 20 test scores for this example, the mean, mode, and median vary very little, but that is not always the case.

Unless statistics are both valid and reliable, they should not be used. It is said that Benjamin Disraeli (1804–1881), a skilled debater and first and only Jewish prime minister of England, once said: "There are three kinds of lies: lies, damned lies, and statistics" (Miner & Rawson, 2000, p. 434). Indeed, statistics can be valuable, but as Disraeli suggested, they also can be manipulated to support almost any assertion. For instance, a toothpaste manufacturer used to claim in commercials that three out of four dentists preferred their product. I always wondered how many dentists were queried. To give your statistics clout, you must *tell the audience where you obtained the statistics*. If your source was the American Dental Association, then that would have a major impact. If the source was Acme Toothpaste Company, the producer of the product, then the statistics are suspect. Further, why didn't the fourth dentist prefer the toothpaste? Some people might argue that they would not want to use a product that 25 percent of dentists would not recommend. In this case, you must *explain what your statistics mean*, because they don't speak for themselves and need to be interpreted and related to your listeners. Perhaps the American Dental Association says that no other toothpaste is recommended so highly. That would explain a lot and it would have the aforementioned clout.

Statistics are frequently boring and unintelligible to many who hear about them. My advice is to *use statistics sparingly*, because nothing puts an audience to sleep faster than a speech cluttered with numbers from beginning to end. Of course, sometimes it is helpful to *use statistics to quantify your points*. Depending on your case, the statistics can be used to your advantage. Another example is baseball. Major league players make millions of dollars

to hit the ball, but even the best have batting averages of just .300 or better. That means that the best batters hit the ball about 30 percent of the time. Looking at it another way, the .300 average batters fail in their objective 70 percent of the time.

If complicated statistics are employed, that is, those comprised of decimals and lots of numerals, then round them off. For instance, "1.3398542 million" can have the same meaning and sound better like this: "about 1.3 million" or "approximately one–and–a–third million." It is frequently helpful to develop visual aids to help clarify statistics for the audience. We will get into that later under "visual aids."

As a speaker in a classroom situation, you should plan ahead for your speech. One thing you can do is survey your fellow students and then compile the statistics for use in your speech. For instance, you may be planning a speech on some aspect of alcohol consumption. In such case, it might be appropriate to hand out a simple questionnaire several class sessions ahead of time. The questionnaire might ask if they drink, how much they drink, how frequently they drink, etc. The same approach can be applied to any number of topics and issues. Another major benefit is that you have already included your audience in your speech. As we discussed in Chapter 4, demographics and psychographics are very important in understanding the makeup of the audience. If you acquire information from them in advance, they might be more interested in hearing how you use that information that they supplied to you.

Expert Power

No one can know everything; so in a speech it can be very beneficial to offer the authenticity through the words or testimony of experts or authorities. It answers the question: Who says so? Such a person would possess *expert power*, which occurs when others recognize you as possessing some expertise or knowledge. If you are doing a speech on why someone would contemplate suicide, then employ expert knowledge from the research or accounts of a psychiatrist (Devito, 2004, p. 343). One who has expertise on a particular subject carries the weight of their education and experience. When supporting your point of view with the testimony of others, you can either quote them verbatim (see the next section on quotations) or paraphrase what they have said in your own words. That is up to you. However, there are two instances when it is better to quote directly than to paraphrase: (1) when the

person you are quoting has said it so well you cannot possibly say it better, and (2) when the testimony is controversial and you want your audience to hear it straight from the source. As a speaker, unlike in a court of law, you would not have someone come to testify but you can use their words if you make it clear that you are quoting or paraphrasing.

Quotations

Quotations are good supporting materials in introductions, bodies, or conclusions. They are used to gain attention, to support main points, or to wrap up speeches. You may recall the reference to "To be or not to be" under quotations as attention–getters in Chapter 5. Another example of using a quote as an attention–getter is found in a speech by Bernard Baruch to the United Nations on June 14, 1946. Baruch, a "self–made millionaire financier" who headed the U.S. War Industries Board in World War I, was directed by President Harry Truman to proffer the U.S. position on atomic energy (Safire, 2004, p. 710). Baruch stated, with the quote printed here in italics: "We are here to make a choice between *the quick and the dead*" (p. 711). From Acts 10:42 and 1 Peter 4:5, the reference was to a decision to be made between living and dying. For a reading of the entire speech, see Safire (2004, pp. 711–713).

Definition

In the previous discussion of quotations, you may have noticed the word "quick." Many audience members may not understand what the word means in regard to Baruch's use, so it may be helpful to tell what it means. In the aforementioned quote, quick means living. It would certainly help in understanding that quote to know the meaning. If in doubt, tell the audience what something means. They will appreciate it and will be better able to follow what you are saying. Indeed, defining is simply telling what a word means.

There are several important things to consider with definitions. Certainly, definitions can be literal or abstract and they can incorporate other supporting devices that you are reading about in this chapter. Some ways to define are by example, by association (comparing or contrasting), by explaining, or by detailing. Sometimes it is helpful to offer the origin of the word, its *etymology*, and how it may mean different things to different generations. When using definitions, be aware that some words have more than one definition and can mean different things to different audience members.

Don't be too complex in defining and be careful not to bore an audience with too many definitions. Merely inform the audience how you plan to use the word in your speech.

Description

Description can be similar to definition, but would not necessarily apply to words but to yourself, others, places, things, events, and even things that have occurred in history. In the example from earlier in this chapter, the student used association to compare and contrast, but she also told what it feels like to jump from a BASE, as she had done it several times. There are many examples of the use of description. For instance, what does it feel like to be a soldier in the Middle East? If you have been there, then you can use sensory perception, such as how it was hot and dry like an oven or how it felt to be shot at by the enemy. If you were not there yourself, then incorporate details through "expert power" testimony from a person who was there. You might even use quotes. In the BASE–jumping example, the student was her own "expert."

Personal Experience

Personal experience can be a wonderful supporting device if used properly. However, it must be related accurately or it will merely be hypothetical in nature. Throughout the book we have seen examples of student speeches that included personal experience. Some of those that effectively incorporated personal experiences were on drywall, artificial insemination of cattle, and BASE jumping. In each case, the respective student speaker had participated in the activities of which he/she spoke. Be aware, however, that personal experience can go only so far in supporting assertions. Speeches require much more support than "I know because I have done it".

Reinforcement or Themes

Some speeches are supported by reinforcement. In other words, the speaker may emphasize something by using repetition or reiteration of a particular theme. Repetition uses the same words or phrases and reiteration would put the same ideas or thoughts into different words. A famous example of repetition is found in the address made at the Lincoln Memorial during the civil rights movement by Martin Luther King, Jr. It is a speech that has become

known as the "I Have a Dream" speech because King repeatedly stated the words "I have a dream" eight times as a prologue to get his points across to the audience. However, six times he also used the phrase "Let freedom ring from...."

Reinforcement in a speech is very similar to reinforcement that is done in radio and television. Unlike print media (books, newspapers, magazines), in which one can go back and read something as many times as necessary, the spoken word is fleeting. The listener cannot go back and hear something again, so the speaker repeats it.

No matter whether a speech is informative or persuasive, reinforcement is typically incorporated. Look no further than the conclusion of a speech, in which the effective speaker summarizes what he/she has been saying. Indeed, that is the basic structure of the speech as we saw in Chapters 5 and 6: Tell them what you are going to do, do it, and then tell them what you just did.

Visual Aids

Visual aids are excellent supporting materials. As Tony Jeary (1997), an inspirational speaking expert, observed: "Good visual aids reinforce, clarify, and drive home points. They are indispensable for introducing or summarizing ideas, saving time, and helping the audience focus its attention" (p. 166). Most of the time, a speaker has a limited amount of time to deliver the message. If, as it is said, a picture is worth a thousand words, then imagine how many thousands of words you can add to a speech by using visual aids. What better way to add more to the message without exceeding the time limitations? In many situations and for many topics, visual aids may be the most effective supporting materials. Madison Avenue advertising agent Alan Koehler (1964) believed: "The single most memorable element in many a successful speech has been a visual aid" (p. 33). One must understand that we live in the age of the *vidiot*, which describes those people who demand a full audio/visual presentation to keep their attention. They require more than words to maintain their focus. Business communication authority Cheryl Hamilton (2008) added: "Effective visual aids are helpful to the business and professional speaker (especially the technical speaker) because they improve listener memory, speed comprehension and add interest, and add to speaker credibility" (p. 362).

Please be advised that if a visual does not contribute to the speech, then it should not be used at all. In other words, don't incorporate visuals unless they are truly *aids*. In fact, visuals should always be used as *aids* and should not be allowed to dominate the speech. When audio and visual media emerged, many people were enamored with the technological wizardry and innovation. The programming content early on was not as important as the magic. However, that soon changed and consumers became much more interested in the programming itself; they moved past the wonder of how words and pictures can travel invisibly through the air. Radio has no pictures that can be seen with one's eyes, so the words are left to tell the story. A child was once asked if he preferred television or radio. He replied, "Radio, because the pictures are better." Words can certainly paint a vivid picture in the mind's eye. For instance, a sports play–by–play announcer verbally paints the picture. Some would argue that baseball lost its luster when it became so widely available on TV. With television, less commentary is needed, but some in the TV business have never understood that concept. Don Hewitt (2001), the creator and producer of CBS' *60 Minutes*, said his program changed TV news forever by letting the pictures complement the words, not vice versa:

> Before *60 Minutes*...the accepted wisdom was that television writers put words to pictures. That's ass–backwards. What *60 Minutes* is going to do, I said, is put the pictures to the words. If we don't do it that way, all we're doing is writing captions. (p. 2)

Speechmaking has frequently been based on the same philosophy, but audio/visual innovations have caused some speeches to become dog and pony shows. Don't use visuals just to be using them. Most people enjoy seeing and hearing other people. As Mr. Hewitt said, we need to put the emphasis on the words, on what we have to say.

Visual aids should not be complicated, but should be relatively simple—even in this age of PowerPoint. Visual aids run the gamut from words (or text) to graphics to a combination of words and graphics. Visuals can be pictures, drawings, maps, tables, objects, etc. Pie charts, bar graphs, line graphs, flow charts, and diagrams can be effective depending on a given topic. In his TV sitcom *The Norm Show* (1999–2001), comedian Norm Macdonald extolled the virtues of pie charts. He said: "People like pie charts. Know why? Because people like pie." Visual aids can be almost anything, but they must

be practical to use in the context of the speaking situation and they must contribute to your presentation. The best student speech I ever heard was "how to artificially inseminate a cow." However, the student could not bring a cow to class, so other creative means had to be employed. The student made a cow from a cardboard box, which he had painted black and white like a Holstein. He fixed the side of the box so that he could flip open the front to show the diagrams he had made of the bovine beast's innards. He also made an opening at the end of the box through which he inserted his hand as he demonstrated how to perform the procedure. One time, in a speech about "The History of Pizza," one of my students made a pizza pie chart. He made a real pizza that showed, in slices, the most popular toppings. After the speech, the audience literally ate the visual aid.

There are other things to keep in mind when employing visual aids in a presentation. First of all, *make certain that the entire audience can see the visual aid* from both near and far distances. Second, *keep visual aids simple* by using them only for your main points and main ideas. And third, take caution in making visuals that *don't contradict your verbal message*. A good example is the news anchor introducing a story of the beauty queen while the graphic over his/her shoulder is of a pig. Karpf (2006) added:

> Although cinema is usually characterised [sic] as a visual medium, when face quarrels with voice the results can be disastrous. Films dubbed into another language, no matter how expertly, lose some essential synergy between body and sound. And when the dubbed voice belongs to a famous icon, the effect is almost always—at least to those familiar with the original—shockingly comic. (p. 11)

It is important to give the audience members an opportunity to absorb and comprehend your visuals, but *remember never to read the visuals to them*. It is important to *remove or hide each visual after you have finished explaining it*. You don't want the channel noise (interference) created by the audience paying more attention to the visual after you have finished with it.

When preparing visual aids, whether text or graphic, there are other things to keep in mind. Most importantly, don't make the audience strain to sort out your message. Pretty colors and "cool" graphics can be distracting to the audience member. Use appropriate colors to prevent both confusion and headaches for those who are viewing the presentation. Design experts Miles Kimball and Ann Hawkins (2008) explained: "To use color effectively in design, you must understand how people perceive color both physiologically and cognitively" (p. 248). Likewise, pay attention to your color contrasting.

Font selection should also be appropriate and consistent. Pay attention to your alignment and justification. Don't crowd a lot of material into one visual aid and don't crowd a lot of visuals into the presentation. Layout of each visual aid and/or series of visuals is of utmost importance, so don't underestimate its impact on the audience. Visuals that are easy to see and read lead to easier understanding, and better comprehension leads to a more effective message. It is important to understand that your visual aids are a reflection on you and your credibility as a speaker. If a speaker employs visual aids that are poorly made, then the audience will see the speaker as a poor one—and rightfully so. Much like the rest of a speech, visual aids should be well thought out and planned.

Although visuals are used primarily in the body of a speech, it is important to understand that visuals are not just for supporting your main points. They can sometimes be used in introductions to gain the attention of the audience. Whether used in the introduction or the body, visuals must be used effectively to reinforce or to help clarify your ideas for the audience. As mentioned in Chapter 3, visual aids can affect your interpersonal interaction with the audience and they can have an impact on the time it takes to give a speech. So, be sure to practice your speech while incorporating the visual aids.

There are many kinds of visual aids and some are better than others for use in speeches. The situation or context will have a lot to do with which ones may be employed. As we go through the various kinds of visual aids, observations will be made about their usefulness or effectiveness in certain contexts.

Types of Visual Aids

Computers. Computers are very useful and versatile for presenting a variety of visual aids. For one thing, it is easy to transport laptop computers and/or data from meeting to meeting, eliminating the need for other bulky supporting materials of the past. Further, many modern classrooms are equipped with computers, so most times the student needs only to bring along the software. It is also possible to e–mail the information to your own account and then access it once you are in the classroom.

Viewing the data on computer equipment is particularly easy to do and helpful to the audience when the speaking environment is equipped with proper viewing technology. If the room has a good projection system and a

large screen, the audience is more likely to accept the presentation. Of course, with smaller groups—for instance, in a conference room—a TV monitor might be sufficient for presentational purposes. However, the presenter should be aware that monitors can be too small and, depending on the lighting, can be difficult to see due to glare. Computer presentations can consist of slide shows, Web pages, moving images, both text and graphic images, etc. Perhaps the most popular and versatile computer program used is PowerPoint, which can provide a convergent presentation using a variety of the aforementioned tools.

There is little question that Microsoft's PowerPoint can be a powerful visual aid, but its use as a visual device in public communication and elsewhere has come under fire in recent times. One of the reasons for the emergence of programs such as PowerPoint was the dawn of the visual age. If you have seen or used PowerPoint, you know that it basically incorporates a series of slides and even moving images that are projected onto a screen. Old–fashioned slides, seen through the slide projector, make good visual aids. However, the technology has become very dated—if not almost obsolete. Slides, like other presentations requiring projectors, are good for large audiences. A disadvantage of slides is that they are best viewed in dark rooms, meaning that there is little eye communication between the presenter and the audience. You probably won't have much occasion to use a slide projector and will probably use a computer for such images.

As with anything else, if you don't know how to use PowerPoint, then don't try to use it in your speeches just because other students may be using it. This isn't a competition. Visual aids may be required, but PowerPoint is but one type of visual aid. In fact, a student who did his demonstration speech on how to do an effective PowerPoint presentation achieved one of the better uses of PowerPoint as a visual aid.

Overhead Projectors. Overhead projectors, which may display transparencies or opaque documents, remain a highly effective visual presentation device. They can be used for small audiences or for relatively large audiences. They are easy to use, they are cost effective, and they can take on either a formal or informal look. A well–prepared presenter will prepare overheads even when he/she has planned to use PowerPoint. What if the computer technology fails or is not present for some reason? If the presenter has copied the PowerPoint slides to transparencies, then an overhead projector, document camera, or hard copy handouts can be employed.

I have seen many overhead transparencies used in speeches and some are more creative than others. One memorable example was used in a speech called "The History of Pirate Flags." The student made a master transparency with the image of a pirate ship that had a flagpole but no flag. On another transparency, she copied images of a number of pirate flags. She cut out each flag, which was about one square inch in size. As her speech progressed, she exchanged one pirate flag for another. You can get an idea of how it worked as you look at an outline of the body of the speech:

II. The History of Pirate Flags
 A. Where did the Jolly Roger flag come from?
 1. You may think of the typical skull and crossbones flag when you think of pirates.
 2. It was actually only flown by a pirate called Edward England.
 3. The Jolly Roger was meant to strike fear into the hearts of all that saw it.
 B. Where did the term Jolly Roger originate?
 1. It originated from the French term "jolie rouge."
 2. It came from the mispronunciation of Ali Rajah.
 3. The most logical origin of the term probably came from the nickname for the devil, "Old Roger."
 C. What did other pirate flags look like?
 1. Solid color flags were used to signify the intent of the attacking pirate ship.
 2. Symbols on flags were derived from tombstones.
 D. Bartholomew Roberts and Edward Teach had their own flags with personalized symbols.

The visual aids of the ship and various pirate flags were creative and they worked well to support the main points of the student's speech. If one gives some thought and consideration to it, visuals aids need not be complicated to be effective.

Digital Presenters or Document Cameras. Digital presenters or document cameras are kind of an offshoot of overhead projectors, but they are much more versatile. Basically, the document camera is attached to a small platform fitted with a camera and lights. The document camera can make use of transparencies, hard copies, or opaque objects that can fit onto the platform.

Even better, the camera head can be rotated to capture other images around the classroom, such as the class itself or a person who is speaking. Depending on your own particular setup, the captured image is then sent to a display device, such as a video projector or television monitor. Obviously, the type of display device will vary depending on audience and room size. Additionally, the image can also be saved or recorded to a computer, to the Internet, to DVD and /or videotape.

In a lecture on the history of the recording industry that I made to mass communication students, I referred to an early recording format called a wax cylinder. Wax cylinders were a predecessor to wax discs, or records. One of my colleagues owned a wax cylinder and allowed me to show it to the class of 300 students. Certainly, I would not pass around such a rare object, so the best solution was to display it using the aforementioned document camera.

Objects. Objects can make very good visual aids for some presentations, especially in speeches to demonstrate how to do something (instructional speech) or to show how something works. They can be large or small, but they need to be manageable. I once had a student who wanted to demonstrate how to make a dessert that was ice cream based. Unfortunately, his cooler did not keep the ice cream in a frozen state and his visual aid was a disaster. It so flummoxed him that he went way over the time limit and, in general, did not do a good job with the speech. On the other hand, one student used a poster board on which she had drawn a large mixing bowl. She had placed Velcro strips on the bowl. As she showed how to mix a cake, she attached small representations of the materials on the poster. For instance, she had a picture of a stick of margarine embossed with text stating ¼ cup for her measurement. She did the same for the flour, milk, sugar, etc. She had no mess or confusion, but she had the finished product that she let the students consume after her speech. Students indeed love food and will pay tremendous attention when they know they will be rewarded after the speech.

Visual aids are also effective in persuasive speaking. A good historical example of the use of an object occurred in post–Civil War America. Benjamin F. Butler of Massachusetts was elected to the House of Representatives. Butler, who had served as a Union general, was incensed by the organization of the Ku Klux Klan in 1866 and he introduced a bill to fight them. During one of his speeches, "he dramatically waved a bloodstained nightshirt, taken, he told the House, from the back of an Ohio–born white teacher in a Mississippi school for blacks, who had been kidnapped and brutally flogged by

Klansmen" (Boller, 1991, p. 88). From that point forward, "waving the bloody shirt" came to symbolize Republicans' ire toward Democrats (p. 88).

Poster Boards. Poster boards are also objects, and although they seem old fashioned, they are still quite useful and versatile. A poster can be large or small, but must be of a size that the entire audience can comfortably view. If your setting is equipped with a document camera, then you can make a smaller poster for display.

When preparing poster boards, there are some things to remember. For white or other light color poster paper, use dark ink that will offer the best contrast. Colors, such as pink, yellow, or orange, just don't offer enough contrast for easy viewing. No matter what visual aid you choose to employ, don't make the audience work hard to see and decipher it. If you hand print on the board, keep it to a few words and write neatly and legibly. And, don't make the poster too busy with many images and/or words.

Videotapes, Audiotapes, Compact Discs (CD), and Digital Video Discs (DVD). Videotapes, audiotapes, compact discs (CD), and digital video discs (DVD) are tricky devices to use as visual aids and should be used with caution. When the speaker understands how to employ them properly, they are most effective. I have seen both sides of the situation. In one informative speech about laser eye surgery, the student speaker was required to speak for four to six minutes. However, three minutes into the speech, she stopped talking and started a videotape. For the next three minutes, a huge eye appeared on the screen as a monotonic narrator technically described the procedure. The student then stopped the tape and stared blankly at the audience. As the instructor, I finally asked if there was to be more—such as a conclusion. There was none forthcoming. I told the student that her speech had lasted just three minutes, which was the same amount of time as the narrator's. Only half the speech was hers and she had failed to meet her obligations.

On the other hand, two different students asked about using video footage in informative speeches about snowboarding and wakeboarding. I cautioned them that any video would need to be used properly to be effective. In each case, the students used a few seconds of video to demonstrate certain moves used in the recreational activities. Both did so effectively. Audiovisual aids can have drawbacks when used improperly, but can be quite effective when used correctly.

Handouts. Handouts are sheets of paper or other materials given to members of the audience. The presenter can create handouts, which may take the form of outlines, copies of articles, photos, or a combination of text, graphics, and other visuals. Handouts are okay for small, informal groups but can nonetheless be distracting because the audience tends to read the handout instead of listening to the speaker. A good example is found in church bulletins that are handed out by ushers at the door. At one time or another, who hasn't missed what the speaker is saying because he/she is reading the bulletin? I have found myself reading the bulletin when the speaker or topic or both are uninteresting. Handouts can be useful in business settings, such as at board meetings or such, where the attendees may need hard copies to help them digest complicated information. As with all visual aids, handouts should not be a script of what the speaker is saying, but should be aids that contribute to or complement the presentation. The bottom line is that the speaker should use handouts judiciously and sparingly, if at all.

Chalkboards and Whiteboards. Chalkboards and whiteboards (non–electronic and electronic) allow the presenter to create visual aids as the speech progresses. Although an advantage of these visuals is flexibility, they are very informal and are too primitive for many settings and situations. Electronic whiteboards so far have found their primary appeal to be in K–12 classrooms. However, they are showing up in higher education and the business world. Electronic whiteboards offer several features. Copy/capture allows the presenter to capture and save notes digitally. A copy/camera arm can turn the whiteboard into a projection system, and copy/front–projection adds the ability to use PowerPoint.

Flip Charts. Flip charts are large sheets of paper attached at the top and held by an easel. They look like a large spiral notebook or a giant legal pad. The advantage of flip charts is that the presenter can produce the visuals ahead of time so that the pages can literally be flipped as the presentation progresses. Flip charts are useful for informal situations and for small group settings. For her informative speech, a student once demonstrated how to write a check. As a bank teller, she had noticed that many of her customers asked her to fill in their checks for them. Upon conducting research into the matter, she discovered that many other people ask tellers to write the checks for them. Her purpose was to teach the audience how to write a check and how to fill out a

deposit slip. As she did so, she also explained the numbers at the bottom of the check. For her visual aids, she brought a flip chart containing a drawing of a blank check on one page and a blank deposit slip on the other. As she explained the process, she filled in the proper words and numbers as one would do on a check. The visual looked much like the big ceremonial checks given to winners of golf tournaments. Of course, the visuals could also have been done on poster paper, a transparency, or an opaque paper. Nonetheless, the flip chart allowed her to cover the visuals between the uses of each.

You and/or Other Students or Audience Members. You and/or other students or audience members can be effective visual aids. The impact of a speaker's physical appearance will be discussed in Chapter 8. As mentioned there, a speaker can influence the message by his/her manner of dressing, the use of nonverbal gestures and movements, how he/she looks physically, etc. As a visual aid, you would certainly help yourself by dressing appropriately and by employing good personal hygiene. The late Michael K. Deaver, an advisor to President Ronald Reagan, was both praised and criticized for doing what any good communicator should do. Deaver focused as much on how President Reagan looked as he did on the words Reagan used (Daniel, 2007, p. D12). Some students have tried to become part of the visual experience by wearing clothing that may be appropriate to the topic of their speeches. If the topic is golf–related, then golfing attire could contribute. The same could be said for hunting, fishing, painting, crabbing, rowing, camping, or whatever the case might be. One of my students asked to be excused to go to the restroom immediately prior to his speech. Such a request is not unusual, as some students get nervous and just need to go. This case was different. When the student returned, he began a speech on "The History of Men's Underwear." I had never heard a speech on the topic, but it turned out to be very informative and interesting. As the student moved from his introduction into the body of the speech, he illustrated his points in a most unusual manner. He removed his pants to show his underwear. It turned out that he had gone to the restroom to put on about six pairs of underwear. As he removed one, he revealed another. No, he never removed everything! In actuality, I didn't know what to think. However, the presentation was informative, humorous, entertaining, interesting, and in good taste. The audience of his fellow students absolutely loved it.

There are so many ways to be your own visual aid, such as demonstrating sign language, sports, and other activities. Other students can also be asked to participate as visual aids. I have seen it done several times, as the speaker asks fellow students to help. Note that it is best if there is pre–planning so that the student is not caught by surprise—unless, of course, that is your intent. In a speech on card tricks, the speaker can ask another to pick a card. In a speech on "massage," the speaker can employ a fellow student to demonstrate how a massage is done. As with all other visual devices, be creative but be careful to make sure that the visual is appropriate.

The Best-Laid Plans

What do you do when something doesn't work? When it comes to having your visual aids ready for the speech, make sure that you have all the bases covered. Technology can be very tricky and sometimes things just don't work right or may not work at all. Planning is critical. First of all, be sure you know how to use the technology that is available in your setting. If you are not proficient in the use of the technological equipment in your class-room, don't try to use it at all. Even if the equipment is familiar, there may be some differences or quirks that can cause problems. Over my career in radio broadcasting, I worked for several different stations. Although all the equipment looks basically the same, there are differences. No professional communicator would try to go on the air at a different station without first becoming familiar with the technological setup and then practicing with it. The same can be said for almost any kind of technological equipment, so make sure in advance of your speaking time to know how to use it. Also, in a classroom situation, let the instructor know what you want to do. You will find that most instructors are very helpful. No matter what, always be armed with a backup plan:

Be sure to have printouts of your PowerPoint slides and even copy them to transparencies.

Make sure you have a backup disc in case the one you brought doesn't work.

If you bring your own laptop for the presentation, make certain that the settings are correct and compatible with the classroom equipment.

If you plan to show an Internet site in your presentation, make sure that there is ac-
cess to the Internet. If there is no access, then you might consider saving examples
to a disc.

These things may never happen to you, but chances are problems will crop
up if you do this long enough. As professional speaker Dave Paradi (2004)
advised: "We need to think about these and other problem situations, as
they'll likely occur at some point. It is better to be prepared than to find
yourself with a problem and realize you've never stopped to think of a
backup plan" (p. 42).

Chapter 8
Effective Delivery Style: Voice and Appearance

It is imperative for speakers to understand that "a speech is more than ideas" (Klepper & Gunther, 1994, p. 44). Indeed, a speech is "sound" and "performance" and "focusing on the ideas alone is like trying to sell a car without a paint job" because "the shimmer of the paint...attracts buyers as much as what's under the hood" (p. 44). The United States presidency is good place to look for examples in the effective use of sound and performance in speechmaking and communication. Michael Waldman (2000), a special assistant and chief speechwriter for Bill Clinton from 1992 to 1999, observed:

> Almost alone on the national stage, presidents commanded the bully pulpit. Their voices fit the media of the day: Roosevelt's tenor voice and measured cadences were perfect for radio. Kennedy's deft press conferences, vivid rhetoric, and glamour were perfect for an era when television was becoming more important, and photography was going color. Reagan's winking delivery of sound bites before beautiful backdrops fit a time when the evening news compressed political messages into small pieces. (p. 23)

Likewise, Bill Clinton, "determined to fill the role of the strong modern president," frequently referred in his speeches to Franklin Roosevelt, Thomas Jefferson, and Abraham Lincoln (p. 23).

Indeed, there are several factors that every speaker should consider regarding effective delivery of a speech. There are four methods or modes of delivery: *impromptu*, *read from a prepared manuscript*, *memorized*, and *extemporaneous*. The speaker must decide how the speech will be delivered verbally and nonverbally. Although the purpose here is not to emphasize voice and diction, there are some relatively simple things than can help in developing and/or improving one's personal vocal style. One's physical and nonverbal communication is extremely important in getting a message across in an effective manner. Hillbruner (1966) observed: "Certainly whether a speaker uses a manuscript, memorizes the speech verbatim, or speaks from notes, tells us something about him. It tells us something about the power of his memory, and it indicates his cursory or complete involvement in his ma-

terial and in his ideas" (p. 131). In other words, these "important factors of the speaker's psyche...relate to his speaking prowess" (p. 131).

In Chapter 1 of this book, some misconceptions about public speaking were addressed including an example of how numerous people view it as just getting up there in front of people and talking. Author Ralph Culp (1968) illustrated the misconception of that notion when he wrote: "A speech exists only in performance..." (p. 20). A speech, he opined, is not a speech unless it employs the principles of delivery: "Good speech performance obviously *begins* with your inventing and your arranging, and it is *further enhanced* by your style of phrasing" (pp. 20–21).

So to Speak: Methods of Delivery

Frequently, students in basic public speaking courses with anxieties believe that they need a safety net to overcome their problem of speaking before an audience. Therefore, many of them will resort to reading their speeches in an effort to get through the assignment and sit down. Obviously, that is not what public speaking is all about. I don't want someone reading to me, nor do most audience members want that. Small children like to have someone read them stories, but adults have moved far beyond that stage. Some ambitious students even try to memorize their speeches to give the impression that they are thoroughly prepared and so (they think) they are really doing a good job. Public speaking is a real world function and it is not about acting, so memorization is not the answer any more than is reading. Likewise, too many public speaking instructors believe that beginning students need to go through some sort of rite of passage by giving an unprepared, off–the–cuff speech— which is known as an impromptu presentation. The reasoning behind assigning impromptu speeches to beginning students is to somehow get them over the fear of speaking to an audience. Most of the time the strategy backfires as the student becomes even more scared than before.

Depending on the situation, one would present the information in impromptu form, read the speech, memorize it, or speak extemporaneously. The purpose here is to explain what each of these types of delivery is, and to identify some of the advantages and disadvantages of each. Each is designed for particular times and places, and upon reading the descriptions of each, one can understand which method is best for a given situation. Typically, the best method is to speak extemporaneously, as it is the form that combines the best elements of the other three methods of delivery.

Impromptu, Offhand, or Off–the–Cuff Speaking

An old anecdote has it that Daniel Webster was asked after an impromptu speech how one could become a skillful impromptu speaker. Webster allegedly responded that impromptu speeches don't exist. The puzzled inquisitor commented that the speech seemed impromptu. If it was not, he wondered, then how long did it take to prepare for it? Webster retorted: "About forty years" (Marsh, 1967, p. 15).

Impromptu speaking is the hardest speech of all. The best and most experienced impromptu speakers are those who know what to do without having much time to think about it. Lee Iacocca, retired Chrysler Corporation CEO, is one of those who believe in impromptu speaking as an exercise for learning how to think quickly. He recalled one of his beneficial experiences at a public speaking seminar. Iacocca stated: "…we had to talk off the cuff for two minutes about something we knew nothing about—such as Zen Buddhism, for example. You could start off by saying you didn't know what it was, but then you'd have to keep going—and pretty soon you'd find *something* to say. The point was to train you to think on your feet" (Iacocca & Novak, 1984, p. 53). Although Iacocca was not yet an accomplished public speaker, he was well into his career and had considerable experience on which he could rely.

Reading from a Prepared Manuscript

Typically, one would be better off not reading a speech. The presentation is boring to those in the audience who would just as soon read the manuscript themselves on their own time as have it read to them. Believe it or not, several times over my career I have heard faculty from the English department say, "Public speaking is just English standing up." Their point, which is very misguided, is that all one has to do is write a speech (essay), get up and read it before others, and then it is a "speech." Author Mark McCormack (1997) commented: "Reading a fully–scripted speech is not really 'public speaking'. It's more like 'reading in public,' which most people would consider impolite behavior" (p. 136).

There are times, however, when one has no choice but to read because it affords tremendous control over the speech's wording. Perhaps the speech is about a highly sensitive matter that needs to be conveyed exactly. However, there is little conversational quality and no spontaneity. One example would be an appearance before Congress to read an article into the record. For ex-

ample, on September 25, 2002, Richard M. Lewis, chief technology officer of Zenith Electronics Corporation, appeared before the House Committee on Energy and Commerce to read his "Prepared Witness Testimony" regarding the United States' transition from analog to digital television (DTV). Mr. Lewis and others responded to Chairman W.J. "Billy" Tauzin's call "to elicit discussion on what the Congress and the FCC can do to encourage a more orderly and timely successful transition to digital television" and "on the obstacles that have been identified as impediments to the transition" and suggestions "for solving the key problems that are central to the current logjam." Mr. Lewis responded by reading, in part:

> Together, industry and government have made significant progress, but more remains to be done. All parties need to step up and do their part to get the remaining issues resolved. A successful DTV transition is dependent on the adoption and implementation of a nationwide standard for sending DTV over cable. It is critically important that cable systems and DTV products be compatible. We must conclude the digital must carry debate, and copy protection issues must be settled. High–quality programming is absolutely required so that consumers receive value for their investment. I am confident that these issues can be addressed if we all work together, but we must act promptly. I commend you, Mr. Chairman, and the other Members of this Committee for your ongoing efforts to move the various industry sectors toward agreement on these matters. I will of course be glad to attempt to answer any questions you may have, and I thank you again for this opportunity to appear here today. (Congressional Budget Office, 2002)

Certainly, Mr. Lewis wanted to present an accurate assessment of his company's position, and reading was his only option.

Other than speeches before Congress, it is obvious that there are other times in the real world in which reading a script aloud is done on a regular basis. Courtroom testimony is frequently read, especially when something needs to be stated verbatim and without error. Another example of a written speech occurs when a football coach resigns or is fired. Most read prepared statements so that no mistakes are made. Some may plan to sue their former employer, so they don't want to risk slipping up. However, if you have ever heard someone read these statements, you know how monotonous they can be.

Interpretive reading can be a part of public speaking. A good example is President Franklin Roosevelt's "fireside chats" on radio. Roosevelt read a manuscript, but he had "the ability to command attention and interest, speaking to an audience as if 'they were just people in a room'" (Lowrey & John-

son, 1953, p. xii). President Abraham Lincoln also read his speeches. Donald T. Phillips (1992), author of *Lincoln on Leadership*, wrote that Lincoln's intelligence as a communicator led him to be careful with his words. He spent much time thinking and preparing his presidential address, including both of his inaugurals, the Gettysburg Address, and the last speech he ever gave. Lincoln read his speeches, but his delivery was impassioned in order to best get across his message (p. 151).

Politicians are not the only ones who read from prepared manuscripts. Radio and TV announcers regularly read copy, but as Roosevelt and Lincoln did, they try to make their presentation sound spontaneous—both verbally and nonverbally. On radio, the announcer is not seen, so does that mean nonverbal communication is not employed? Absolutely not! Effective radio announcers will use all the nonverbal communication that a TV commentator would. As a result, the listener can feel the naturalness of the speaker. Were the announcer to sit there all stiff and upright, even the most casual listener could detect that something was not right.

Memorization

Most people in the real world are not actors, so they would not have occasion to memorize a script. A memorized speech or presentation sounds canned and unnatural. Unless you have training and experience in memorizing long passages of text, the memorized mode is extremely difficult to accomplish. The speaker does not have notes, so extreme anxiety can set in if one gets off track. There is no one there to prompt the speaker and to get them back on task. Even actors have prompters, Teleprompters, and lines taped to props and other actors. As with reading, memorized speeches sound like they are memorized.

Extemporaneous Speaking

The most preferred method of speaking is the extemporaneous mode, because it combines the best elements of the other three forms of presentation. This form also helps the speaker avoid a major pitfall of reading or memorizing, which is losing one's place and struggling to re–find it. And, it is much better to plan and practice than to go into a speech cold, unplanned, and unprepared. In most course descriptions for basic public speaking courses, one will typically find that extemporaneous speaking is the primary objective. That is what effective public speakers do to communicate with the audience.

The mode of delivery is important, but a large problem is that students rarely learn how to present themselves and their material effectively. One can have the best prepared (i.e., written) speech in the world, but it won't mean much if the speaker cannot effectively get the message across in the actual presentation.

A major reason that extemporaneous speaking is preferred over other methods of delivery—particularly reading—is that it is imperative for a speaker to initiate and to continue to make eye contact (eye communication) with the audience. Without doing so, the speaker establishes little, if any, credibility with the audience. Who wants to listen to someone who won't look at him or her? Lack of eye communication certainly indicates a disinterest on the part of the speaker. Particularly in the United States, direct eye communication is considered an indication of the source's candor, confidence, and conscientiousness (Devito, 2004, p. 182). Eye communication, or eye contact, also serves another important purpose for public speakers. As you will recall from Chapter 2, feedback is an essential component of the communication process, as it enables the speaker to read and decode the audience's nonverbal communication.

To speak extemporaneously, *you should make notes on note cards*. Make sure that the note cards are for keeping you on track. In other words, each card should reflect the information contained on your outline. They are not there to tempt you to read them. Refer to the notes and then reestablish eye communication with the audience. Note cards allow you to emphasize your main points and they allow you to ad lib remarks about those points. Unlike with reading and memorization, the speaker is humanized. Print your cards, number them, and try to limit the content on each of them. Note cards are better than sheets of paper, because they are smaller and less distracting. Furthermore, the smaller cards don't limit your nonverbal communication, such as gesturing.

Practice the presentation as many times as you find necessary so that you can become very familiar both with the material and with any visual aids that you might employ. Then, present the speech so that it sounds fresh and spontaneous, but *do not memorize* it. If you are thoroughly prepared, then you know what you need to say. One of the more common comments that I make in critiquing student speeches is: "You know the material—just relax and tell us about it." In regard to critiquing, after each speech you should critique yourself. Analyze what you did so that you can correct mistakes in order to improve the next time you give a speech. On the positive side, you can also

take pride in what you did well. When I worked in broadcasting, I made it a daily practice to record my on–air performance. Every day I would study the recording to see what I did wrong and what I did correctly. It is amazing how much improvement one can make by doing such a simple thing.

Most speeches have time limits. Therefore, if the speech is three to five minutes, then shoot for four minutes each time you practice it. Should you go over or under four minutes, you would still exceed the minimum or finish under the maximum limit. As mentioned above, practice the entire speech including the use of visual aids, which can impact the timing of a speech. And don't forget what we discussed in Chapter 3. When you practice your speech enough it will help alleviate much of the anxiety you might otherwise experience.

In a Manner of Speaking: Your Speaking Voice

The vocal presentation of a speech is just as important as the method of de-livery. Although the voice and delivery work in concert together, they can also create barriers, as we learned in the communication process in Chapter 2. Like it or not, people judge you on the words you choose to use. The late Steve Allen (1986), original host of *The Tonight Show* on NBC, explained: "Not everyone is lucky enough to be wealthy. But no one need be impover-ished in language, nor need anyone be deprived of the distinction that comes from using words with strength and grace" (p. xiv). Without question, others judge you on how you say words. "Your most valuable asset as a speaker is your voice" (Baldoni, 2003, p. 111), and effective speakers will change their voice to emphasize the message. As we learned in our discussion of visual aids in Chapter 7, the right words can tell a story effectively. However, we can also add in this chapter on delivery that those words must be presented in an appropriate speaking voice. Allen (1986) added: "The first purpose of education is to enable a person to speak up and be understood. Incoherence is no virtue" (p. xiii). Cicely Berry (1973), a vocal delivery specialist, agreed. Berry stated that your "voice is the means by which, in everyday life, you communicate with other people" (p. 7). One's posture, movement, dress, and involuntary gestures can offer insights into your personality. Because the speaking voice conveys "your precise thoughts and feelings," the more re-sponsive and efficient the voice is, the more accurate it will be to your inten-tions (p. 7).

Many novice communicators try to sound like they think people expect them to sound. However, the effective communicator typically develops a personal style through trial, error, and experience. You are who you are—a unique individual and no one can be you as only you can be. Roger Ailes, chairman, CEO, and president of Fox News, observed: "The best communicators I've ever known never changed their style of delivery from one situation to another. They're the same whether they're delivering a speech, having an intimate conversation, or being interviewed on a TV talk show" (Ailes & Kraushar, 1988, p. 33).

As a beginning broadcaster, I tried to emulate those announcers who I admired. It took me a year or two, but I finally realized that I could never be like those people. I decided that I would make myself as professional as I could be, but that I would be *myself*. It took work, but I accomplished it. You don't have to be a broadcaster to be yourself. No matter what professional endeavor you choose, you should strive to be natural and to be yourself. Your goal should not be to mimic another person's voice or style. Improve your own voice and ultimately your own style, or individuality. Many experts believe, and rightfully so, that the speaker is the message. We will discuss that concept further in Chapter 10. However, it takes a lot of work and it can be a lengthy process. One's personal or individual style is the sum of several factors, such as *pitch*, *volume/loudness*, *pace/rate*, and *pronunciation/emphasis*. A good, clear speaking voice absent any annoying characteristics is important. The purpose here is to offer some information and advice, but not to be holistic in scope. If your institution has a course in voice and diction, then I recommend that no matter your major you consider taking it. It would certainly help you in most professional pursuits. In the meantime, we will cover some things that you can keep in mind should you want to improve your vocal delivery.

Pitch

Pitch is one's vocal frequency range and its limits can be stretched tremendously. Monotonic means one pitch. Karr (1953) defined pitch as "the relative height or depth of a tone. If we were talking in musical terms, pitch would refer to the position of a given note on the musical scale" (p. 394). Who has not been bored silly by a monotonic professor? You certainly don't want to be like that. Ordinarily, we use very little range in our voices, but simply adding only a note or two to both ends can greatly increase our over-

all speaking range. However, one should not overstretch the voice in either direction (high or low), or the result will be a ridiculous sounding voice. In the radio–television industry, many young, inexperienced announcers tend to become what we call "pukers." In other words, they overstretch their voice to the point that it sounds like they are throwing up. They are trying to sound like they think others sound, but the result is not natural and it is not particularly pleasing to hear. Just be yourself. As musician Willie Nelson observed: "Trying to be someone else is the hardest road there is" (Nelson & Pipkin, 2006, p. 3).

Loudness (Volume)

Loudness, or *volume*, is the dynamic level of your voice. As a speaker, you should always be sensitive to managing your own volume. A boring person is typically mono–dynamic, or one loudness. Loudness typically varies with a given situation, but one should ordinarily try to speak as though one person is listening within a range of a few feet. You should always remember that you are speaking to one person at a time. Each of these listeners is a person who is experiencing your communication one–to–one. If you ever find yourself in a situation that requires a microphone, don't alter your loudness. The microphone will do that for you. Remember to speak clearly, but speak as though everyone is within three to five feet of you. Sometimes, of course, there will be a large audience and no microphone. In such cases, remember to speak more forcefully.

You may recall the *Seinfeld* episode in which Kramer's girlfriend was a low–talker. She spoke so softly that no one could hear her, but everyone acted as though they did. At one point, Jerry did not realize that he had agreed to wear one of the low–talker's puffy shirt designs on NBC's *Today Show*. The point is that the low–talker was not doing her part to aid her polite listeners in the communication process.

Pace (Rate)

Pace, or *rate*, is the speed at which someone speaks, and an effective communicator will vary voice speed. Try not to talk too slow or too fast, but try to vary the speed as necessary in accomplishing your purpose. Note announcers like Paul Harvey on the radio who not only have distinctive voice quality, but a distinctive pace. Throughout my career in higher education, I have noticed the vast majority of students have pretty good pace when en-

gaged in conversation. However, students who are nervous tend to speak very rapidly during their speeches. It is as though it is a natural reaction to try and finish as quickly as possible. I have also encountered a few Eeyore (Winnie the Pooh's friend) types, who take so long to say something that you want to reach into their throats and pull the words out faster. As Karr (1953) observed: "Some voices are monotonous even in ordinary conversation. But this fault is most inexcusable among public speakers. An audience is practically defenseless against a boresome speaker. Courtesy demands that the long–suffering members of the audience sit and endure it. Of the many crimes committed in the name of public speech, certainly among the worst is the crime of being dull" (p. 352). Pace, like pitch and loudness, needs to be varied. Sometimes a *pause* works better than words in getting the message across.

Enunciation (or Articulation), Pronunciation, and Emphasis

Enunciation (or articulation), pronunciation, and emphasis are also part of the vocal process. Articulation, a.k.a. enunciation, is the study of "vowels, diphthongs, and consonants" (Crannell, 2000, p. 87). Pronunciation combines "vowels, diphthongs, and consonants to form words" (p. 87). In other words, enunciation focuses on individual components of a word, and pronunciation centers on the word as a whole. Emphasis occurs when one stresses certain words or sounds to make them more noticeable. It can also be known as stress. As movie character Austin Powers might say, the incorrect inflection occurs when you put the em–PHAS–is on the wrong syl–LAB–le. Even more importantly, always speak distinctly and be careful not to mumble, slur, or garble your words—especially in a speech. And, as mentioned above in the explanation of pace, sometimes a pause can help emphasize a point.

One shortcoming for many speakers is they fail to warm up, or loosen up, the muscles they will use when speaking. While most people think nothing of loosening up before running or playing a sport, they don't see the use of warming up muscles related to speaking. Most people are less articulate than they have to be merely because they are lazy and don't put forth the effort to enunciate and articulate. Open and close your mouth widely a few times; work the jaw muscles back and forth; press the tongue firmly against the top of the mouth several times; waggle the tongue up, down, to both sides, and in a circle; pucker and release several times; say some words

loudly and softly; and do whatever you can think of that might be related to these activities. Other than the vocalizing, most of the exercises can be done inconspicuously, but if necessary go out in the hallway or into a bathroom to do these things. It is probably enough to do them while walking or driving to the venue where the speech will be given. The bottom line is not to be lazy. Don't sound like your mouth is full of mush; open your mouth and consciously enunciate and articulate. Merely paying attention to how you talk can have a positive impact on the way you sound. You will find fewer people asking you to repeat yourself.

Pronunciation can be another thing altogether. If you are uncertain how a word should be pronounced, find out. If necessary, use an alternate word that you can pronounce correctly. When preparing your speech, an important detail to keep in mind is that written words are different from spoken words. Words on paper can come out very differently when spoken. Although a speech has much in common with an essay, for instance, there are some important differences. Sometimes, speakers and announcers find out during practice that there are some words that just don't roll out of their mouth properly. Try as they might, they always seem to stumble at that point. In this case, speech making can again be compared to radio and television. It is routine practice to use phonetic pronunciations—especially for names in the news. As with broadcasting, no one else will see your speech notes so spell out difficult words phonetically. Don't keep stumbling. Find a thesaurus and use a synonym that means the same thing, but one that you may say more easily.

Likewise, one can utter a variety of words or *vocal segregates* or *gap fillers* that are not typically found on paper, such as "ah," "um," "uh," "like," "so," "well," "you know," "then," "just," "and," etc. In the world of radio and television, professional communicators understand that written sentences—like difficult words—can be much more complex than sentences that are said aloud in a speech, commercial, news story, etc. In writing or planning for a verbal report, sentences should be short and simple. Broadcasters also know that some words need to be written out because they can look much different from the way they sound. For instance, $9.99 looks much shorter and simpler than the spoken nine dollars and ninety–nine cents. Don't use long words or extra words. Make economical use of words and don't use words—unless there are no alternatives—that need explanation. Employ language and style that are appropriate to the audience you are addressing at the moment and remember that one size does not fit all. The occasion also has an

impact on the spoken word—not only on the formality of language, but on the way you would dress. Jargon and slang can be used with some audiences but not with others. Incorrect grammar such as "ain't" is very seldom appropriate. There have been occasions when I have said "ain't" to emphasize something to a class, but I always quickly follow with: "I know that is grammatically incorrect, but it was the best way to emphasize my particular point."

Inflection

Effective communicators make use of all of the aforementioned voice techniques. Known as *inflection*, it is a combination of variations in emphasis, pace, dynamics, and pitch. Inflection is very useful in enhancing understanding by the receiver, which is the ultimate goal for a public speaker. As mentioned in the previous paragraph, open your mouth and speak out.

Conversational Quality

Conversational quality, which we discussed extensively in Chapter 1, is something that can be applied to public speaking. Although a speech may be formal, public speakers should try to sound conversational. A major difference between conversation and public speaking is that speakers invest a considerable amount of time and preparation for their speeches. When the speech is given, the speaker is normally physically separated from the audience and that separation can be either great or miniscule depending on the setting and formality of the speech. Allen (1986) recommended that those studying public speaking take the time to observe modern standup comedians. As opposed to the rapid or staccato delivery employed by comedians of earlier generations, these modern practitioners tend to be more conversational and can relate much more effectively to their audiences. Audiences appear to respond more favorably to speakers who *don't sound* like they are giving a speech and who don't seem to be using big words to talk down to them. The point is that "formal" need not mean stiff, stuffy, or snobby, which turn off more people than not. Karr (1953) listed several "desirable characteristics of the conversational voice" that can be adopted by the public speaker: friendliness, cheerfulness, animation (vitality), restfulness (not constantly aggressive), flexibility (adaptable from "seriousness" to "levity, from "formality" to "informality"), distinctness (clarity), and culture (refinement—"not overniceness, not prissyness, but culture") (pp. 489–491). Karr

also detailed "undesirable characteristics in the conversational voice: condescension, argumentativeness, lifelessness (lazy, listless), heaviness (somberness), and irritating tonal qualities (pp. 491–493). Certainly, public speakers would also need voices that "can be heard, a voice which carries conviction, a voice which suggests sincerity, a voice which does not irritate or antagonize hearers" (p. 7).

A good historical example of conviction and sincerity in the speaking voice can be found in John Quincy Adams, who was the sixth president of the United States (1825–1829) and son of President John Adams. John Quincy Adams returned to Congress after his presidency ended. Adams was known as an eloquent speaker and in 1810 he published a book entitled *Lectures on Rhetoric and Oratory*. The book comprised 36 lectures delivered by Adams, the first Boylston Professor of Rhetoric and Oratory at Harvard, to the classes of senior and junior sophisters at the university from June 1806 to July 1808. Although Adams (1962) wrote that eloquent speakers should not demonstrate emotion or "the passions" (p. 367) as he called it, his contemporaries said that he contradictorily "filled his speeches in the House with anger, sarcasm, indignation, outrage, and contempt" (Boller, 1991, p. 82). Although they disagreed with him, his opponents respected Adams and called him "Old Man Eloquent" (p. 83).

Ultimately, as has already been mentioned, we are judged by our voices. All speech is learned, and although we all learned how to talk from our environments, primarily from our families, we can improve. Many times, sports heroes go on to careers as commentators. However, some never make it because there voices are so unpleasant. An Olympic gymnastics champion, who shall remain nameless for obvious reasons, was all the rage a few years ago after overcoming tremendous pain to win the gold. However, we never heard from her after the games, in part, because during the requisite TV interviews her vocal qualities were irritating to many people.

Always attempt to speak clearly and properly in any conversation, but make certain you do so when you give a speech. Make sure you can say the words you intend to say and make certain to say them the way they are intended.

Physical Appearance

As discussed in Chapter 2, body communication (not body language) is very important. *Physical appearance* is body communication, and like the speak-

ing voice, it has a great impact on the degree of effectiveness achieved in public speaking or in any other communication situation, such as mass communication. People not only judge us by our words and how we sound, but they judge us by how we look and on how we conduct ourselves nonverbally. How we appear to others can be affected by neatness, clothing, posture, arms, hands, feet, head, standing or sitting, facial expression, gestures, movement, walking to/from the podium, etc. Broadcast announcing experts Carl Hausman, Philip Benoit, Fritz Messere, and Lewis O'Donnell (2004) believe that modern media communicators "must use more than good diction and appearance" (p. 14). Personality and physical presence are also important in demonstrating that a broadcast journalist "understands the story and is a trustworthy source of news, while communicating the story in a way that holds audience attention" (p. 14). In fact, as we learned about *perceptual accentuation* in Chapter 3, people who we like are always smarter, better looking, harder working, etc., than people we don't like. So, let your appearance help you with the audience as you walk to the podium. A person's delivery and appearance will have a positive or negative impact on an audience.

Once at the podium, one's nonverbal communication, especially gesturing, has an impact on a speaker's effectiveness in delivering a speech. As pointed out in Chapter 6, gesturing and other physical movements can be wonderful devices in transitioning or getting across a point. Unfortunately, gesturing can also be detrimental if the speaker is uncomfortable with it. Gesturing can be used to emphasize, to point, or to describe, but it should be synchronized with what is being said by the speaker. Emphasis of points may be shown through the open or closed hand or by pointing. Pointing is directed at persons, places, or objects. And, one might make a gesture in the air an attempt to draw something or to show the shape of something. Not only do novice speakers try to sound like a speaker, they also try to emulate physically how they think a speaker acts. Such gesturing can be awkward unless the speaker practices gesturing that looks natural. It is better not to gesture at all than to gesture inappropriately. Monica Wofford (2004), president of a speaking and training company, cautioned: "Be natural. You can only be you, and that adage is never more true than when you're speaking in front of a group" (90). The result is that the audience can tell that you are trying to act like someone other than yourself. Refer back to Chapter 2 and earlier in this chapter, where public speaking was related to conversation. Wofford (2004) suggests that you always "pay attention to your gestures and speaking patterns" (p. 90). The "real you" is a person who takes such nu-

ances to the podium. Wofford's recommendation is to employ "your own style of conversational speaking and movement" and to address "an audience as you would an individual, looking into their eyes and faces, not at their foreheads" (p. 90). By so doing, audience members are more apt to accept you and your message.

Good speakers can make almost any topic interesting and inspirational. One of the better student speeches I have heard was a demonstration (how–to) speech on repairing drywall. One of the worst and most boring was about how to assemble floral arrangements. Neither topic sounds particularly exciting for the average college student, but the difference was the styles of the speakers. The bottom line is, show some life when you speak and you will normally find an appreciative audience.

Visual aids, if they are employed, can also have an impact on your delivery. As recommended in Chapters 3 and 7, be sure that you are comfortable while simultaneously speaking and using visual aids. One way to become comfortable is to plan visual aids ahead of time and use them in practice as you expect to use them during the speech. It was also noted in Chapter 7 that the speaker could be his/her own visual aid. I once was asked to speak at a retirement ceremony for one of my former professors. I began by my speech by saying that I had struggled for days to come up with the right words for the occasion. In fact, I related that I hadn't known what to say right up to the time I arrived at the scene of the festivities. I told the audience: "When I shook Professor X's hand tonight, the words suddenly came to me." As I made the statement, I reached inside my coat pocket and pulled out some papers and started reading a very flattering list of accomplishments of Professor X. The crowd loved it, as they got my point—when I reached into my jacket—that I had accused Professor X of giving me the list when I shook his hand. As we discussed in Chapter 5, humor is a wonderful way to capture and keep an audience's attention. And, if the speaker looks like he/she is having a good time, the audience will tend to enjoy the presentation also.

As noted in Chapter 3, most people experience some form of anxiety or nervousness. Effective communicators keep that anxiety under control and try to remain calm by focusing on the message. Not everyone is going to be a fantastic speaker, but almost anyone can be an effective communicator. Taking the time to develop the delivery will allow you to enjoy your own presentations.

Chapter 9
Informative Speeches: The Foundation of Public Speaking

Informative speaking is the base of all speeches, as all speeches are designed to inform, even when they are occasional or persuasive. One of the major purposes in public speaking is to inform an audience through the use of facts about something that they might or might not already know. As we discussed in Chapter 4 and will revisit in Chapter 10, a fact is something that is true or real; it is a person, event, etc. that either exists or has occurred at some point in history. A fact is a piece of information that cannot be disputed easily.

As we also learned in Chapter 5, an informative speech requires a central idea statement or proposition. Although the speaker may enjoy the topic and may have extensive knowledge of it, he/she should present the information in a nonpartisan manner. The information is presented in order to share knowledge of a topic, to help the audience understand a topic, to explain how to do something, to explain how something works, to describe someone or something, and so on. It is very important that the speaker knows the topic well—presumably better than the audience will know it. Although it may seem obvious, the speaker must be able to present that material in a clear and interesting manner. As with persuasive speeches, which we will explore in the next chapter, the speaker needs to tell the audience members how to apply the information in their own lives. As the speaker, one needs to anticipate potential questions and try to cover that information in the speech. When formulating a speech, one further needs to make sure that the information to be presented will be sound, authoritative, creditable, factual, correct, appropriate, applicable, suitable, effective, and comprehensive. Upon finishing your speech, you do not want the audience asking, "So what?" In the introduction, body, and conclusion you need to tell them "what." As speakers, we want the audience to take something away from the speech. Don Hewitt (2001), producer of CBS–TV news program *60 Minutes*, said he looks for two audience reactions after the show airs: "I didn't know that," and "Wasn't that [topic] fascinating?" (p. 3). Speakers should seek similar responses from audiences.

Primary Categories for Informative Speeches

Informative speeches can typically be divided into four general categories: *description*, *demonstration*, *definition*, and *exposition*. In each kind of speech, the speaker seeks to impart knowledge to the audience and to give clarity to the topic. In fact, each of these words is a synonym for the other. The difference in the four kinds of speeches can be noted in what each "describes."

Description Speeches

Description speeches can be considered the base form of informative speaking, as demonstration, definition, and exposition speeches all "describe" something. Description is employed whenever a speech is given to introduce one's self or others; when speaking about a place; when informing about an event; or when teaching about historical events. As we will discover in Chapter 11, many description speeches are also *occasional speeches*—particularly those occasions calling for *sociality and courtesy* or for *commemoration*.

From Chapter 7 reference was made to a speech on "The History of Pirate Flags," which is a good example of a description speech. Other topics for description speeches might focus on the origins and histories of holidays such as Halloween, Easter, Christmas, Hanukkah, Valentine's Day, St. Patrick's Day, and Mardi Gras. Such topics are most interesting when the speaker reveals little known facts about those holidays, such as why and when they originated and how they evolved into what they are today. Others might describe topics as varied as religion, football, music, diseases, biological warfare, cockfighting, dreams, polygamy, sleep, turtles, snakes, superstitions, wine, doughnuts, sneakers, historical figures, presidents, founding fathers, civil rights activists, inventors, religious icons, and so on. Some examples of actual student description speeches are:

The Real Count Dracula
Vlad the Impaler
The Only Band That Matters: The Clash
The Radio City Rockettes
Mardi Gras Traditions
Toilet Paper: The Invention We Take for Granted
Where Did Halloween Originate?
Atlantis—The Lost Continent
Where Valentine's Day Came From

Origins and Evolution of the Kiss
Bhangra: Music and dance of the Punjabi
Just who were the Black Panthers?
Perfume's many unknowns
Discovering the "Unknown" about Facebook
History of Girl Scout Cookies
Iced Tea: A delicious mystery
The Masters: A prestigious golf tournament
The Evolution of Passenger Airplanes
George Crum: Inventor of the Potato Chip
Uncovering the Seven Wonders of the World
Semper Fidelis—Marine Corps History
The Nu–gen Project in Santa Gertrudis Cattle
The Week of Passover
Tabasco: More than just pepper sauce
The Sacred Ritual of the Circumcision

Here is an introduction outlined for a speech in which the speaker describes Mexico's "Día de los Muertos: Day of the Dead" that is similar to Halloween in the U.S.:

I. What is Day of the Dead?
 A. Halloween on October 31 is a celebrated holiday in America.
 1. The day has become controversial, as many Americans believe that it emphasizes evil too much.
 2. Many churches hold Fall Festivals on October 31 to protest the beliefs and traditions of Halloween.
 B. The purpose of the speech is to inform the class about a Latin American holiday similar to our Halloween.
 C. Day of the Dead is celebrated on the first two days of November in Mexico, and it combines the religious with the secular.
 D. In my speech, I will cover how the holiday originated and how Mexican families celebrate.

Demonstration Speeches

Demonstration speeches are commonly known as *how–to* speeches or *instructional speeches*. Some speech communication experts call them *speeches of process*. Literally, the speaker teaches the audience *how to do* something. Some speakers show audience members how to change a tire or how to change oil in an automobile. On the surface, those topics may seem

rather mundane and uninteresting to audience members. Good speakers, however, are able to make topics important to the audience. I once heard a speech about changing flat tires that was presented successfully to a prevalently female audience. The speaker was aware of the audience's demographics and pointed out the importance of why they should learn how to change a tire. One important point focused on safety. In particular, the speaker provided statistical evidence of how many people are harmed in such situations. For instance, one who relies on some "good Samaritan" to change their tire becomes vulnerable to robberies and rapes by that person who capitalizes on the flat tire as an opportunity to victimize them. Obviously, if one wants to avoid being a victim, and if there is no one to help, then the person would need to know how to change to the spare tire. After the audience was shown the reasons for understanding how to change a tire, the speaker proceeded through the steps necessary in solving the problem:

II. Tools, steps, precautions for changing a flat tire
 A. How to pull over properly.
 1. Come to a stop slowly
 2. Make sure you are on level land
 3. Put in park
 4. Block tire diagonal from flat tire
 5. Find tools
 a. Wrench
 b. Spare
 c. Jack
 B. How to loosen lugs and jack up car
 1. Remove the lugs and then the tire
 2. Replace with spare tire and lower car
 3. Tighten lugs
 C. Precautions for temporary use spare tires
 1. Drive at limited speed
 2. Use only to drive to service station

You might recall another example of a demonstration speech from Chapter 4, in which the speaker demonstrated how to repair drywall, a.k.a. sheetrock. The student used a basic chronological pattern employing steps. Here is an outline of the body:

II. Materials and procedures necessary to be successful
 A. Very few items and tools are necessary to fix drywall (also known as gypsum board)
 1. A utility knife ($1.96)
 2. Drywall screws ($2.50)
 3. Putty knives (3 for $0.88)
 4. Spackling Paste (1/2 pint for $2.97)
 5. Multi Purpose Sander ($1.98)
 6. Two 1" x 2" pieces of plywood ($0.88 per slab)
 7. Drywall (small pieces are free at most home improvement centers)
 8. Screwdriver (Electric Drill is helpful but wood can be bought with drywall holes)

 B. Steps to complete the job
 1. First, cut a piece of drywall in a rectangle or square large enough to cover hole
 a. Rectangle or square because these are easy to reproduce
 b. This simplifies the puttying process later
 2. Second, take the rectangular piece of drywall and trace it onto the wall
 3. Then, cut a hole the same size to fill the cut out
 4. Once you have a clean hole, drill the 1" x 2" inside of the drywall
 5. After you do this, place the drywall that you cut inside of the hole on the wood
 a. If it doesn't fit, you might have to use the utility knife to crop the edges
 b. Putty will hide the cracks
 6. If you have a drill, drill the rectangle in place
 7. Use a putty knife to spackle paste to uneven edges
 8. Allow this to dry (1 to 5 hours)
 9. Next, sand the excess paste to make the edges even
 10. Apply primer, use the proper paint color and allow drying

Topics for demonstration speeches are virtually limitless. Here are some examples of actual student demonstration speeches:

How to inseminate cattle artificially
How to become a Major League umpire
How to create a Super Bowl pool
How to turn grapes into wine
How to cure a hangover
How to carve a Jack–O–Lantern
How to hem a pair of pants
How to play guitar: A basic lesson
Eating healthy with a busy lifestyle
The Advent Wreath: What it means and how to make one
How to Apply to Graduate School
How to perform some simple Card Tricks
How to replace Guitar Strings
Proper hand washing

Definition Speeches

Definition speeches can be either *literal* or *abstract* in nature. Definition is a concise explanation or clarification of the meaning of words, phrases, or symbols. A literal definition is the explicit meaning of those words, phrases, or symbols. Some examples of actual student speeches of literal definition are:

Spontaneous Human Combustion: The Answer to a Burning Question
German Beer
What is noodling?
What punk rock really means
What are aphrodisiacs?
The scientific belief of Kabbalah
The Unlucky Number Thirteen
The true meaning of homeopathic medicine
Numerology: Numbers are More Than Just Math
What is Crowd–surfing?

Typically, most everyone would agree on the meaning of something that can be defined literally. If the instructor points to a table in the classroom, everyone would know what it is. However, if the instructor asks, "What is truth?" then the line has been crossed to abstract meaning. Certainly, there can be a literal definition of "truth," but the meaning can also be abstract. Not everyone would necessarily agree on the meaning of "truth." In Chapter 6 we looked at the body of a definition speech on "truth." To better under-

stand how one would define the word, let's take a look at the introduction for such a speech:

I. An Assortment of Truth Definitions
 A. Truth in a bottle: What are they selling?
 B. Varying Views of truth.
 1. Theories of truth.
 2. Different types of truth.
 3. Truth is apparent in our lives.
 C. Central Idea: Truth is defined individually by the way that we use the word in context.
 1. Categorical definition according to Webster.
 2. Beyond Webster: Theories and various types of truth.
 D. Preview: We can understand truth by exploring theories, by contrasting truths, and by examining truth in society.

Abstract words do not have tangible, physical referents and they cannot be seen as can a table in a classroom. A short list of other abstract words might include love, hate, heaven, hell, good, evil, peace, life, love, space, time, death, faith, fear, freedom, hope, beauty, and on and on and on. There are dictionary definitions of all these words where we can learn both literal and abstract definitions. We can also explore etymological definitions or word origins. In other words, where did the word originate and how has it evolved over time? There are operational definitions that would tell us how something works. As with any other kind of speech, we would use a wide array of supporting materials that were examined in Chapter 7. Those categories are: "illustration and narration," "association," "explanation," "statistics," "expert power," "quotation," "definition," "description," "personal experience," "reinforcement," and "visual aids," As we learned, some supporting materials can fall into more than one category. An example can be seen in the abstract word "faith." In a definition speech on the word "faith," one student used a "quotation" from the Bible that also could be considered "expert power" and "description."

> What is faith? It is the confident assurance that something we want is going to happen. It is the certainty that what we hope for is waiting for us, even though we cannot see it up ahead. Men of God in days of old were famous for their faith. By faith—by believing God—we know that the world and the stars—in fact, all

things—were made at God's command; and that they were all made from things that can't be seen. (Hebrews 11, 1–3)

When do we need to define words? Well, that would depend on the audience. A speaker and an audience, like anyone in a communication situation, can have much commonality in knowledge (*high–context communication situation*) or may share little knowledge (*low–context communication situation*). Basically, in a high–context communication situation, the speaker will have to explain less of what he/she means because all parties are familiar with the information. The information would come from familiarity with the speaker, the topic, the situation, etc. Everyone in the communication situation knows what the other means without having to explain much. A low–context communication situation makes communication more difficult, as the speaker has to spend considerable time explaining things to the audience—or putting things into context. Information that can be unsaid in a high–context situation needs to be said in a low–context situation.

Exposition Speeches

Exposition speeches, also known as *expository speeches*, offer explanations regarding concepts, processes, ideas, or beliefs. Explanation, like all the other forms of informational speaking, makes things clear or understandable, such as what this course is about, what classes you need to take, etc. Two basic rules should be remembered when contemplating an exposition speech: (1) The speaker must thoroughly understand something before he/she can explain it to someone else; (2) The speaker must use words that are clear and understandable to the audience.

Exposition speeches are used for analysis or to dissect a problem, a set of circumstances, a notion, an idea, or an occurrence. For example, one might break down "how founding father John Adams set up our checks and balances system of legislative, executive, and judicial branches." Although exposition speeches are used to instruct, they should not be confused with the how–to or demonstration speech. For example, a speech on "how emu meat is processed" is much different than a speech on "how to process emu meat." So, an exposition speech can be a *speech to instruct*, but would be used to explain concepts focused more on "why" and "how it works" rather than on "how to do" something. Some examples of speeches to instruct would be:

Why do we have middle names?
Reasons people become vegetarians
The process used to make wine
Biological Warfare: America's Hidden Battle
Polygamy in modern America
Attention Deficit Disorder and Attention Deficit Disorder with Hyperactivity
Iced Tea: A delicious mystery
Ninja: The fearsome assassin
What really happens when you sleep?
How a serial killer is made
Dealing with alcohol poisoning
Dangers of alcohol consumption
Aphrodisiacs: Fact or fiction?
What causes headaches?
Strange superstitions of athletes
Basic facts surrounding refugees, stateless persons, and internally displaced persons
The art of Middle Eastern dance
Scuba Diving: A History of Exploration
Some facts about squamata serpentes (snakes)
Economic impact of sports
The future of physicians: Problems with medical liability litigation.
Yoga: A great way to stay in shape

As one can surmise from the information in this chapter, informative speech topics and objectives can be almost limitless. Many topics come from the personal interests of the speakers. One speaker had previously suffered from a ruptured appendix and wondered why such a thing occurred. She researched the topic and gave a speech on it. Here are the outlined points in the body of the speech:

II. What is Appendicitis?
 A. What is the appendix?
 1. It is a small pouch off the large intestine.
 2. It has no functional use.
 3. Why is it in our bodies?
 B. What happens when the appendix ruptures?
 1. The appendix gets blocked.
 2. It fills with pus and bacteria.
 3. It becomes swollen and infected.
 C. What are the symptoms of appendicitis?
 1. Pain starts right below the navel and moves to the right side of

the belly.
2. Nausea, vomiting, and fever are other symptoms.
3. The area is very tender and painful.
D. What are the effects of a ruptured appendix?
1. Can be fatal because the infectious pus spreads inside the abdomen.
2. Peritonitis can develop—an infection of the entire lining of the abdomen and pelvis.
3. It necessitates a longer hospital stay for the purpose of receiving IV antibiotics every eight hours.
4. Bile collects in the stomach and can require stomach pumping.

In a speech called "The Agony of Alzheimer's," a speaker explained the progression of the disease. The speaker had become curious about the topic of Alzheimer's after a grandparent had been diagnosed with it. Here is an outline from the body of the speech:

II. Progression of Alzheimer's
A. Causes/Symptoms
1. Causes of the Disease
2. Seven Warning Signs
3. Basic Symptoms
B. Diagnosis/Treatment
1. Diagnosis Process—Four Steps
2. Alzheimer's Brain vs. Normal Elderly Brain
3. Methods of Treatment
C. Late Stages/Coping
1. Lifestyle Limitations
2. Life Expectancy
3. Effects on Family and Caretaker

No matter whether your overall objective is *description, demonstration, definition,* and *exposition,* the informative speaker needs to tell the audience members how to apply the information in their own lives. In Chapter 10, we will continue our examination of the different kinds of speeches as we move to persuasion. Persuasive speeches share much commonality with informa-

tive speeches, but they go a step further by attempting to convince, to rein-
force, or to actuate.

Chapter 10
Persuasive Speeches: Engineering Consent

It is important that we understand persuasion for two very basic reasons. First, we need to learn how to persuade effectively to meet our own objectives. As William Turner (1985), author of *Secrets of Personal Persuasion*, proclaimed: "The power to persuade is the power to succeed" (p. ix). Karl Anatol (1981), a persuasive communication authority, added: "In order to influence, we have to persuade. Sometimes, we persuade informally, as in the solicitations we make of our friends and family; at other times, we persuade formally—when we present our appeals to school boards, courts, religious congregations, legislatures, and so on" (p. 1). Second, we need to understand persuasion so that we can understand the persuasive tactics that others use on us. Author Vance Packard (1957) called them "hidden persuaders" because "typically these efforts take place beneath our level of awareness; so that the appeals which move us are often, in a sense, 'hidden'" (p. 1). There are indeed pitfalls attached to persuasion when unethical or unscrupulous people use it. We can look back at our discussion of ethics in Chapter 2 to get an idea of how some people eschew ethics in their communication practices. Hitler was mentioned as an example of someone who was a great persuasive speaker, but he used his persuasive talents to accomplish evil. Persuasive speech experts W.F. Strong and John A. Cook (1987) observed:

> At this moment, someone well over 18 is being swindled out of thousands of dollars because of a manipulative and unscrupulous sales representative. The person being swindled does not know how to recognize invalid arguments and does not know the questions to ask that might reveal them. Thus, the study of persuasive speech performs an important "defensive" purpose. It helps us defend ourselves against irrational and spurious claims. Conversely, as teachers of persuasive speech, we have all too often recognized how poorly and ineffectively students present even the simplest "offensive" argument. Virtually every term we have students request a make–up exam using this argument: "I couldn't study for your test because I had to study for Chemistry." Do the students believe that admitting a preference for chemistry should earn them the preferential treatment of a make–up exam for a course they slighted? The argument sabotages itself. Naturally, such poor uses of persuasive speech extend beyond the university gates. (p. 2)

In public speaking classes, many students seem to be more persuasive on their informative speeches than they are on their persuasive speeches. This is a conundrum. Why are they persuasive when they aren't supposed to be and why are they not persuasive when they are supposed to be? We can look back to simple conversation that was discussed earlier in this book. Ordinarily, when our friends tell us they went to a movie, they go on to tell us about the movie (informing us). And, they make evaluative statements and they seem compelled to tell us (persuade us) that we should or should not go to see that particular movie. Why does it seem so impossible to inform others without trying to persuade others? Interestingly, when we directly ask some of our friends to make a judgment and/or to convince us to do something, they will frequently say that we need to decide for ourselves. The same phenomenon carries over to student speeches. I have had students try to convince me that their persuasive speech deserved a better grade than the one I assigned. My typical response is: "If you had been this persuasive on the persuasive speech assignment, you wouldn't need to try and convince me to change your grade now."

On a daily basis, we are all bombarded by persuasive messages. Someone is always trying to get us to do something, to buy something, to go somewhere, to think or act in certain ways, to change our minds, to support or oppose people, things, issues, etc. The list could go on and on and on. To get this very book published, the author had to convince the publisher that it was a good product and that professors would adopt it to use in their classes. From the time we are born we are inundated with persuasion. As we are exposed to persuasion, we learn to use persuasion more and more. Unfortunately, we don't always learn to use persuasion effectively. Although we use persuasion on a daily basis, some of us are not particularly good at it. That is precisely why persuasion is included in our academic curricula.

Effective persuasion requires skill, but there is no mystery to it. Perhaps students fail to understand the objectives of the persuasive speech because they have preconceived notions that it is difficult to do. Many students enter my classes dreading the persuasive speaking assignments at the end of the term. Why is it so hard to understand that persuasion is something they have always done? The chief difference in that kind of persuasion and persuasive speaking is the organization and the more scholarly research that is required. Fear of public speaking is a reality, but there seems to be more fear of persuasive speaking. As this chapter develops, you will see that one can learn skills and strategies to become effective at persuasive speaking. A speaker

persuades with words (language) used in concert with verbal and nonverbal delivery. Further, a conversational style is most useful in persuasion. The more a speaker believes in what he/she is saying, the more the audience will believe. As author William Turner (1985) explained: "Personal belief and personal persuasion have a strong affinity for each other" (p. 67). Be ethical and be yourself; audiences can easily spot someone who is a fake or insincere. A speaker persuades by being personable, by using humor, by using the proper supporting materials, and by being prepared. Always be audience–centered, as has been pointed out numerous times in this book.

Persuasion Defined?

The late Gary Cronkhite (1969), a noted communication scholar, contended that an author who deigns to "'define' a word such as 'persuasion' might be considered painfully presumptuous" (p. 3). He added that anyone "knows that the 'real' meaning of a word is unique to a given individual at a given time in a given set of circumstances" (p. 3). Even a dictionary definition is "an attempt to provide a mold which will synthesize, compromise, or encompass all these unique meanings, vaguely specifying their common collateral and their outer limits" (p. 3). As Cronkhite did in his 1969 tome, I will cite a dictionary definition for purposes here and then will elaborate upon it to fit the needs of this introductory text. According to the *Merriam–Webster Online Dictionary* (available at http://www.m–w.com/), *persuasion* is "the act or process or an instance of persuading," "a persuading argument," and "the ability to persuade." The same dictionary defines *persuade* as "to move by argument, entreaty, or expostulation to a belief, position, or a course of action" or "to plead with." Note that persuasion is not the same as "force". A good persuasive speaker will not seek to impose his/her will on others. As Margaret Painter (1966), author of *Educator's Guide to Persuasive Speaking*, observed: "He who acts willingly remains a friend, but one who is forced against his will rebels" (p. 37).

Persuasion and Argumentation

There is some confusion when it comes to persuasion and argumentation. These two areas are not exactly the same, but both share some common ground. Andrea Lunsford, John Ruszkiewicz, and Keith Walters (2001), co–authors of *Everything's an Argument*, distinguished between the two:

...the point of argument is to discover some version of the truth, using evidence and reasons. Argument of this sort leads audiences toward conviction, an agreement that a claim is true or reasonable, or that a course of action is desirable. The aim of persuasion is to change a point of view, or to move others from conviction to action. In other words, writers or speakers argue to find some truth; they persuade when they think they already know it. In practice, this distinction between argument and persuasion can be hard to sustain. It is unnatural for writers or readers to imagine their minds divided between a part that pursues truth and a part that seeks to persuade. (p. 6)

Argumentation specialist Trudy Govier (1992) added:

Arguments are found where there is some controversy or disagreement about a subject and people try to resolve that disagreement rationally. When they put forward arguments, they offer reasons and evidence to try to persuade others of their beliefs. Consider the following short argument:

Eating more than one egg a day is dangerous because eggs contain cholesterol and cholesterol can cause strokes and heart attacks.

Reasons are given for the claim that it is dangerous to eat more than one egg a day. (p. 1)

Using the "egg" example, the specific purpose might be: "To persuade the audience to avoid the unhealthy practice of eating more than one egg per day." In a persuasive speech, the speaker might organize his/her points into a problem–solution pattern. The central idea or proposition for persuasive speeches (which is discussed later in this chapter) could be the same as for an argument: "Eating more than one egg a day is dangerous because eggs contain cholesterol, which can cause strokes and heart attacks." The problem is cholesterol in eggs. The solution is to stop eating too many eggs.

Persuasion and argumentation are both positive concepts, but many people tend to view them negatively. It is important that the two do not become confused with the more negative connotations held by words often confused with persuasion and argumentation: coercion and bickering. However, some people try to interchange the words. Persuasion does not use force, as does *coercion*, which includes threats both real and implied. *Bickering* is merely petty quarrelling and has nothing to do with arguing. It comes from Middle English word *bikeren*, which means "to attack."

Persuasive and Expository Speaking

As we saw in Chapter 4, a persuasive speech has much in common with expository speaking and offers plenty of information about a subject. Indeed, almost everything that has been covered in this book has led up to persuasive speaking. Although persuasive speaking is very similar to informative speaking, it goes a step or two further than informative speeches. Patrick Marsh (1967), author of *Persuasive Speaking: Theory, Models, Practice*, explained: "A good persuasive speaker is not exclusively a persuasive speaker; he is equally good at the various kinds of speaking and has the judgment to know when to use his persuasive talents and when to refrain if other methods are more appropriate" (p. 11). Indeed, expository speaking can be easily adapted to persuasion. Marsh (1967) added:

> Our definition differs from the more conventional view that expository discourse is solely concerned with information and not with attitudes and beliefs. The latter view would leave the instilling of new attitudes and beliefs to persuasive discourse. The concept we prefer to follow holds that the implanting of any new neural trace (information or attitude) in another is the function of expository speaking. The relationship of the speaker and listener is that of teacher and student. (p. 5)

Persuasive speeches are designed to influence attitudes, beliefs, or actions that are consistent with the speaker's specific purpose. As former Chrysler CEO Lee Iacocca advised: "…you should always get your audience to *do* something before you finish. It doesn't matter what it is—write your congressman, call your neighbor, consider a certain proposition. In other words, don't leave without asking for the order" (Iacocca & Novak, 1984, p. 54). Persuasive speaking specialist Karl Anatol (1981) recommended that a speaker focus on the desired result from the time he/she begins to prepare the speech: "Before you begin to outline your message, you should list the kinds of behavioral responses you want from your audience" (p. 1). Indeed, the effective persuader attempts to engineer consent to his/her propositions.

As the reader well knows, this textbook is designed for introductory public speaking classes. Therefore, the purpose of this chapter is to introduce students to basic persuasive speaking theory, models, and practice. In reality, most of the book thus far has been concerned with persuasive speaking. We have learned about the speaker's purpose, topic, and audience, organization of the speech, supporting materials in a speech, and delivery of a speech. All of these categories apply to persuasive speaking. Persuasive speaking may

indeed be somewhat more complicated and complex than informational or occasional speaking, but in reality it is just a step beyond informative speaking, as we will examine throughout this chapter. Like good informative speakers, effective persuasive speakers build their speeches around significant supporting materials (facts, evidence, and proof) that are presented in an interesting and appealing manner. The speaker appeals to the listener's motives and allows that listener to make up his/her own mind.

There are basically three purposes of persuasive speaking: *to convince, to actuate,* and *to reinforce, inspire, or motivate.* Students frequently ask me if their grade for the persuasive speech depends upon whether or not they actually persuade someone—get someone to believe or do something—in their speeches. My answer harkens back to my own undergraduate days and, interestingly enough, not to public speaking class but to algebra and trigonometry classes. My professor, considered at the time to be the greatest mathematician in the world, was not particularly concerned with whether students got the correct answer. Indeed, he was more concerned with us showing how we got to our answer. Persuasion is very similar, as it does not necessarily mean that someone is persuaded. Rather, the persuasive process—how the speaker goes about it—is the most important aspect. Persuasion, of course, is accomplished through communication. Or, as Gary Cronkhite might proffer, persuasion is accomplished by our "given set of circumstances". As we focus on persuasive public speaking, we will frame persuasion for this basic textbook as it applies to *speeches to convince, speeches to actuate,* and *speeches to reinforce, inspire, or motivate.* It is an introduction to persuasion in an introductory public speaking course, and no student is expected to master the art of persuasive speaking in just a portion of a semester or quarter. For the student who wants to become even more knowledgeable about public speaking, there are entire advanced courses designed to meet their needs.

Speech to Convince

A *speech to convince* is one in which the speaker hopes to change the audience's opinion about something and/or to get them to commit—at least mentally—to a certain point of view or perspective. As public speaking educators George Fluharty and Harold Ross (1966) observed, the speaker "is careful to adapt his arguments to the receptivity of his listeners. The speaker may have to offset or counteract previous knowledge, prejudices, and desires. It is not

always enough to show listeners that a proposition is true; it is often necessary to arouse their desire to believe the truth" (p. 257). Persuasion does not necessarily take place immediately, but can take a long time. Scheidel (1967) commented: "The evidence seems to indicate that the possible influence of a typical persuasive speech is limited in immediate effect, and even more limited if lasting effect is desired. A single persuasive speech is not likely to change basic value systems learned over a lifetime" (p. 56). For example, smokers are continually bombarded with persuasive messages designed to get them to quit smoking and most smokers would probably agree that smoking is dangerous. So, one could argue that most smokers have been convinced of the dangers of smoking.

Speech to Actuate

Convincing someone to act—or to quit—can be another thing altogether. A *speech to actuate* tries to get the audience past the belief or agreement stage and attempts to get the listener to do something, such as vote, lose weight, or quit smoking. Whether the audience member immediately acts on what the speaker wants does not determine the successfulness of the speech. As we saw in the preceding paragraph, a smoker may be persuaded that smoking is bad, but may not quit smoking—at least right away. In such case, persuasion still took place, because it caused the listener to think about change. The same is true of a speech to actuate. The listener may be convinced that he/she should vote or quit smoking or whatever, but still may not *act on* what the speaker wants. It does not mean that the speaker failed in persuading. When the Democratic or Republican National Conventions convene, the major objective is to select the respective party's representatives to run for president and vice president. Although all the delegates are committed to their party, they are not necessarily committed to a particular presidential candidate or running mate. The speaker's purpose would then be to plead with those individuals in an attempt to get them to act by throwing their support behind a particular candidate. Likewise, a person might regularly attend a certain church, but that person might not have committed to join the church. In which case, the minister would normally allocate a portion of the message in an attempt to persuade those persons to act. The bottom line is that one can agree with a proposition without acting on it. The minister would follow Iacocca's advice in trying to get the audience member to do something. In this case, the "something" would be getting the person to join the church of-

ficially. If the person doesn't join, it does not mean that the minister did anything wrong. We have to understand that we can only state our cases and we cannot always provoke action. Again, it does not necessarily indicate failure.

Speech to Reinforce, Inspire, or Motivate

A speech to reinforce, inspire, or motivate is one that seeks to awaken, arouse, excite, or challenge the passion and emotion of an audience already in agreement with our perspective. It is designed to keep in the fold those audience members who are already in agreement with the speaker. Let's revisit the examples given above. A Democrat attending the Democratic National Convention would not expect to hear someone give a speech trying to convince the audience to vote Republican. A member of the congregation at a Methodist church would not expect the minister to try to get him/her to convert to Catholicism or Judaism. In both these examples, the audience members would expect to hear themes in support of their beliefs. Therefore, they seek reinforcement for the path they have chosen to take. A speech to reinforce, inspire, or motivate can also be used for occasional, or ceremonial, speaking, which we will examine in Chapter 11.

Classical Rhetoric and Persuasive Speaking

The classical rhetorical approach to persuasion can be traced to Marcus Fabius Quintilian, a Spanish native who pleaded cases in the courts and later became the mentor to young men who would become great orators of Rome. Quintilian's approach held that there are five steps involved in the construction or composition of persuasive speeches: *invention, disposition or arrangement, expression or style, memory,* and *delivery or action* (Bizzell & Herzberg, 1990, pp. 3–4).

Invention

Invention is the discovery of effective persuasive strategies and arguments or proofs that are appropriate for persuasion. According to Aristotle's view, rhetoric is discovering every available means of persuasion. A persuasive presentation differs little from other forms of persuasive communication today, such as speeches, commercials, news releases, etc. Politicians and representatives of governmental institutions and entities have to learn over and over again the basic principle of rhetoric—it is a valid part of civilized society to seek to persuade—but the persuader, the rhetorician, had best not lie.

There is the obvious ethical dimension. There also is a very real practical consideration. For instance, every public relations professional (one who has been in the business long enough to be deemed a professional) knows that if you lie to the press or the public, *you will be found out*. Some professionals have said it is easier to restore virginity than to restore the credibility lost through just one lie to a reporter. Politicians at all levels have to relearn that fact continually—and many become losing politicians in the process. The same principle of credibility applies to discourse in marketing and advertising. The level of credibility may depend on the time frame involved and to the intentions of the principal. Is the candidate/seller seeking to build understanding for an extended relationship or just trying to make a buck? Is the intention to sell a cemetery lot to take the money and go, or is it a rational effort to build a customer relationship?

The *proposition* is a major consideration in developing effective persuasive strategies and arguments. As we will see later in this chapter regarding *pathos, or psychological proof,* the persuasive speaker moves toward a *proposition* that the speaker intends to affirm or deny. In a persuasive speech, the *proposition* is the central idea. The proposition, like the central idea, is a complete sentence that tells the listener the speaker's position on an issue. Then, using evidence and proof, the speaker attempts to move the listener toward accepting the proposition. Note the word *attempts*, as persuasion is a process that may end in success or failure. As we first discussed in Chapter 4, in persuasive speaking we must concern ourselves with *propositions of fact*, *propositions of value*, and *propositions of policy*. Here are some examples of actual titles from student persuasive speeches:

Minimum legal drinking age: Too high for its own good
The effectiveness of corporal punishment
Golf is an athletic endeavor
Golf is not a sport
The importance of donating blood
Go discover the world
Convicted but innocent: The Innocence Project
Hunting as a means of deer population management
Single–Sex education: An idea worth considering
Be charitable this holiday season
The Pete Rose dilemma
Rudy Giuliani: A prime choice for president
Tort reform: Keeping justice in America
Television: A harmful and wasteful practice

Cell phone addictions

Legalizing gay marriage

The Bowl Championship System (BCS): Better than a playoff system

The necessity of prison reform

Gun control: Restricting our rights

The Patriot Act: A violation of American civil liberties?

Educational opportunity in America: An inner city tragedy

Abolishing the Electoral College

The college meal plan—Is it really worth it?

Cancer coffin: The dangers of indoor tanning revealed

America's other drinking problem: Soft drinks

Open your heart to adopting Chinese children

Please Don't Drink and Drive

Don't fear gas prices

Live a healthy lifestyle

Monetary responsibility (you need to care)

Motorcycles and the 'safe road'

Overweight America

Practice safer sex: The truth about sexually transmitted diseases

Obesity in America

Nuclear Power: Captain Planet approves

Bringing down the house: Online gambling

Mandatory driving tests for senior citizen drivers

Why people should become organ donors

Support a national sales tax

Propositions of Fact

When the speaker states the proposition, it should be understood that some facts are easily verified or proved and others are not. There are some things that are absolutely true and unquestionable. A speaker will take one of two positions: that what is proposed is true or that what is proposed is false. Evidentiary support will be given to prove the trueness or falseness of a proposition. In many respects, a speech utilizing a proposition of fact has much in common with an informative speech. The difference is that in an informative speech, the speaker would be expected to be unbiased. In a persuasive speech, the speaker would be biased toward his/her own proposition and would make a case for it. It is imperative to understand that one's belief *can be* a fact, but a belief and a fact are not interchangeable. Believing that there is an Easter bunny does mean that there is in fact an Easter bunny. In other words, beliefs can be false. There will be more discussion regarding beliefs in the section on *values*.

If one were to give a speech about Mardi Gras and its origins and traditions, there may appear to be no dispute and therefore no need for a persuasive speech. It would then be purely informational. Presumably, everyone would agree that the speaker was correct and that his/her sources for the information were credible. However, it is possible for such facts to be challenged. In a real informative speech on Mardi Gras, a student stated that the tradition originated in New Orleans. An audience member took exception and disputed the fact, saying that Mardi Gras was actually started in Mobile, Alabama, and that New Orleans later adopted it as its own. The professor agreed that the speaker was in error, because the source for the information was incorrect. The professor then directed the students to more legitimate sources that confirmed Mardi Gras' origination in Mobile. The error was understandable in that New Orleans has become so synonymous with Mardi Gras, but facts are facts and Mobile was where Mardi Gras started.

Many people hold beliefs that they accept as true, but just because an overwhelming number of people might believe that Mardi Gras originated in New Orleans does not make it so. However, since there does appear to be cause for some dispute over those facts, one could give a persuasive speech to convince the audience of Mardi Gras' origins. Such a speech would be practical if some authority from Mobile desired to address the real origins once and for all. Likewise, New Orleans officials might have evidence to dispute Mobile's claims.

In an informative speech about cockfighting, a student discussed the history of the phenomenon and its status as a "sport." Cockfighting originated in Greece and later spread to America. The "sport" of cockfighting can take two forms: steel and naked heel. As the student speaker acknowledged, cockfighting is a controversial issue and is illegal in the United States. The student did not make a statement such as "cockfighting should be legalized" or "cockfighting is inhumane and should remain an illegal practice." The purpose was merely to inform the audience of the history and sport of cockfighting. There is no dispute that cockfighting exists and it is doubtful that many audience members would know enough about it to dispute any facts. Although cockfighting is a controversial issue, the speaker made no value judgment on it. Merely, the speaker presented facts that were based on solid research. Therefore, persuasion would exist only if the speaker crossed the line into a proposition of value or a proposition of policy. Of course, the speech did facilitate a lively discussion of cockfighting.

Propositions of Value

Propositions of value are concerned with principles, standards, qualities, or concepts that are deemed by the speaker to be worthwhile or desirable. It is important to understand that value has nothing to do with personal opinion. If you say you enjoy something, then that is your personal preference. You may recall the example about golf in Chapter 4. You do not have to explain why you like something, such as golf, but you might be challenged to explain your position if you make a value statement. Some believe that propositions of value can best be determined by asking the question: "Which is best among the alternatives?" (Gruner, Logue, Freshley & Huseman, 1977, p. 202). Further, "there are two types of issues [propositions or claims] of value; one type poses a question about the application of a value judgment, and the other asks for a comparison between two or more concepts or things (p. 202). The following questions illustrate the types of speeches that one could build around propositions of value:

Is hip–hop music really music?
Are illegal immigrants a threat to national security?
Should Americans spend less time watching television?
Is the "board of commissioners" type of government better than the "single county
 commissioner" model?
Was Benedict Arnold a patriot or a traitor?
Is the Patriot Act a violation of American Civil Liberties?
Does recycling save more than it costs?
Are intelligence tests really indicative of intelligence?
Is hunting of wildlife cruel and unnatural?
Was the atomic bomb dropped on Japan a moral alternative?
Is hunting a moral method of controlling the deer population?

In regard to values, public speaking professors Dan O'Hair and Rob Stewart (1999) explained: "Rather than attempting to prove the truth of something, as in claims of fact, a speaker arguing a claim of value tries to show that something is right or wrong, good or bad, worthy or unworthy" (p. 374). Harry Beckwith (1997), an advertising and marketing professional, summed it up this way: "Tell people—in a single compelling sentence—why they should buy from you instead of someone else" (p. 199).

Propositions of Policy

A proposition of policy can take either an *affirmative* or *negative position*. Simply put, the speaker will try to persuade the audience that something should be done (affirmative) or should not be done (negative). Note that propositions of policy ordinarily contain the word "should." Consider the differing views in the following examples:

The *affirmative* speech:

General Purpose:	To persuade
Specific Purpose:	To convince lawmakers in the United States to legalize the traditional sport of cockfighting.
Proposition:	Law–abiding Americans should have the right to pursue the long held family traditions and customs of cockfighting.

The *negative* speech:

General Purpose:	To persuade
Specific Purpose:	To reinforce the need for existing laws that ban cockfighting in the United States.
Proposition:	Cockfighting involves the inhumane treatment of animals and should continue to be illegal in this country.

The *affirmative* speech:

General Purpose:	To persuade
Specific Purpose:	To convince lawmakers that the State of Georgia should ban smoking in all public places.
Proposition:	Georgia lawmakers should ban smoking in public places.

The *negative* speech:

General Purpose:	To persuade
Specific Purpose:	To convince Georgia lawmakers not to ban smoking in all public places.
Proposition:	Georgia should not ban smoking in public places due to the constitutional rights of all citizens to their pursuit of happiness.

As you can see from the examples, a proposition of policy is more com-
plicated than speeches of fact or value because the speaker also incorporates
both of those concepts in order to get the audience to adopt the policy that is
being proposed. If the speech were a sales presentation, the speaker might
want the listener to buy his/her product or service. In such case, the policy
would be: "You should buy my laundry detergent." The value: "I am an ex-
pert on laundry detergent and it is better than the competitors' products." The
fact: "I will give you your money back if my detergent isn't better than the
others."

Whether your proposition is one of fact, value, or policy, you will need
to support your claim. As such, there are three appeals, evidence, or types of
proof used by persuasive speakers: *personal proof, psychological proof,* and
logical proof. Aristotle called them *ethos, pathos,* and *logos* and communica-
tion scholars continue to use the terms today. Most experts on persuasion
seem to agree that some combination of these three kinds of proof is neces-
sary for successful persuasion to take place.

Ethos, **or** *personal proof,* focuses on the speaker as a person. Many ex-
perts believe, as was mentioned in Chapter 8, that the speaker is the message.
Public speaking authority James Sayer (1983) wrote: "While all three factors
have been found to be significant in causing a speaker's message to be ac-
cepted by an audience, no less an authority than Aristotle noted several cen-
turies before the birth of Christ that *ethos* might be the most potent
persuasive tool at the disposal of the speaker" (p. 73). Deborah Barrett
(2008) added: "A positive ethos will take you a long way toward influencing
your audiences with your intended message, whereas a negative ethos is one
of the greatest barriers to effective communication" (p. 7). There is little
doubt that persuasion hinges considerably on the perception that the listener,
or audience member, has of the speaker as a person. If a speaker is to be suc-
cessful at persuasion, it is imperative that the audience sees in him/her a per-
son who personifies intelligence, experience, capability, proficiency, candid-
ness, honesty, trustworthiness, and cordiality—things that add up to give a
speaker *credibility* or *charisma* with the audience. Some speakers are well
known to the audience in advance, and that can be bad or good. Certainly, a
prestigious speaker with a good reputation beforehand would have an advan-
tage with the audience. A speaker needs only to possess some of those quali-
ties to be successful, because most of us believe that those who have a
number of good qualities would also have many other positive qualities. In
communication, we call it the *halo effect.* Likewise, there is a *reverse halo*

effect, as a speaker with a questionable reputation would have a major obstacle to overcome. If we see something negative in a speaker, we automatically assume that the person must have other negative attributes.

Aristotle believed that despite his/her reputation, the speaker should focus on establishing ethos for each individual speech. Student speakers, who are in the class because it is required, come before audiences with few expectations, as they have had little or no time to establish either a good or bad reputation. Certainly, by two or three speeches into the term, fellow students (as audience members) will have developed a sense of expectation concerning what the speaker might bring to the podium.

As we discussed in Chapters 4 and 5, *identification* is very important in persuasive speaking. It is easier to get someone to believe, or for us to believe someone else, when we share common ground. An example can be found in a speech delivered by an official from a state office of corrections, that is, a prison system. The official was invited to speak to a group on the subject of inmate privileges. Previous audience analysis showed that the group was against the concept of allowing privileges, such as television, basketball, and weightlifting. To establish common ground, the official said that he, too, had long been against allowing such privileges in prisons until he began work in the system as a guard. He explained to the group that such privileges helped to ensure the safety of guards and other prison personnel. As he related, those people who are sentenced to a lifetime behind bars have nothing else to lose. Therefore, by giving something to prisoners who otherwise had nothing to lose, guards could threaten to take away those privileges. That threat alone protected the guards. The speaker helped the audience understand that there are two sides to the issue and that allowing television, basketball, and weightlifting privileges to prisoners paled in comparison to a guard losing his/her life.

***Pathos*, or *psychological proof*,** appeals to the *attitudes* and *motives* of the audience. Attitude is our conscious predisposition to act in certain ways under certain circumstances or situations. One's attitude can be good, bad, or indifferent, depending on the circumstance or situation. It is "an evaluation of something" (Dodd, 2008, p. 371). We are not born with *attitude*, but we develop it through our own experiences, exigencies, and constraints. As a result, some experts believe that perception is not in the sender, but is in the receiver. Motive is different from attitude, and is an unconscious, spontaneous desire or physiological need that causes one to act. In other words, motive is normally accompanied by physiological change. Attitude has more to

do with one's mental state and motive is more physiological, but the two can interact.

A good speaker will use expository skills and strategies to move slowly toward the primary objective. As pointed out at the beginning of this chapter, persuasive speaking is an extension of expository speaking. Identification, rapport, or credibility should be established in the introduction to the speech. An effective persuasive speaker will not jump right into the persuasive proposition. Most audiences need cultivating and any abruptness can turn them against the speaker and his/her views. I have long known a mechanic in my small hometown who exemplifies the barriers caused by abruptness. When I would return home, there were times that I needed maintenance on my automobile. Normally, there would be other men sitting around the garage and having a good time in conversation with the mechanic, who also owned the garage. The mechanic would steadily continue working on a car while simultaneously conversing—or as we called it "shooting the breeze" or "shooting the bull"—with the guys. If I or anyone else walked in and tried to get anything done right away, it simply would never get done. However, if I joined in with the bull session by talking and telling jokes, the man would eventually get around to asking: "Well, are you here just to shoot the bull or do you need something?" At that point, I would reply: "Now that you mention it, I am having some trouble with my transmission." He would then say, "Let's take a look at it." Then, and only then, he would begin to repair my car. The point is that a persuasive speaker should never pursue the objective unless the audience is ready psychologically.

As discussed earlier in the chapter, many people do not realize that they have been targeted by all manner of persuasive speakers and methods. They don't seem to understand that others have learned how to manipulate them through *physical motives* and *social motives*. More than 50 years ago, psychologist A.H. Maslow devised a *hierarchy of human needs and motivation* that to this day continues to help us understand persuasion. Maslow built a pyramid consisting of the base needs of human beings. The greater needs form the foundation and lesser needs are found successively as the pyramid grows upward.

Maslow (1954) began his pyramid of human motivation with *physiological needs* of all human beings, such as air, water, minerals and vitamins, shelter, warmth, physical activity, rest, sleep, and sexual activity for purposes of reproduction and procreation of the species. Once these most basic of needs are met, humans move to Maslow's second level that focused on *safety*

needs, such as the need to avoid danger and the need for some kind of struc-ture to life that might include stability, order, and limitations. After the physiological and safety needs are satisfied, humans can move toward the third level. The third level is *belongingness and love needs* such as need for relationships with a romantic partner, a family, and friends and coworkers. The fourth level centered on *esteem needs* that he divided into lower and higher need categories. Lower esteem needs include attention, recognition, respect, status, and fame. Higher esteem needs include achievement, mas-tery, freedom, responsibility, and independence. Maslow (1954) explained: "All people in our society (with a few pathological exceptions) have a need or desire for a stable, firmly based, usually high evaluation of themselves, for self–respect, or self–esteem, and for the esteem of others" (p. 90). Maslow (1954) prefaced his fifth level of human motivation thusly:

> Even if all these needs are satisfied, we may still often (if not always) expect that a new discontent and restlessness will soon develop, unless the individual is doing what he is fitted for. A musician must make music, an artist must paint, a poet must write, if he is to be ultimately at peace with himself. What a man *can* be, he *must* be. (p. 91)

Therefore, Maslow's fifth level of *self–actualization needs* included one's realization of personal potential, self–fulfillment, and general personal growth. At this level, humans act on their own volition.

Let's look at Maslow's hierarchy in simpler terms that can be boiled down to two categories: *physical motives* and *social motives*. We *need* cloth-ing for protection, safety, and warmth, but we don't *need* Acme Clothing, as Brand X would be suitable for the job. We *need* water to survive, but we don't *need* Acme bottled water. We *need* shelter, but we don't *need* the Taj Mahal to be our house. The point here is that we *need* some things and we *want* or *desire* others. Our wants are driven more by social motives to keep up with the Joneses or to fit in with the people we believe to be desirable. Those in the business of persuasion, such as advertising and sales, make it their mission to tell us we *need* something that we really don't need but might want. We don't even necessarily need cleaner clothing than what we have, but advertisers tell us we can get whiter whites and brighter colors by using their detergent. My personal favorite is the detergent that is forever being hailed as "new and improved." So, what are they telling us, that the previous version was old and substandard?

Logos, or *logical proof,* basically means that the speaker presents evidence and then draws conclusions from that evidence. As we discovered in Chapter 7, assertions and opinions must be supported. Therefore, when we use the term "logical proof" we are really referring to supporting materials. Evidence, according to most experts, is also associated with the credibility of the speaker that we already discussed. If a speaker is more credible with the audience, there is that much less evidence the speaker will have to provide. Nonetheless, a speaker should not assume that his/her credibility profoundly influences the audience. A speaker should not take a risk, but should always present sufficient evidence to the audience. As with all the supporting materials we discussed in Chapter 7, the speaker must make sure that the evidence is sound.

Arrangement

As with any speech, organization is critical. *Arrangement,* of course, includes the selection of an effective organizational pattern (as we discussed in Chapter 6) and employment of proper persuasive techniques. As noted in that chapter, some of the more widely used patterns are: the *chronological* (time), the *spatial* (space), the *topical* (categorical), *causal* (cause–effect or effect–cause), *problem–solution* (need–remedy or disease–remedy), *ascending or descending order* (most to least important or least to most important), the *elimination* (method of residues), the *journalistic* (five Ws and the H), *deductive order*, *inductive order*, and the *motivational* (action response). Which pattern should you use in your persuasive speech? The answer can be very simple. Use the pattern that works best for what you are trying to achieve in your speech. Persuasive communication specialists Erwin Bettinghaus and Michael Cody (1987) advised: "If we present our persuasive messages using familiar patterns, we may have some confidence that rejection of the message will not be due to its organizational structure" (p. 143). Anatol (1981) added: "Whatever your strategy, it will be useful only if it assists you in achieving the desired results" (p. 1).

As we discovered in Chapter 7, supporting materials are important in making a speech believable. Obviously, proof and evidence are of utmost importance to persuasive speeches. Proof and evidence are found primarily in the categories examined earlier: "illustration and narration," "association," "explanation," "statistics," "expert power," "quotation," "definition," "description," "personal experience," "reinforcement," and "visual aids."

In persuasion, it is important to remember what we pointed out in the discussion of "expert power" in Chapter 7: "No one can know everything; so in a speech it can be very beneficial to offer the authenticity through the words or testimony of experts or authorities. It answers the question: Who says so? Such a person would possess *expert power*, which occurs when others recognize you as possessing some expertise or knowledge." It is important to understand, though, that one's own personal experience or expert testimony is still "an interpretation of facts or a judgment of value based upon them" (Fluharty & Ross, 1966, p. 110). If your "expert" were the sole authority on a matter, then the other side would not be able to bring in its own authority to refute what yours has testified.

Expression or Style

Expression or style is the use of proper, suitable, and impressing language. Richard Perloff (2003), an authority on persuasive dynamics, stated: "Great persuaders have long known that how you say it can be as important as what you say. Persuasion scholars and speakers alike recognize that the words persuaders choose can influence attitudes" (p. 197). Perloff explained that speech could be *powerless* or *powerful*. According to Perloff (2003), powerless speech "is a constellation of characteristics that may suggest to a message receiver that the communicator is less than powerful or not so confident" (p. 200). An example is the person who states that his/her forthcoming question might be construed as stupid. In an actual speech presentation, the speaker might start out by saying that he/she has had a bad day, is very nervous, did not have time to prepare properly, or doesn't feel well, etc. In other words, the person would make excuses for why the presentation will not be a good one. Powerful speech, on the other hand, "is marked by the conspicuous absence of these features" (p. 200). It is obvious to most researchers that powerless speech is ineffective in persuasion. However, Perloff (2003) added: "Although powerful speech is usually more persuasive than powerless language, there is one context in which powerless speech can be effective. When communicators wish to generate goodwill rather than project expertise, certain types of unassertive speech can work to their advantage" (p. 202). In a persuasive speech utilizing the problem–solution pattern, the speaker might ask a question regarding an alternative solution, such as: "That isn't the kind of result that you are looking for, is it?"

Language, or the words the speaker chooses to implement, is important to the persuasive effort. It is important to note that language can be effective or ineffective depending on the speaker, the message, the audience, and the situation. Use appropriate words that the entire audience can understand and to which they can relate. A speaker should use proper grammar and should pronounce words correctly. Harry Beckwith (1997), an advertising and marketing professional, believes that the speaker should "find fresh ways to make their points" and should avoid "clichés and other tired words" (p. 201). Beckwith explained: "You cannot bore someone into buying your product" (p. 201).

Most of the time, a speaker would follow the same rules of professional decorum that we have discussed throughout this book. Some situations call for different approaches. In a 1970 speech to an audience of ROTC students, legendary movie star John Wayne attempted to persuade the group that anti–Vietnam War protests on American college campuses were just plain wrong. Wayne obviously had a few drinks before his speech, but he was able to get his point across to the future soldiers. Wayne passionately stated:

> I went to school at the University of Southern California. When I went there, there was a fella [sic] in control of the college. He was the boss man there. If anybody had walked into, his, uh, office, and torn down the picture or written lewd words on the pictures of his family, we as members of the college would have kicked the hell out of his organization. I don't give a shit if you go to the school or not, you can't stand to have this happen. Oh Christ, I'm not trying to talk for clapping, I'm trying to talk for you guys. You better start thinking. It's getting to be re–goddamn–diculous. If you guys don't start thinking as men, we're going to have a lousy country. Jesus! They're trying to wreck our goddamn country. It's time for you younger guys to take over, I don't know what the hell to do. (Roeper, 2001, pp. 73–74)

A good general rule to follow in all speeches, and especially in persuasive speeches, is to use language that is appropriate for the occasion. The language used in the previous example of Mr. Wayne's speech would turn off many audiences, but may have been effective with the group he was addressing. Almost always, however, a speaker should avoid the incorporation of foul language in a speech.

Memory

Memory is the utilization of devices such as catchphrases or even note cards to help us speak extemporaneously. It also involves extensive practice or rehearsal of the speech by the speaker. An effective persuasive speaker would rely less on note cards than would an informative speaker. To be persuaded, an audience needs to be convinced that the speaker is an authority on the subject. I tell my students a story about an experience I had shopping for a new automobile. After virtually every question I asked, the salesperson would go ask the manager for the answer. Finally, I asked to deal directly with the manager. Not only was it frustrating for me, I didn't trust the salesperson. Obviously, he wasn't particularly knowledgeable about his topic. Additionally, it was a waste of my time to wait on him to come back after every question. The bottom line was that the salesperson had established no credibility, which is inherently important in persuasion. In regard to sales talks, James Baker (1928), an authority on public speaking, listed four requisites for a person to be successful in the sale of "an article, a service, or an idea": "1. He must have the goods. 2. He must know the goods. 3. He must show the goods. 4. He must talk the goods" (p. 213). Baker added, "If he rightly handles these four points, he may sell the goods" (p. 213).

Delivery or Action

Delivery or *action* is the actual vocal and physical presentation of the speech as we discussed in Chapter 8. Quintilian believed that in every speech a speaker must inform, move, and please. In other words, the speaker's message may be important, but if it is presented to the audience in a lackluster manner then it won't be very effective.

Listening to and Analyzing Persuasion

Many students who enter a public speaking class are well aware that they will be expected to give speeches. Few understand that a major objective is to learn about that process so they not only will know how to communicate to others, but also will learn what others do to communicate to them. In today's society, we are constantly bombarded with information and much of it is designed to persuade us to act or think in certain ways. As I tell students in my classes, "You need to understand how to persuade so that you can understand how others try to persuade you." This is nothing new, but with the technologies available today, persuaders have even more channels at their

disposal. Four decades ago, public speaking educators George Fluharty and Harold Ross (1966) urged us to understand the importance of critical listening: "The rise of persuasion as a social process in advertising and political propaganda creates the necessity for critical listening as a daily habit" (p. 10).

Chapter 11
Occasional Speeches: Sincerity, Originality, and Brevity

Sometimes in our lives and careers, we are asked to speak on *occasions* that do not call for purely informative or persuasive speeches. The key word here is, of course, *occasion*. Occasional, or ceremonial, speaking situations can run a wide gamut and can be informative, persuasive, entertaining, or some combination of any or all.

In this book considerable attention has been given to assessing the similarities and differences between public speaking and conversation. Occasional speeches typically share even more commonality with conversation than do other informative and persuasive speeches. Our encounters with others are frequently peppered with comments about how well the other person is, comments about the weather, and so on. In reality, we are not always concerned with that person or the weather. Rather, we are merely seeking to be courteous and social. When someone gives us something or does something for us, it is only proper that we respond in kind with something positive to say in return. Occasional speeches merely provide a bit more of a formal way to be nice to others. As Ralph Borden Culp (1968), author of a public speaking book, observed:

> The chairman of a meeting, for example, or the leader of any kind of group, must speak continually to reinforce the bonds that hold the group together. It is normal for the speaker of the evening of the major contributor to a group's discussion of its needs to be introduced by an officer of the group or by some person directly assigned to the task of creating an atmosphere of acceptance. It is seldom acceptable to present awards, or receive them; to welcome an individual, or respond to such a welcome, without making a formal speech. (p. 59)

Culp further believed that humans expect these speeches and even "seem to feel a need for them" (p. 59). Therefore, one could conclude that occasional speaking is indeed a form of *entertainment*. As with informative and persuasive speaking, Fluharty and Ross (1966) stated that an occasional speech "must be suited to the occasion, or rather to the audience assembled upon the

occasion," because the occasion "affects the expectations and reactions of the listeners" (p. 45). As will be seen as we discuss a variety of occasional speeches, a faux pas can occur if the speaker is not sensitive to those expectations of the audience. For instance, an audience would not expect a speaker delivering a eulogy to begin with a comment about the happy occasion that brought everyone together.

Unique Considerations for Occasional Speeches

It is important to understand that the occasional speaker, like the informative or persuasive speaker, must have something to offer the audience. Margaret Painter (1966), an expert on public speaking in educational settings, explained: "The speaker must have something worthwhile to say, organize his ideas for understanding and brevity, use acceptable language, and interest his listeners. In addition, he must meet the demands of the particular situation. Probably the greatest problem of the occasional speaker, however, is the need to find a new way to express the old, familiar ideas which the situation requires" (p. 176).

Overall, occasional speeches should be sincere, original, and brief. There are several other important and unique characteristics that need to be considered. These include *atmosphere, content, organization, length,* and *presentation style.*

Atmosphere

As we learned in Chapter 2, communication always takes place in a *context* that will ultimately affect the nature and intent of the speaker's message. Both the occasion and the physical dimension (where the speech takes place) have a tremendous impact on what the speaker will say and how it will be said. The audience expects a certain atmosphere to be present in a given situation and the speaker should add to that atmosphere. Some situations lend themselves to solemnity or seriousness and others are made for frivolity and silliness. Other occasions can fall somewhere in between. It is said that one speaker went through a particularly difficult time during an after–dinner speech. With an intention to compliment the food, he began by saying: "What a wonderful meal. If I had eaten one more bite I would be so full that I couldn't give my speech." To the speaker's chagrin, an audience member shouted out: "Give that man a sandwich." Even after his speech was well

under way, he still was not safe. Someone in the back said: "Speak louder; we can't hear you back here." An audience member on the front row retorted: "Change seats with me, because I can hear him very clearly." Sometimes, the speaker cannot win no matter what. Many of the occasional speeches mentioned in this chapter can take place in situations in which the audience really is not in the mood to listen or take the speaker seriously. Be prepared for that and don't let it bother you. It may not be you; it might simply be the atmosphere.

Content

As with atmosphere, the audience has expectations about the content of the occasional speech. Appropriateness, fairness, and accuracy are givens. Occasional speeches are not appropriate for finding fault, proving your point, bringing up something unpleasant, or inciting controversy (Fluharty & Ross, 1966, p. 237). If the occasion is a solemn one, as alluded above, then the speaker should speak solemnly and use dignified language. If the occasion is a happy one, then the speaker's words and demeanor should reflect that.

Organization

The organization of occasional speeches has much in common with other forms of speeches in that they include an introduction, a body, and a conclusion. As with all other types of speeches, occasional speeches should be easily understood by the audience. A speaker should choose appropriately from among the organizational patterns that we previously examined in Chapter 6.

Length

The length of a speech is always an important consideration. Most audience members neither expect nor want an occasional speaker to go on and on and on. People have things to do and places to go, so the effective speaker should be aware of that. Who has not sat through a graduation speech in which the speaker seems to speak for an eternity? Graduation ceremonies are long enough without the keynote speaker filibustering away. Make your remarks and get out of the way. Time limitations should be taken into consideration for all speeches and most especially for occasional speeches. Lincoln's Gettysburg Address, which we will examine later in the chapter, is a prime example of a brief occasional speech. It is not particularly well known that the speaker prior to Lincoln went on and on for two hours. In contrast, Lincoln

was extremely brief—his speech consisted of just 268 words—and the audience was very surprised by that brevity. The Gettysburg Address is considered a great speech and a major part of that may very well have to do with its short duration. The bottom line is that it is probably better to err on the side of brevity when making an occasional speech.

Presentation Style

Although a speaker should always be aware of the occasion and location of the speech, these things typically bear more importance in occasional speaking. It is always helpful to know ahead of time when the speaker will be called upon, to know in what kind of venue or facility the speech will be given, and to know whether the group being addressed has specific expectations that could impact what will be said and how it will be delivered. As with atmosphere and content, presentation style is affected considerably by the occasion.

Types of Occasional Speeches

James Humes (1976), author of *Roles Speakers Play*, observed: "Although the variety of speech occasions seems unlimited, there are actually only seven roles to play" (p. 5). Those roles are advocate, lecturer, commemorator, toast maker, moderator, introducer, and honoree. Occasional speeches can be *for sociality and courtesy; for commemoration;* or *for counseling*. Occasional speeches normally have an overall objective *to reinforce, to inspire,* or *to motivate*. As we saw in Chapter 10, speeches to reinforce, inspire, or motivate seek to awaken, arouse, excite, or challenge the passion and emotion of an audience already in agreement with our perspective. They are typically persuasive speeches that are designed to keep in the fold those audience members who already tend to agree with the speaker. Many of the speeches in the other categories detailed below can be considered as *speeches to reinforce, inspire,* or *motivate*. They are especially useful at conventions, dedications, graduation ceremonies, rallies, patriotic gatherings, fundraising campaigns, elections, and so on. As persuasive speaking authority Margaret Painter (1966) elaborated:

> The similarity of speeches on such occasions lies in their major objective: action with an emotional response. Listing the essentials of speeches of this type is inadequate. The flowering of the ideas, the embellishments of the framework, is what makes the inspirational speech so impressive that listeners respond happily. Gener-

ous use of the impelling motives and the factors of interest are needed in an inspirational talk to induce the audience to listen willingly and then to respond with the desired emotions and actions. To accomplish this, the speaker first determines his theme and, hopefully, expresses it in a memorable form. (p. 189)

Speeches for Sociality and Courtesy

Speeches for sociality and courtesy tend to be more informative than persuasive and they can include *introducing someone*; *making an announcement or announcements*; *presenting a gift or award or accepting a gift or award*; *welcoming or responding to a welcome*; or *making or responding to a toast*.

Introducing someone. When *introducing someone*, it is important to consider whether the occasion is to inform about the person in great detail or to introduce the person to give his/her own speech. Typically, a speech to introduce a historical figure, such as Benjamin Franklin, would be given as an informative speech as described in Chapter 9. A speech to introduce a classmate would also fall under informative speaking rather than occasional speaking. In my classes, the introduction of a classmate is the first speech done by students. Appropriate organizational patterns for a speech of introduction might include the *chronological pattern*, the *spatial pattern*, or a combination of the two. For example, a chronological order would proceed at the beginning of the person's life and move forward. A spatial pattern might focus on where the person has lived—especially if the subject has moved quite a bit—or the speech might be divided into categories addressing the person's education, hobbies, and goals.

If your objective is to introduce a person who will be giving a speech, then you should build interest and excitement for the speaker and help the audience understand why this particular person should be welcomed to speak to them. Gather as much information as possible about the person, or topic. That information should then be honed into something manageable. The speaker, as with other types of speech situations, should take the audience into consideration. A speech of introduction can be detailed or simple. If the person were being introduced due to some honor, then the introduction would be more detailed. If the person were being introduced as the keynote speaker, then the introduction would focus on the speaker's outstanding accomplishments, achievements, experience, etc. In other words, the purpose is to let the audience know why this speaker is qualified to present his/her

topic. As such, the speaker doing the introduction would follow a plan, or buildup, for the speaker being introduced. The speaker would begin with an attention–getting story or accomplishment that leads into a statement about the importance and viability of the topic; the reason the audience should relate to the topic; the speaker's qualifications; and then the actual presentation of the speaker to the audience. Further, you should keep your introduction brief, as you don't want to steal any thunder from the featured speaker. Check and double–check your information about the speaker so that you are totally accurate. As this is an occasional speech, make sure that you adapt your introduction both to the occasion and to the audience. It is typically good to add some dramatic impact to build the audience's anticipation for the speaker.

Making an announcement or announcements. Announcements are done for two reasons. One method is basically executed to communicate important information, which would make it an informational speech. The other is a small version of an action speech, because the person making the announcement is attempting to get the listener to do something. Perhaps the speaker wants to get students to vote in the student council election, to urge others to attend the pep rally or ballgame, and so on. An announcement might employ the *journalistic organizational pattern* that was explained in Chapter 6. It would address the who, the what, the when, the where, the why, and the how. The speaker would employ an attention–getter; share the occasion or the purpose for the event being announced (who and what); list facts concerning dates and times (when); tell where it will take place; explain why it is important for the listener to attend; and tell how the listener's attendance will impact the event.

Presenting a gift or award or accepting a gift or award. There are many occasions when someone might expect you to present or to accept some type of gift or award. In such cases, a presenter should heap abundant commendation or admiration on the recipient of the award. At the same time, the presenter should not embarrass the recipient by going too far with the praise. Unless the recipient is warned ahead of time, he/she should not be expected to say much more than an impromptu expression of appreciation. If a speech of acceptance is desired, then the recipient should be allowed to prepare remarks for the occasion. A good presenter will note the occasion for the gift or award; will mention the reasons for the gift or award; will express the sen-

timents and best wishes of the entire group responsible for bestowing the gift or award on the recipient; and will present the speech in a formal manner.

A prepared acceptance would require an expression of appreciation; acclamation of the faith the presenter and organization have bestowed upon him/her; a declaration of gratitude due to the significance and importance of the gift or award; and, if the occasion calls for it, the acceptance speaker should share any plans he/she has for using the gift or award. As for the latter, an example might be a student accepting a scholarship, who would therefore tell which college he/she would be attending. No matter what the acceptance is, James Humes (1976) advised:

> When that gift or plaque is presented to you, they [the audience] don't want you to advocate a bill or lecture on law. They just want you to say a few words—to be yourself. That is the time to shed the judge's robe or executive's mantle. Let the audience see the real you underneath. That's what they would like to see. (p. 75)

When accepting an award, it is important to remember that you don't have to be profound in your remarks; merely accept the award graciously and move on.

Welcoming or responding to a welcome. A speaker on this occasion should tell the audience why the person is being welcomed, if it is not already apparent, and should be sure to show appreciation for the audience's presence for the occasion. If, for example, the occasion were a welcome for a group of distinguished alumni on their return to the old alma mater, then the speaker might want to mention how they have contributed to the successes and achievements of the college.

Making or responding to a toast. The toast is truly a speech in which the person delivering it can and should have fun. Toasts can take place on almost any occasion, but more formal presentations are typically offered at weddings or testimonial affairs. One of the older and more famous toasts in existence is based on "eat, drink, and be merry" from the Bible in Ecclesiastes 8:15. In a sense, a toast is a tribute. Toasts can vary greatly depending on the occasion, which could be at a formal dinner, at a wedding, or at some other type of celebration.

Toasting is said to have originated in Greece where someone was acclaimed for some specified reason or wished "good health." The practice was refined in Rome to become the forerunner of today's toasts. Literally, toast

was bread that was heated and browned. The Romans consumed it to temper the taste of wine that was used to "toast" or to honor someone (Irvin, 2000, p. 2). Toasting has evolved over time and it is probably less important in the United States today than it once was (Phillips, 2007, p. C1). There seems to be less emphasis on the ceremonial intricacies of the toast and, as a result, less significance of the speech itself.

Alcohol is not a necessary ingredient in toasting, as any drink will do. To formulate a toast, it is recommended that the speaker:

1. Make a reference to the meeting, or gathering [the occasion].
2. Refer to the achievements of the recipient of the toast.
3. Express for the entire group present your goodwill.
4. Propose the toast formally. (Wright, 1948, p. 47)

The person performing the toast should be well prepared, well rehearsed, and should limit their remarks to one to three minutes. If alcohol is part of the occasion, then it is important—as with any public speaking situation—to be cautious. If you have had too much to drink, then it would be best to let someone else take over. Despite what you might have seen on television and in the movies, do not bang on a glass. Rather, you should stand up and hold up the glass until the audience sees you, but do not hold up the glass while the toast is taking place. If you are in the audience, do not drink your glass down all at once. The person being toasted does not take a drink, as it would be like applauding yourself.

If someone proposes a toast, then it is only polite to respond to it. A person toasted, at the very least, should merely "say a sincere 'thank you'" and should "return the compliments paid" (p. 62). If you don't know about the toast ahead of time, then you must make impromptu remarks. If you keep the above guidelines in mind then it will help whenever such an occasion presents itself.

Wedding toasts, which have evolved considerably over time, have gone from "a simple 'To your health and happiness' to a soliloquy that requires personalization, preparation, practice and presentation" (Warner, 1997, p. 7). In addition to the suggestions noted above, a wedding toast should be expressive, touching, unpredictable, clever, and humorous. Wedding toasts are a "melding of poetry, quotations, prayer, wit, anecdote and heart–rendered sentiment" (p. 7). An "important thing to remember is that a wedding toast is the one essential ingredient for any wedding reception" and "without the wedding toast, [the reception is] just a very expensive party," so the toaster—as

with all speakers—"must be prepared" (p. 8). Here are some recommenda-
tions for preparing a toast as synopsized from *Diane Warner's Complete
Book of Wedding Toasts* (1997). Use eloquence, poignancy, whimsy, and
wit. While giving the toast, keep eye contact with both the bride and groom.
Employ appropriate verbal and nonverbal communication in your delivery,
as has been discussed throughout this book. Feel free to use ideas, phrases,
quotations, anecdotes, etc. that you can find in a variety of places. Finally,
and perhaps most importantly, enjoy yourself on the happy occasion.

Speeches for Commemoration

Speeches for commemoration can be used *to eulogize, to bid farewell, to
dedicate something*, or *to recognize an anniversary of someone or some-
thing*. Commemorative speeches can even be combinations of eulogies,
farewells, tributes, dedications, or anniversaries.

To eulogize. A eulogy, which takes place at a funeral or memorial service,
presents a situation in which the speaker strives to synopsize the sentiments
that are held by the audience. Audience–centeredness is of utmost concern,
as the speaker should focus on the audience members' feelings. There are
several objectives to be met in a eulogy:

1. Focus on the person's life (biography, accomplishments, honors, etc.).
2. Elaborate on the qualities that made him/her special.
3. Point out the bonds or experiences shared between the deceased and
 the audience members.
4. Tell the audience what they can take with them—or learn—from the
 person's life.
5. Finally, the speaker should bid farewell to the deceased.

To bid farewell. The farewell speech has much in common with the eulogy,
except that the speaker focuses on himself/herself. Some might call the fare-
well a self–eulogy, as the speaker may be resigning, retiring, moving, etc.
For whatever reason, the person is leaving something behind. There have
been many famous farewell speeches throughout history, but one of the best
known is General of the Army Douglas MacArthur's April 19, 1951, "Fare-
well Address to Congress" a.k.a. his "Old soldiers never die" speech. Mac-
Arthur (1964, p. 460) ended his speech this way:

I am closing my fifty–two years of military service. When I joined the Army even before the turn of the century, it was the fulfillment of all of my boyish hopes and dreams. The world has turned over many times since I took the oath on the Plain at West Point, and the hopes and dreams have long since vanished. But I still remember the refrain of one of the most popular barrack ballads of that day which proclaimed most proudly that—

"Old soldiers never die, they just fade away."

And like the old soldier of that ballad, I now close my military career and just fade away—an old soldier who tried to do his duty as God gave him the light to see that duty.

Good–by.

Not only was MacArthur bidding farewell, he was making a statement regarding his views on war. Throughout the speech, he referred to strategies employed by the U.S. military in the past and he warned Congress of impending crises that would be presented by the continuing threat of communism. He prefaced his comments by saying: "I trust, therefore, that you will do me the justice of receiving that which I have to say as solely expressing the considered viewpoint of a fellow American."

Another famous farewell speech that bears mentioning is that of baseball legend Lou Gehrig. In his July 4, 1939, speech before a game in Yankee Stadium, Gehrig chose not to dwell on the deadly disease that he had contracted and that later bore his name. Rather, Gehrig focused on how fortunate he had been in his life that he had been able to play baseball for a living. He began his speech: "Fans, for the past two weeks you have been reading about a bad break I got. Yet today I consider myself the luckiest man on the face of the earth." He repeated the "lucky" theme several times in his short speech and then he ended it this way: "So I close in saying that I might have had a rough break; but I have an awful lot to live for!"

Another of the more famous farewell lines ever spoken was by Captain Nathan Hale, an American soldier of the Revolutionary War. Hale, who was just 21 years of age, was determined by the British to be a spy. He was hanged on an apple tree in New York City on September 21, 1776. Hale was denied his last requests; he wanted to send letters to his family and he wanted a Bible. Upon being allowed to speak his last words, Hale declared: "I only regret that I have but one life to lose for my country."

To dedicate something. Speeches of dedication are given to mark the opening of some public interest. There are probably few Americans who are not aware of President Abraham Lincoln's Gettysburg Address; however, it

seems most people have no idea what the topic was or why the speech was delivered. In reality, it was given to dedicate the national cemetery at Gettysburg, Pennsylvania, where thousands of Americans had died in the Battle of Gettysburg in July 1863. It was a rare occasion for President Lincoln to give a speech outside Washington, DC, and Gettysburg marked just the third time he had done so (White, 2005, pp. 225–226). Carl Sandburg (1954), proclaimed author and Lincoln biographer, noted that "a printed invitation notified Lincoln that on Thursday, November 19, 1863, exercises would be held for the dedication of a National Soldiers' Cemetery at Gettysburg" (p. 439). Indeed, Lincoln was not even the top billed speaker that day, as that honor was bestowed on Edward Everett, a former U.S. senator and governor of Massachusetts among other things. Only after Lincoln accepted the invitation to attend was he asked to participate in the proceedings at all. Perhaps due to Lincoln's lower billing, legend has it that Lincoln scribbled the speech on the back of an envelope aboard a train while on his way to Gettysburg. As you may recall from earlier in this book, public relations professional Vic Gold (1975) questioned the story of Lincoln as "the lonely figure in a stovepipe hat and shawl scribbling out his classic address en route to the speech site" (p. 177). Gold said that although "it makes a good tale," he was skeptical of its authenticity" (p. 177). In reality, Gold was correct in that the speech was well planned and calculated and it indeed went through several drafts. Persuasive speaking authority Thomas M. Scheidel (1967) believed: "The best historical evidence gives little support to the above account" (p. 97). Scheidel believed we should "do all that we can to stamp out this old myth" because "it may lead students to believe something of value can be created without any considerable effort" (p. 98).

Lincoln formulated the famous "Four score and seven years ago" opening because of its biblical tone. Several months prior to the speech, Lincoln used the same theme in an informal speech—although he didn't know at the time that he would use it at the dedication of the Gettysburg cemetery. For example, the famous opening line was originally stated as: "How long ago is it?—eighty–odd years since, on the Fourth of July for the first time in the history of the world a nation by its representatives, assembled and declared as a self–evident truth, that 'all men are created equal'." Indeed, the actual introduction to Lincoln's speech at Gettysburg sounds very similar to Moses' address to the people of Israel after their exodus from Egypt 40 years earlier. As recorded in Deuteronomy, Chapter 1, verses 6–8 in *The Living Bible*, Moses began his speech as follows: "It was forty years ago, at Mount Horeb,

that Jehovah our God told us, 'You have stayed here long enough. Now go and occupy the hill country of the Amorites, the valley of the Arabah, and the Negeb, and all the land of Canaan and Lebanon—the entire area from the shores of the Mediterranean Sea to the Euphrates River. I am giving all of it to you! Go in and possess it, for it is the land the Lord promised to your ancestors Abraham, Isaac, and Jacob, and all of their descendants.'"

Author William Safire (2004), Pulitzer Prize winner and essayist for the *New York Times Magazine*, concluded that the Gettysburg speech could be construed "as a poem based on the metaphor of birth, death, and rebirth—with its subtle evocation of the resurrection of Christ" (p. 59). Safire added:

> Four images of birth are embedded in its opening sentence: the nation was "*conceived* in liberty"; *brought forth*," or born, "by our *fathers*"; with all men "*created* equal." This birth is followed by images of death—"*final resting place*," who *gave their lives*," "brave men, living and *dead*," "these honored dead"—and by verbs of religious purification—*consecrate…hallow.*"

> After the nation's symbolic birth and death comes resurrection: out of the scene of death, "this nation, under God, shall have a *new birth* of freedom" and thus "*not perish*," but be immortal. (pp. 59–60)

Authors Michael M. Klepper and Robert E. Gunther (1994) observed that the "address changed the world without any bells and whistles. It was like a stealth attack. It slipped into people's minds and hearts, transforming a nation" and it was truly an occasional speech, as "Lincoln simply had the right words at the right time" for the right occasion (p. 8). Interestingly, as Lincoln walked away after the speech, he uttered his personal belief that the speech was a terrific failure. The "slow–spoken" speech follows in its entirety as handwritten in pencil by, according to Carl Sandburg (1954), Charles Hale of the Boston *Advertiser*:

Gettysburg Address

November 19, 1863

> Four score and seven years ago our fathers brought forth on this continent, a new nation, conceived in liberty, and dedicated to the proposition that all men are created equal.
>
> Now we are engaged in a great civil war, testing whether that nation, or any nation so conceived and so dedicated, can long endure. We are met on a great battlefield of that war. We have come to dedicate a portion of that field, as a final resting

place for those who here gave their lives that this nation might live. It is altogether fitting and proper that we should do this.

But, in a larger sense, we cannot dedicate—we cannot consecrate—we cannot hallow—this ground. The brave men, living and dead, who struggled here, have consecrated it, far above our poor power to add or detract. The world will little note, nor long remember, what we say here, but it can never forget what they did here. It is for us the living, rather, to be dedicated here to the unfinished work which they who fought here have thus far so nobly advanced. It is rather for us to be here dedicated to the great task remaining before us—that from these honored dead we take increased devotion to that cause for which they gave the last full measure of devotion—that we here highly resolve that these dead shall not have died in vain—that this nation, under God, shall have a new birth of freedom—and that government of the people, by the people, for the people, shall not perish from the earth.

Lincoln's short speech was about the same length as Lou Gehrig's farewell to baseball speech. It proves the point that speeches of great impact do not have to be of tremendous length. Indeed, the speech did last fewer than three minutes, which explains why there were no pictures taken because "a photographer before him had not the time to focus his lens, put a plate into his camera and release the shutter; the address was over almost before it began" (Lorant, 1954, p. 187).

Believe it or not, there were critics of the speech and Lincoln was among them, as he believed it "fell on the audience like a wet blanket." Massachusetts Senator Edward Everett later wrote to Lincoln: "I shall be glad if I could flatter myself that I came as near to the central idea of the occasion in two hours as you did in two minutes" (Safire, 2004, p. 59). Even so, upon conclusion of the speech Everett and Secretary of State William H. Seward, who sat on the platform with Lincoln, believed the speech to be a failure. Many newspapers, including the London *Times*, were also critical, but two of them broke from the negative trend. Stefan Lorant (1954), a Lincoln biographer, wrote that the Chicago *Tribune* was the first to issue favorable comment about the speech. Further, the Springfield (Massachusetts) *Republican* advised the reader to "Turn back and read it over," as "it will repay study as a model speech" (pp. 187–188).

Professor Ronald C. White, Jr. (2005), author of *The Eloquent President*, commented that it could indeed be perceived as unfortunate that the Gettysburg Address has "been treated in splendid isolation from the rest of Lincoln's speeches" (p. 224). Professor White wrote *The Eloquent President* with the purpose of demonstrating that Lincoln's speeches were "a string of

pearls" and that every pearl, "although of different color and size, possesses its own beauty" (p. 224).

To recognize an anniversary of someone or something. The anniversary speech can be given to commemorate weddings, birthdays, holidays, and so on. It is a celebratory speech in which the speaker may focus on the importance or significance of the event that spawned the anniversary celebration. The speaker may also include a thorough treatment of account of any ideals, values, influences, and any other items of significance to the event being commemorated.

Speeches for Counseling

Speeches of counsel are very similar to speeches for commemoration, but the difference is that speeches of counsel tend to learn toward persuasion. They are indeed both occasional and ceremonial, but the speaker also seeks to get the audience to act or think a certain way. Speeches for counsel are exemplified by *inaugural addresses*, *nominations or nomination acceptances*, *declarations*, *commencement addresses*, and *sermons*.

Inaugural addresses. Michael Waldman (2000), who served as special assistant and chief speechwriter for Bill Clinton from 1992 to 1999, stated:

> Few things equal the dizzying thrill of working on a new president's inaugural address. Power and energy seem to flow to the new leader, cascading from unseen and untapped sources, pooling in the one person who will briefly embody the nation's hopes. The document will set the tone for a new administration, chart the course for the politics of an era, and, possibly, change the way a country sees itself. (p. 29)

Waldman recalled sitting around Clinton's dining room table at the Arkansas Governor's Mansion for a preliminary discussion of Clinton's inaugural address. Along with Waldman and Clinton were George Stephanopoulos and David Kusnet, another speechwriter. Waldman (2000) recounted the meeting and how Clinton launched into the project:

> "Ask not what your country can do for you," he intoned. "You have nothing to fear but fear itself. If you can't stand the heat get out of the kitchen. Live free or die. And in conclusion: read my lips!" Clinton pinkened with laughter. He was reciting a speech made by Eddie Murphy in the movie *The Distinguished Gentleman*, which had arrived in Little Rock cinemas the week before. Murphy plays a con artist who

talks his way into Congress. His victory speech is a hilarious collection of political clichés. We laughed along with Clinton—partly in memory of the movie, partly at the insider tingle of hearing the President–elect deliver the same lines. (p. 29)

Every president wants to deliver a memorable inaugural address that will live on throughout history. Several presidential inaugural speeches stand out from all the others: Abraham Lincoln's (second inaugural), Woodrow Wilson's (first inaugural), Franklin D. Roosevelt's (first inaugural), John F. Kennedy's and Ronald Reagan's (first inaugural). Lincoln's second inaugural address was particularly important because he had been reelected unexpectedly during the fourth year of Civil War. Lincoln used the inaugural in an attempt to move the nation forward.

Nominations or nomination acceptances. Most citizens will never have the opportunity to nominate a person to run for president of the United States, but many people are called on to nominate someone to be president of the parent organization, the garden club, the lodge, the fraternity, etc. In such cases, facts are far more relevant than personal opinions. The speaker should run through a set of requirements demanded by the office or position. The speaker also should inform the audience of the nominee's experience and qualifications for the position. Finally, the speaker would formally nominate the person as a candidate. Should a response from the nominee be solicited, similar guidelines given earlier about accepting an award or honor may be helpful. The nominee could state that he/she is honored by the nomination and is looking forward to the election process.

Declarations. Declarations are similar to inaugural addresses. We saw a good historical example of a declaration speech in Chapter 6. President Franklin D. Roosevelt's December 8, 1941, "Declaration of War Speech" was delivered to Congress one day after the Japanese attack on Pearl Harbor. Roosevelt opened his speech by telling about the attack on Pearl Harbor and other military installations in the Pacific, moved on to failed negotiations with Japan, prognosticated what would happen in the future, and then culminated with his request that Congress officially declare war. The bottom line is that the president wants something done about the situation and proposes that his solution is the best. It is an example of how occasional speeches can frequently be persuasive speeches.

Commencement addresses. Graduation speeches are much maligned, as many people rue sitting through them. But, graduates and their families who see the speech as a rite of passage also welcome them. The best graduation speeches are short and to the point. As the graduation speech is a speech for counseling, the speaker is expected to pass on advice. Typically, the speaker would urge graduates to use their knowledge to better both themselves and the world around them. The graduation speaker should be careful to note that they are there primarily to speak to the graduates, but they should also be aware that family and friends are also present.

Sermons. Sermons are religious messages and are primarily used for rein-forcement. Depending upon the philosophies of the particular religion or de-nomination, there may be more convincing or actuating involved. Many times, sermon themes are dictated by conference leaders and may not be the sole idea of the minister. Sometimes ministers find written sermons that they can use. However, even religious leaders are individuals and are subject to personal influences on topic, purpose, organization, and delivery. Sermon experts Thomas Long and Cornelius Plantinga (1994) wrote: "Reading a sermon is an importantly different experience from hearing one, and both differ from actually seeing a preacher aim and fire. So, understandably, some written sermons do not do their authors full justice" (p. xiii). They added that "anyone knows who has heard a tape of Winston Churchill's great World War II speeches, it is quite possible to utter something of nearly final mag-nificence with a slightly slurred matter–of–factness" (p. xiii). The word ser-mon itself can be a barrier to effective communication. Some people are put off by the idea of hearing someone preach a sermon. In that way, the word "sermon" shares much in common with the word "speech." Author Joseph Donders (2006) observed:

> Preaching is a strange thing. Preaching can be frustrating. As a preacher, I know very well what I am talking about. You can preach and preach, people can listen and listen, and you just wonder what all that preaching and all that listening accomplish. I am afraid that very often they accomplish nothing at all. Something else must be added.... (p. 34)

Reverend Larry Summerour, my favorite minister, believes in getting right to the point. His sermons never run long, which is something that pleases me immensely. Regarding his brevity, he once commented: "If you can't get your point across in 15 minutes or less then you never will. You will lose

your audience." In my opinion, Larry's sentiments sum up the ultimate secret to public speaking no matter the occasion or the purpose.

Bibliography

Adams, John Quincy. (1962). *Lectures on Rhetoric and Oratory* (Volumes I and II). New York: Russell & Russell. (Reprinted)

Ailes, Roger and Kraushar, Jon. (1988). *You Are the Message: Getting What You Want by Being Who You Are*. New York: Currency Doubleday.

Allen, Steve. (1986). *How to Make a Speech*. New York: McGraw–Hill Book Company.

American Institute of Certified Public Accountants. (2005, January 6). Skills/Competencies [WWW]. URL http://www.aicpa.org/nolimits/become/skills/index.htm

Anatol, Karl W.E. (1981). *Persuasive Speaking* (2nd Ed.). Chicago: Science Research Associates, Inc.

Anderson, Neal T., Park, Dave, and Miller, Rich. (2003). *Stomping Out Fear*. Eugene, OR: Harvest House Publishers.

The Art of Communicating Language. (2000). Princeton, NJ: Films for the Humanities & Sciences FFH 10177.

Baker, James Thompson. (1928). *The Short Speech: A Handbook on the Various Types*. New York: Prentice–Hall, Inc.

Baldoni, John. (2003). *Great Communication Secrets of Great Leaders*. New York: McGraw–Hill.

Barrett, Deborah J. (2008). *Leadership Communication* (2nd Ed.). Boston: McGraw–Hill Irwin.

Beckwith, Harry. (1997). *Selling the Invisible: A Field Guide to Modern Marketing*. New York: Warner Books.

Beebe, S.A., Beebe, S.J., and Redmond, M.V. (2002). *Interpersonal Communication: Relating to Others* (3rd Ed.). Boston: Allyn and Bacon.

Berra, Yogi and Kaplan, Dave. (2002). *What Time Is It? You Mean Now?* New York: Simon & Schuster.

Berry, Cicely. (1973). *Voice and the Actor*. London: Harrap Limited.

Bettinghaus, Erwin P. and Cody, Michael J. (1987). *Persuasive Communication* (4th Ed). New York: Holt, Rinehart and Winston.

Bitzer, Lloyd F. (1968, Winter). "The Rhetorical Situation," *Philosophy and Rhetoric*, *1*, pp. 1–14.

Bizzell, Patricia, and Herzberg, Bruce (Eds.). (1990). *The Rhetorical Tradition: Readings from Classical Times to the Present*. Boston: Bedford Books.

Boller, Jr., Paul F. (1991). *Congressional Anecdotes*. New York: Oxford University Press.

Brody, Marjorie. (1998). *Speaking Your Way to the Top: Making Powerful Business Presentations*. Boston: Allyn and Bacon.

Buttrick, David. (1994). *A Captive Voice: The Liberation of Preaching*. Louisville, KY: Westminster/John Knox Press.

Christensen, David and Rees, David. (2005a, January 6). Communication Skills Needed by Entry–Level Accountants. American Institute of Certified Public Accountants. [WWW]. URL http://www.aicpa.org/index.htm

————. (2005b, January 6). Communication Skills Needed by Entry–Level Accountants. American Institute of Certified Public Accountants. [WWW]. URL http://www.aicpa. org/pubs/cpaltr/oct2002/business/busind2.htm

Communication Techniques Volume I: Individual and Group Communications. (1980). Maxwell Air Force Base, AL: Air University.

Congressional Budget Office. (2002, September 25). Regarding the Transition to Digital Television. [WWW]. URL http://energycommerce.house.gov/107/hearings/09252002 hearing 719/hearing.htm

Coplin, Bill. (2003). *Ten Things Employers Want You to Learn in College.* Berkeley, CA: Ten Speed Press.

Crannell, Kenneth C. (2000). *Voice and Articulation* (4ᵗʰ Ed.). Belmont, CA: Wadsworth/ Thomson Learning.

Cronkhite, Gary. (1969). *Persuasion: Speech and Behavioral Change.* Indianapolis, IN: The Bobbs–Merrill Company, Inc.

————. (1984). Review of George Gerbner and Marsha Siefert (Eds.), *Ferment in the Field: Communications Scholars Address Critical Issues and Research Tasks of the Discipline* in *Quarterly Journal of Speech, 70* (4), pp. 468–473.

Crowley, Sharon and Hawhee, Debra. (2009). *Ancient Rhetorics for Contemporary Students* (4ᵗʰ Ed.). New York: Pearson/Longman.

Culp, Ralph Borden. (1968). *Basic Types of Speech.* Dubuque, IA: Wm. C. Brown Company Publishers.

Dangerfield, Rodney. (2004). *It's Not Easy Bein' Me: A Lifetime of No Respect but Plenty of Sex and Drugs.* New York: HarperEntertainment.

Daniel, Douglass K. (2007, August 19). "Michael Deaver, Reagan's chief image consultant." Associated Press report in *The Atlanta Journal–Constitution*, p. D12.

Denka, Andrew. (2005, January 6). "Ask Andy" Advice Column—Archive Articles: Communication Skills. American Institute of Certified Public Accountants. [WWW]. URL http://www. aicpa.org/nolimits/prof/askandy/questionanswer.asp

Detz, Joan. (1984). *How to Write and Give a Speech.* New York: St. Martin's Press.

Devito, Joseph A. (2004). *The Interpersonal Communication Book* (10ᵗʰ ed.). Boston: Allyn & Bacon.

Dodd, Carley H. (2008). *Managing Business and Professional Communication* (2ⁿᵈ Ed.). Boston: Pearson/Allyn and Bacon.

Dolman, John, Jr. (1922). *A Handbook of Public Speaking.* New York: Harcourt, Brace and Company.

Donders, Joseph G. (2006, January/February). Not alone. *Alive Now*, pp. 34–36.

Downs, Hugh. (1995). *Perspectives.* Atlanta: Turner Publishing, Inc.

Eidenmuller, Michael E. (2008). *American Rhetoric* [WWW]. URL http://www.american rhetoric.com/rhetoricdefinitions.htm

Fluharty, George W. and Ross, Harold R. (1966). *Public Speaking.* New York: Barnes & Noble, Inc.

Ford, Wayne. (2006, January 19). Tempting Distraction. *Athens Banner–Herald*, pp. C1, C3.

Frost, S.E., Jr. (1942, 1962). *Basic Teachings of the Great Philosophers.* New York: Anchor Books/Doubleday.

Futrelle, David, Mannes, George, and Weisser, Cybele. (2005, June 7). Great ways to better yourself. *Money Magazine,* [WWW]. URL http://money.cnn.com/2005/06/02/pf/smartest_better_0507/index.htm

Gold, Vic. (1975). *I Don't Need You When I'm Right: The Confessions of a Washington PR Man.* New York: William Morrow & Company, Inc.

Govier, Trudy. (1992). *A Practical Study of Argument* (3rd Ed.). Belmont, CA: Wadsworth Publishing Company.

Gray, Giles Wilkeson. (1964, October). *The Founding of the Speech Association of America: Happy Birthday. Quarterly Journal of Speech*, 9–12. [WWW]. URL http://www.natcom.org/nca/Template2.asp?bid=529.

Green, M. (1969). *Television news: Anatomy and process.* Belmont, CA: Wadsworth Publishing Company.

Gruner, Charles R., Logue, Cal M., Freshley, Dwight L., and Huseman, Richard C. (1977). *Speech Communication in Society* (2nd Ed.). Boston: Allyn and Bacon, Inc.

Hamilton, Cheryl. (2008). *Communicating for Results: A Guide for Business and the Professions* (8th Ed.). Belmont, CA: Thomson Higher Education.

Hausman, Carl, Benoit, Philip, Messere, Fritz, and O'Donnell, Lewis B. (2004) (5th Ed.). *Announcing: Broadcast Communicating Today.* Belmont, CA: Wadsworth Publishing Company.

Herrick, James A. (2005). *The History and Theory of Rhetoric: An Introduction* (3rd Ed.). Boston: Allyn and Bacon.

Hewitt, Don. (2001). *Tell Me a Story: Fifty Years and 60 Minutes in Television.* New York: Public Affairs.

Hill, Julie. (2004, September). All aboard: Electronic whiteboards are the new workhorses of the classroom. *Presentations*, pp. 37–40.

Hillbruner, Anthony. (1966). *Critical Dimensions: The Art of Public Address Criticism.* New York: Random House.

Hoff, Ron. (1996). *Say It in Six: How to Say Exactly What You Mean in 6 Minutes or Less.* New York: Barnes & Noble Books.

Hoffman, Gloria and Graivier, Pauline. (1983). *Speak the Language of Success.* New York: A Jove Book.

Humes, James C. (1975). *Podium Humor: A Raconteur's Treasury of Witty and Humorous Stories.* New York: Harper & Row, Publishers.

———. (1976). *Roles Speakers Play.* New York: Harper & Row, Publishers.

Hunt, John Gabriel (Ed.). (2005). *The Inaugural Addresses of the Presidents from George Washington to George W. Bush.* New York: Gramercy Books.

Iacocca, Lee and Novak, William. (1984). *Iacocca: An Autobiography.* New York: Bantam Books.

Irvin, Dale. (2000). *The Everything Toasts Book.* Avon, MA: Adams Media Corporation.

Jeary, Tony. (1997). *Inspire Any Audience: Proven Secrets of the Pros for Powerful Presentations.* Tulsa, OK: Trade Life Books.

Jeffers, Susan. (1987). *Feel the Fear and Do It Anyway.* New York: Fawcett Columbine.

Jones, Chuck. (1996). *Make Your Voice Heard: An Actor's Guide to Increased Dramatic Range through Vocal Training.* New York: Back Stage Books.

Kaiser Family Foundation. (2005, March 9). Generation M: Media in the Lives of 8–18 Year–olds. [WWW]. URL http://www.kff.org/entmedia/entmedia030905pkg.cfm

Karpf, Anne. (2006). *The Human Voice: How This Extraordinary Instrument Reveals Essential Clues about Who We Are*. New York: Bloomsbury Publishing.

Karr, Harrison M. (1953). *Developing Your Speaking Voice*. New York: Harper & Row, Publishers.

"Keeping it simple. (2007). *Deliver*, p. 5.

Keller, T., and Hawkins, S. A. (2002). *Television news: A handbook for writing, reporting, shooting, & editing*. Arizona: Holcomb Hathaway.

Kimball, Miles A. and Hawkins, Ann R. (2008). *Document Design: A Guide for Technical Communicators*. Boston: Bedford/St. Martin's.

Klepper, Michael M. and Gunther, Robert E. (1994). *I'd Rather Die Than Give a Speech*. Burr Ridge, IL: Irwin Professional Publishing.

Koch, Arthur. (2008). *Purposeful Speaking*. Boston: Pearson/Allyn and Bacon.

Koehler, Alan. (1964). *The Madison Avenue Speech Book: For People Who Are Scared to Make a Speech and Don't Want to Show It*. New York: McGraw–Hill Book Company.

Lane, Shelley D. (2008). *Interpersonal Communication: Competence and Contexts*. Boston: Pearson/Allyn and Bacon.

Lasswell, Harold D. (1948). "The Structure and Function of Communication in Society." In Lyman Bryson (Ed.). *The Communication of Ideas* (pp. 37–51). New York: Harper & Brothers.

Lerner, Harriet. (2004). *The Dance of Fear: Rising above Anxiety, Fear, and Shame to Be Your Best and Bravest Self*. New York: Perennial Currents.

Locker, Kitty O. and Kaczmarek, Stephen K. (2007). *Business Communication: Building Critical Skills* (3rd Ed.). Boston: McGraw–Hill Irwin.

Long, Thomas G. and Plantinga, Jr., Cornelius (Eds.). (1994). *A Chorus of Witnesses: Model Sermons for Today's Preacher*. Grand Rapids, MI: William B. Eerdmans Publishing Company.

Lorant, Stefan. (1954). *The Life of Abraham Lincoln: A Short, Illustrated Biography*. New York: A Mentor Book/New American Library.

Lowrey, Sara and Johnson, Gertrude E. (1953). *Interpretive Reading: Techniques and Selections*. New York: Appleton–Century–Crofts, Inc.

Lunsford, Andrea A., Ruszkiewicz, John J., and Walters, Keith. (2001). *Everything's an Argument* (2nd Ed.). Boston, MA: Bedford/St. Martin's.

MacArthur, Douglas. (1964). *Reminiscences*. Greenwich, CT: Fawcett Publications.

Maltz, Maxwell. (1975). *Thoughts to Live By*. New York: Pocket Books.

Marsh, Patrick O. (1967). *Persuasive Speaking: Theory, Models, Practice*. New York: Harper & Row, Publishers.

Maslow, A. H. (1954). *Motivation and Personality*. New York: Harper & Row, Publishers.

McCormack, Mark H. (1997). *Mark H. McCormack on Communicating*. London: Arrow Business Books.

McCroskey, James C. (2006). *An Introduction to Rhetorical Communication* (9th Ed.). Englewood Cliffs, NJ: Prentice Hall.

McDaniel, Rebecca. (1994). *Scared Speechless: Public Speaking Step by Step*. Thousand Oaks, CA: Sage Publications.

McKenna, Colleen. (1998). *Powerful Communication Skills: How to Communicate with Confidence*. New York: Barnes and Noble Books.

Miner, Margaret and Rawson, Hugh. (2000). (3rd Ed.). *The New International Dictionary of Quotations*. New York: A Signet Book.

Monroe, Alan H. (1945). *Monroe's Principles of Speech* (Brief Edition). Chicago: Scott, Foresman and Company.

Natalle, Elizabeth. (2008). *Teaching Interpersonal Communication*. Boston: Bedford/St. Martin's.

Nelson, Willie and Pipkin, Turk. (2006). *The Tao of Willie: A Guide to the Happiness in Your Heart*. New York: Random House.

O'Hair, Dan and Stewart, Rob. (1999). *Public Speaking: Challenges and Choices*. Boston: Bedford/St. Martin's.

Packard, Vance. (1957). *The Hidden Persuaders*. New York: Pocket Books.

Painter, Margaret. (1966). *Educator's Guide to Persuasive Speaking*. Englewood Cliffs, NJ: Prentice–Hall, Inc.

Palmer, Arnold. (1997). *Arnold Palmer Golf Academy Golf Journal: A Personal Handbook of Practice, Performance, and Progress*. Chicago: Triumph Books.

Papper, R. A. (1995). *Broadcast News Writing Stylebook*. Needham Heights, MA: A Simon & Schuster Company.

Paradi, Dave. (2004, July). When technology fails, be ready. *Presentations*, p. 42.

Parkinson, C. Northcote. (1957). *Parkinson's Law and Other Studies in Administration*. Boston: Houghton Mifflin Company.

Peale, Norman Vincent. (1959). *The Amazing Results of Positive Thinking*. New York: Fawcett Crest.

———. (1982). *Positive Imaging: The Powerful Way to Change Your Life*. New York: Fawcett Crest.

Perloff, Richard M. (2003). *The Dynamics of Persuasion* (2nd Ed.). Mahwah, NJ: Lawrence Erlbaum Associates, Publishers.

Peter, Laurence J. (1972). *The Peter Prescription: How to Make Things Go Right*. New York: William Morrow and Company, Inc.

Phillips, Donald. (1992). *Lincoln on Leadership: Executive Strategies for Tough Times*. New York: Warner Books.

Phillips, Julie. (2007, December 29). "Don't embarrass yourself at toast time." *Athens Banner–Herald*, pp. C1, C3.

Pratt, Betty. (1952). "Five Easy Exercises That Relieve Mental and Physical Tension." In *Journal of Living. How to Calm Your Nerves and Relax*. New York: Journal of Living Publishing Corporation.

Rader, Dotson. (2004, July 11). "My fear fuels me." *Parade*, pp. 4–6.

Raines, Laura. (2007a, February 25). "Making your pitch." *The Atlanta Journal–Constitution*, pp. R1, R4.

———. (2007b, May 6). "Think again." *The Atlanta Journal–Constitution*, pp. R1, R4.

Rauch, Basil (Ed.). (1957). *The Roosevelt Reader: Selected Speeches, Messages, Press Conferences, and Letters of Franklin D. Roosevelt*. New York: Holt, Rinehart and Winston.

Regenold, Stephen. (2004, July). New respect for doc–cams. *Presentations*, pp. 34–36, 38.

Rodenburg, Patsy. (1993). *The Need for Words: Voice and the Text*. New York: Routledge Theatre Arts Book.

Roeper, Richard. (2001). *Hollywood Urban Legends*. Franklin Lakes, NJ: New Page Books.

Rogers, Everett M. (1994). *A History of Communication Study: A Biographical Approach*. New York: The Free Press.

Safire, William. (2004). *Lend Me Your Ears: Great Speeches in History*. New York: W.W. Norton & Company.

Sandburg, Carl. (1954). *Abraham Lincoln: The Prairie Years and The War Years One–Volume Edition*. New York: Galahad Books.

Sayer, James E. (1983). *Guide to Confident Public Speaking*. Chicago: Nelson–Hall.

Scheidel, Thomas M. (1967). *Persuasive Speaking*. Glenview, IL: Scott, Foresman and Company.

Simons, Tad. (2004, March). Does PowerPoint make you stupid? *Presentations*, pp. 24–26, 27, 30–31.

Spence, Gerry. (1995). *How to Argue and Win Every Time: At Home, In Court, Everywhere, Every Day*. New York: St. Martin's Griffin.

Sprague, Jo and Stuart, Douglas. (1988). *The Speaker's Handbook* (2ⁿᵈ Ed.). Orlando, FL: Harcourt Brace Jovanovich Inc.

Stephens, M. (1993). *Broadcast news*. Orlando, FL: Harcourt Brace Jovanovich College Publishing.

Stokes, Jamie (Ed.). (2001). *The Little Book of After Dinner Speeches*. Bath, UK: Parragon Publishing.

Strong, W.F. and Cook, John A. (1987). *Persuasion: A Practical Guide to Effective Persuasive Speech*. Dubuque, IA: Kendall/Hunt Publishing Company.

Tibbetts, A.M and Tibbetts, Charlene. (1987). *Strategies of Rhetoric with Handbook* (5ᵗʰ Ed.). Glenview, IL: Scott, Foresman and Company.

Trenholm, Sarah and Jensen, Arthur. (2008). *Interpersonal Communication* (6ᵗʰ Ed.). New York: Oxford University Press.

Turner, William. (1985). *Secrets of Personal Persuasion*. Englewood Cliffs, NJ: Prentice–Hall, Inc.

Vasquez, Jody. (2004). *Afternoons with Mr. Hogan: A Boy, a Golf Legend, and the Lessons of a Lifetime*. New York: Gotham Books.

Waldman, Michael. (2000). *POTUS Speaks: Finding the Words That Defined the Clinton Presidency*. New York: Simon & Schuster.

Warner, Diane. (1997). *Diane Warner's Complete Book of Wedding Toasts: Hundreds of Ways to Say "Congratulations!"* Franklin Lakes, NJ: New Page Books.

The Way. (1971). Wheaton, IL: Tyndale House Publishers.

Werts, Diane. (2007, September 18). "TV's lost art: Talk." *The Atlanta Journal–Constitution*, p. F4.

White, Maria Mallory. (2003, January 26). Dreams Can Happen: Visualization Method Works. *The Atlanta Journal–Constitution*, pp. R1, R4.

White, Jr., Ronald C. (2005). *The Eloquent President: A Portrait of Lincoln through His Words*. New York: Random House.

Wills, Garry. (1992). *Lincoln at Gettysburg: The Words that Remade America*. New York: Touchstone/Simon & Schuster.

Wofford, Monica I. (2004, December). Speaker's Notes: You don't have to be perfect to be effective as a speaker. *Presentations*, p. 90.

Wood, Julia T. (2007). *Interpersonal Communication: Everyday Encounters* (5th Ed.). Belmont, CA: Thomson/Wadsworth Learning.

Wright, C.W. (1948). *Better Speeches for All Occasions*. New York: Crown Publishers.

Yaverbaum, Eric and Bly, Bob. (2001). *Public Relations Kit for Dummies*. New York: Wiley Publishing, Inc.

Zeldin, Theodore. (2000). *Conversation: How Talk Can Change Our Lives*. Mahwah, NJ: HiddenSpring.

Index